The Sculpture of **Clement Meadmore**

THE SCULPTURE OF CLEMENT MEADMORE

ERIC GIBSON

Hudson Hills Press

NEW YORK

First Edition

Text © 1994 by Eric Gibson
Illustrations © 1994 by Clement
Meadmore

Published in the United States by
Hudson Hills Press, Inc., Suite 1308,
230 Fifth Avenue, New York, NY
10001-7704.

Distributed in the United States, its
territories and possessions, Canada,
Mexico, and Central and South America
by National Book Network.

Distributed in the United Kingdom and
Eire by Art Books International Ltd.

Exclusive representation in Asia,
Australia, and New Zealand by EM
International.

Editor and Publisher: Paul Anbinder

Copy Editor: Fronia W. Simpson

Proofreader: Lydia Edwards

Indexer: Karla J. Knight

Designer: Martin Lubin

Composition: Trufont Typographers

Manufactured in Japan by Dai Nippon
Printing Company

Library of Congress Cataloguing-in-
Publication Data

Gibson, Eric.
 The sculpture of Clement
Meadmore / Eric Gibson. — 1st ed.
 p. cm.
 Includes bibliographical references
and index.
 ISBN 1-55595-098-1
 1. Meadmore, Clement—Criticism
and interpretation. 2. Minimal
sculpture—United States.
I. Meadmore, Clement. II. Title.
NB237.M3G53 1994
730′.92—dc20 94-13836
 CIP

CONTENTS

ACKNOWLEDGMENTS

I am most grateful to Paul Anbinder, president of Hudson Hills Press, Inc. for first approaching me about writing this book, and for making it possible for me to see a number of the publicly placed sculptures in situ.

I am also grateful to Clement Meadmore. He has been extremely generous with his time and with allowing me access to both his studio and his archive. The book would have been more difficult and less thorough without his cooperation. Equally important has been his open-minded attitude to what a monograph should be, sharing my view about the need for a true critical study rather than, as such studies often are, a work of promotional literature. One is not always so lucky with one's subjects.

Hilton Kramer kindly took the time to review the manuscript and to offer a number of extremely helpful suggestions, thus adding to an already considerable professional and personal debt.

In addition to much else, my wife, Kay, has had to endure the extended absences, both physical and mental, I needed to complete this book. Yet, as usual, she has been unqualifiedly understanding and supportive throughout. Words hardly seem an adequate way in which to express my gratitude.

Others have helped in large ways and small. My editor at the *Washington Times,* Ken McIntyre, was most considerate when it came to granting the necessary time to work on the book. The staff at the library of the National Gallery of Art provided much timely assistance. And finally, Jim Kelly, travel agent extraordinaire, made visiting the various outdoor sites happily painless and economical.

1

In a typical sculpture by Clement Meadmore, a single, rectangular volume repeatedly twists and turns upon itself before lunging into space, as if in a mood of aspiration or exhilaration, or simply to release physical forces held in tension. The appearance of Meadmore's sculptures has been likened by one critic to "a cigarette butt or a nail puzzle," and by another to the Hellenistic Greek sculpture *Laocoön*.[1] Stylistically, Meadmore's works fuse elements of Abstract Expressionism and Minimalism. Their effect is one of fluid immediacy, as of a signature. Since Meadmore's sculptures are often very large (they are most commonly placed outdoors), this impression of effortless physical grace is simultaneously underscored and called into question.

What is less apparent—invisible, actually—but just as important, is the central paradox of their creation. Sculpture that appears spontaneously generated is instead the product of protracted labor. Meadmore makes his sculptures by combining and recombining two basic elements, a cube and a quarter circle, until a basic configuration emerges that satisfies him. He then tailors its proportions and makes any other adjustments he deems necessary.

Thus, what appears to have been brought forth in an instant gesture has in fact been arduously labored over. What is emotionally expansive is wrought from a number of starkly rigid, self-imposed constraints: the use of geometric modules; the insistence that in combination they "transcend geometry"[2] and express a larger feeling; finally, that they be true to their physical nature in being able to remain balanced of their own weight, without assistance from internal counterweights or bolts into the ground. Meadmore's is an approach that has, over a career of some forty years, yielded sculpture of uncommon force and feeling.

2

Clement Meadmore was born in Melbourne, Australia, in 1929.[3] The impulse toward art seems to have come from his mother, Mary Agnes Ludlow Meadmore, a Scotswoman who had lived in Australia from the time she was a small child. As a boy, Meadmore was strongly impressed by his mother's interest in the work of an uncle, Jesse Jewhurst Hilder (1881–1916), an Australian watercolorist in the style of Corot.[4] She also instilled an interest in ballet and, first among artists, Edgar Degas. It is tempting to see in this early exposure to Degas the seeds of Meadmore's mature work, which frequently suggests the stresses and strains of bodily motion.

Meadmore's first career choice, however, was not art but aircraft engineering. This may have come from his father, Clement Robert Webb Meadmore, who, after an early career as a vaudeville actor, had opened a shop specializing in model trains and engineering. After completing his early education, Meadmore enrolled in the Royal Melbourne Institute of

Technology to study engineering but soon changed to industrial design. A once-weekly class in sculpture was given as part of the program, but it focused on sculpture as three-dimensional design rather than as aesthetic expression.

Meadmore was, in fact, already pursuing his own interest in sculpture independently. He made his first pieces—carved wooden V shapes tautly strung with wire— while completing his industrial-design studies. After graduation, he embarked on the beginner's familiar path, making sculpture in his spare time while engaged in more lucrative pursuits—in his case, those of an industrial designer—during the day. A turning point of sorts came in 1953 when, on a visit to Belgium, he saw an outdoor exhibition of modern sculpture at Middelheim Park, in Antwerp. The experience moved him to buy welding equipment on his return to Melbourne.

Prefiguring his later inclinations, Meadmore's first sculptures alternate between a rigorous geometry

and a simmering expressionism. They are welded, the earliest of them conforming to the prevailing idiom of contemporary constructed sculpture. They are reliefs composed of interlocking vertical and horizontal rods of varying lengths. The rods are heavily encrusted and built up with matter. They resemble the open-work, linear sculptures of New York School sculptor Ibram Lassaw in the 1940s, but are more rigorously structured.

They give no inkling that Meadmore was an artist who would eventually favor a robust physicality in his work. All, particularly the gridded rods, are as nearly diaphanous and self-effacingly insubstantial as steel sculpture can be, as if Meadmore wished to suggest form not built up by accretion but eaten away by light. Meadmore then embarked on planar constructions in which he attempted to evoke the effect of Franz Kline's gestural, black-on-white abstract paintings using sheets of welded steel, an approach similar to that adopted a few years later by Mark di Suvero

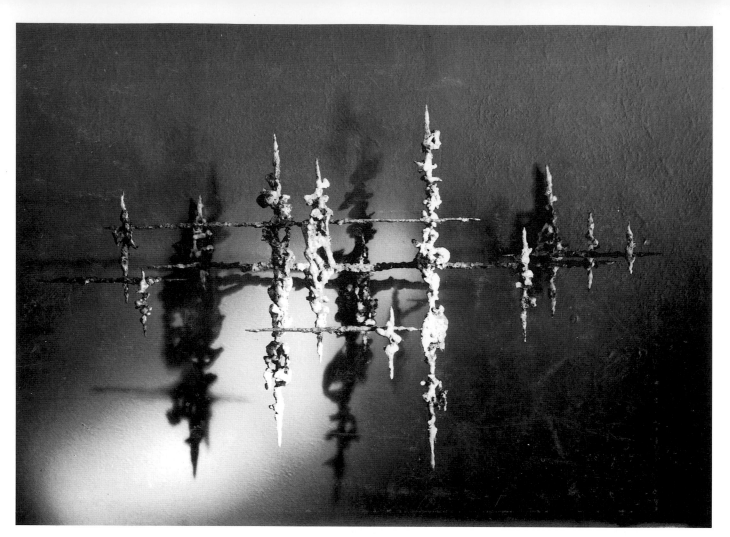

UNTITLED 1956
Steel
Dimensions unknown
Private collection

CONCLAVE 1959
Steel
Dimensions unknown
Private collection

UNTITLED 1960 ▷
Steel
13½″ × 15″ × 14″
Virginia Spate, Sydney, Australia

in his large-scale sculptures of metal and timber.

Meadmore's earliest mature work follows soon after, in the mid- to late 1950s. It consists of sculptures composed of rectangular planes placed at right angles to each other. Rather than being thin sheets of steel, as the elements in such constructed sculpture historically were, each plane is thick and slablike, resembling a solid of cast bronze. In fact, each one is a hollow volume formed by welding six sheets of steel to produce a hybrid, a form that is both a volumetric plane and a planar volume. The sculpture produced by this approach departed somewhat from the established Constructivist tradition. Not only was Meadmore's new work composed of manufactured rather than found forms, but it had a greater mass and bulk than anything previously produced in this idiom. (In this it anticipates sculptures of a similar character that David Smith would begin making in 1962.)

In their details, the sculptures differ from the finely honed, pristine character of much geometric ab-

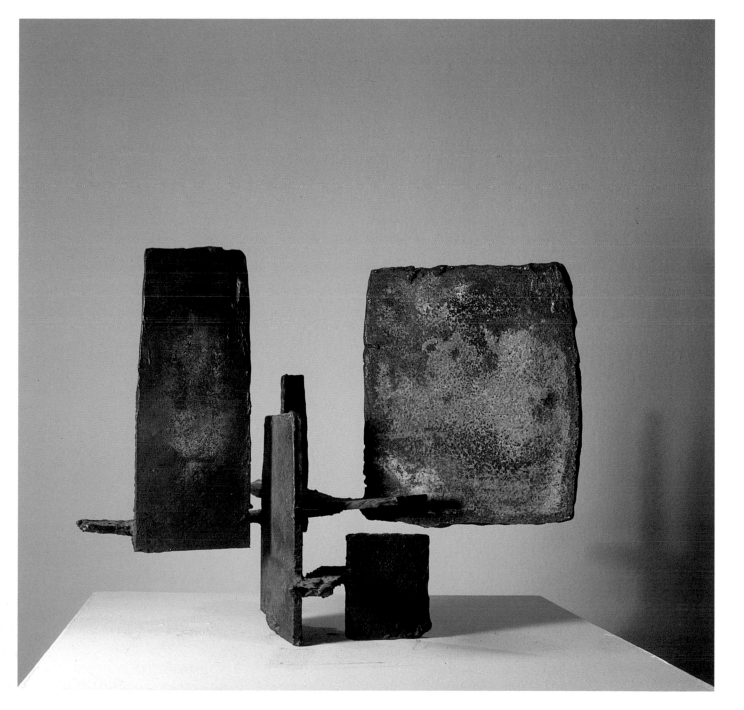

straction. The slab-planes are not perfectly rectangular. Surfaces are not even but are scarred and pitted; they gently swell or undulate. At the corners, where the steel sheets meet at less-than-perfect right angles, Meadmore has left traces of the torch in the form of thick encrustations of metal brought up by its heat and allowed to cool in the manner of his earlier, Lassaw-like reliefs. These irregularities were deliberate, sought-after effects aimed at imparting a measure of expressiveness to these otherwise austere sculptures. Their purpose was to evoke, through the traces of their making, the artist's individual touch, much as did contemporary American Abstract Expressionist painters in their work through drips and other painterly marks on the canvas. In addition, in the bulk and surface treatment of some of the larger slab-planes, Meadmore wished to convey something of the massive forms of Stonehenge, with which he had been familiar from books since the early 1950s. Here again, Meadmore went against the tradition of con-

structed sculpture, which often created an impression of weightlessness.

There are clear affinities in this work with the painting of the time. The planes occupy a shallow depth reminiscent of Cubist painting's relieflike space, a characteristic particularly noticeable in light of their pronounced lateral spread. The outer edges of the pieces align in such a way that it is possible to circumscribe whole sculptures of this period with an imaginary rectangle. Only rarely do individual elements jut beyond an implied framing border. Recalling the origins of Cubist sculpture, they appear dependent on precedents in painting, not sculpture.

In a sense, they were. In the late 1940s, Meadmore had bought what he thinks must have been "the only copy of Mondrian's writings that ever reached Australia." In the course of reading it, he realized that "the thing Mondrian had was not translating into sculpture, or [his followers] were not translating it into sculpture. So the first sculptures I did came out of Mondrian, trying to do what he did

but in three dimensions."[5] Nonetheless, they are unequivocally sculpture, and not only by virtue of their physical bulk and spread. The perpendicular relation of the slab-planes to each other stakes a claim for these sculptures in the surrounding space, while the intervals between are calculated to give the internal spaces a plastic role equal to that of the solids.

This body of sculpture points to Meadmore's later direction in a number of ways: in the artist's efforts to infuse a geometric vocabulary with palpable feeling; in his adaptation of traditional closed or monolithic form to the language of open-form, modernist construction; and in their incipient monumentality. Many of the larger pieces strain for a size and scale that Meadmore would fully attain only later.

In 1963 Meadmore moved to New York, permanently settling there and becoming an American citizen. Although he had enjoyed a certain amount of success as an artist in Australia, ultimately he felt isolated and frustrated there.

Australia did not have, and was not near, a major art capital. In spite of the presence of occasional traveling exhibitions, reproductions were the main source of contact with works of art. In particular, he felt that Australian private collectors of the day had imposed a virtual embargo on purchasing modern abstract art of the kind he was making:

I never sold a thing to a collector when I lived there. They all felt we should have been busy working in an Australian idiom—lots of paintings of the outback and the red earth and the aboriginals and gum trees—which I thought was nonsense. Since I've been here [New York] I've had important public commissions, selling major pieces to be put in front of buildings in Australia. But I've still sold nothing to private collectors. It's all incredibly short-sighted. I mean, modern American art came into its own when it stopped trying to be "American."

All told, the artistic climate was too parochial for Meadmore's taste. "In terms of art history," Meadmore says, "making art in Australia is like winking at a girl in a dark room."[6]

DUOLITH 1962
Steel
15″×15″×9″
Private collection

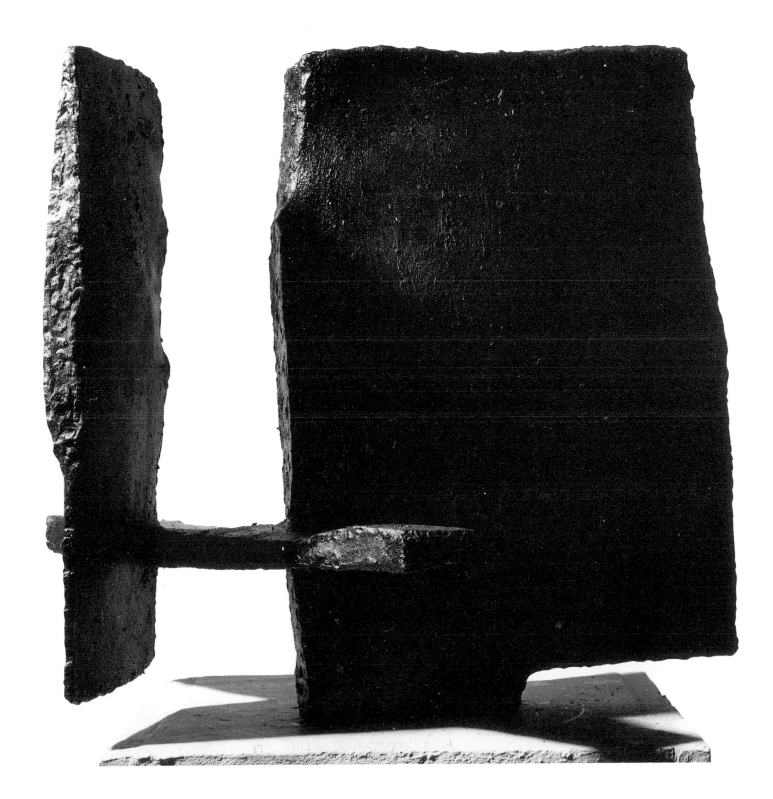

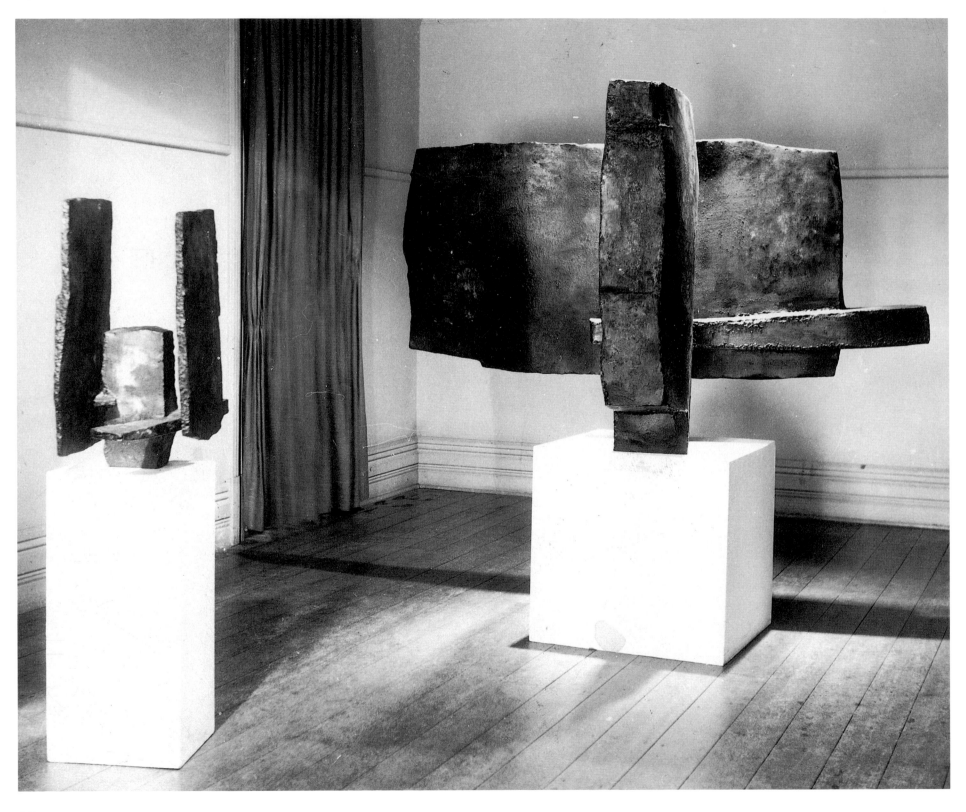

3

For an artist wishing to place himself in a stimulating artistic climate, one capable of providing what was authentic rather than secondhand in the way of aesthetic experiences, Meadmore could hardly have selected a more propitious environment than New York in 1963. He arrived in the midst of a twelve-year upheaval in American art that had begun in 1958 with Jasper Johns's first solo exhibition at the Leo Castelli Gallery and would continue through the Museum of Modern Art's *Information* exhibition of 1970. This was a survey of Conceptual Art, perhaps the most radical, in its renunciation of the art object itself, of all the radical art movements of the 1960s.

At the time of Meadmore's arrival in New York, the dominance of the Abstract Expressionist movement was receding, replaced first by Pop Art, which appeared on the scene around 1962, and then in quick succession by Minimalism, Optical Art, Earthworks and Process Art, and finally Conceptual Art. This creative ferment brought with it a fundamental shift in the attitudes that governed the creation and criticism of art.

Drawing on Cubism and Surrealism and adding to them aspects of Jungian psychology, the Abstract Expressionists had sought to articulate a metaphysical vision as well as a view of the artist as the self-creating loner-hero. They did so through the spontaneous, unpremeditated application of paint in configurations dubbed "gestural" for the way the path and character of the paint mark so distinctively mirrored the movement of the artist's hand or arm in applying it. In addition to whatever iconographic meaning they might have had, those marks were intended to stand as a direct record of the artist's inner self, one unfiltered through inherited artistic formulas or any other trace of the conscious will.

Beginning with Pop Art, the art that followed decisively turned its back on all such precepts. Its tone was the "cool" of detached observation or rational thought rather than the "heat" of Abstract Expressionist emotion and self-revelation. The Pop artists' utterances were often cast in a tone of irony. In place of the highly individualized handling of materials—the artist's "touch"—1960s art stressed the anonymous, the industrially fabricated, and the mass produced. Artists of the 1960s shifted their gaze from the inner depths of self and the heights of metaphysics to the world around them, looking on it both as source (Pop Art) and the locus of the work of art (Minimalism, Earthworks).

Indeed, artists of this decade strove to make their work as "real" as such nonart objects as furniture. (In 1968 the Museum of Modern Art organized an exhibition called *Art of the Real*. Although it focused on hard-edge abstraction, the title reflected the broader artistic outlook of the day.) Frank Stella spoke for many when in 1964 he said, "My painting is based on the fact that only what can be seen *is* there. It really is an object. . . . What you see is what you see."[7] Art was no longer conceived as a vehicle of inner experience.

◁◁ **JUSTICE** 1962
Steel
28″ × 14″ × 24″
Suzanne Huguenin, New York

◁ **DUOLITH III** 1962
Steel
49½″ × 78″ × 42½″
National Gallery of Victoria, Australia

In sculpture, developments were arguably even more radical than in painting, because the effort of each succeeding movement to define itself as more "real"—purer in form and less "arty" in character—than the one before it progressively eroded the historic definition of sculpture as "form in space." In the oversized, sagging hamburgers, fans, and toilets of Claes Oldenburg, Pop sculpture sounded the same note of irony as that movement's painting. The sculptors represented a direct repudiation of the style of open-form, welded sculpture, often with anthropomorphic associations, that was pioneered in this country by David Smith and constituted the sculptural counterpart of Abstract Expressionist painting.

But it was Minimalism that signaled perhaps the greatest break with the old order. In the work of the critic-sculptor Donald Judd, who had his first solo exhibition in 1963, the year Meadmore arrived in the United States, as well as in that of artists such as Robert Morris and Carl Andre, sculptors turned their backs on sculpture as it had hitherto been defined.

Instead of the complex sculptures of the welders composed of related and dependent parts, the Minimalists exhibited elementary geometric volumes placed individually or in rows or stacks. Where the earlier sculptors had made their own work, the Minimalists often contracted it out to a fabricator. What Judd called "compositional hierarchies"—major and minor elements in a work of art—were banished. In their place, identical geometric modules, each of equal importance and arranged in series or according to some compositional principle based equally in logic, became the norm. With this new formal simplicity and radically altered set of organizing principles came a new mode of address. Influenced by gestalt psychology, the Minimalists selected forms sufficiently simplified and regular that they could be "known" in their totality from a single viewpoint, unlike earlier modernist sculpture, whose complexity required the viewer to walk around it. "Expressionist" traces such as scabrous surfaces were replaced by smooth, undifferentiated outer skins. Anthropomorphism was dismissed as outmoded, as was humanism in all its aspects. Finally, the Minimalists abandoned the base, placing their sculpture on the floor or wall to emphasize its "literalness," its status as an object in ordinary space, and to attain a more instantaneous, direct relationship with the viewer.

In rapid succession, a series of reactions to Minimalism set in. The art critic Lucy Lippard organized the *Eccentric Abstraction* show of 1966 that reintroduced expressionist and surrealist content into sculpture with the work of Eva Hesse and others. Robert Morris's "anti-form" sculpture and his *9 in a Warehouse* exhibition organized for Leo Castelli in 1968 highlighted work in which the artists—Morris himself, Richard Serra, and others—effectively ceded creative control to factors outside themselves. They used materials (felt) and procedures (throwing liquid lead into a corner) to create sculpture whose form was indeterminate beforehand and in some cases ever-changing.[8] The second half of the 1960s saw the rise of Earthworks and Process Art as artists turned from the studio and gallery space to the open landscape to make sculpture.

Central to these tendencies was what Lippard characterized as "the dematerialization of the art object" in the title of her 1973 book. Meadmore himself, writing in 1969, described the trend as "a disillusionment with the meaning of human ordering of materials, once regarded as the essence of art."[9] It all reached a kind of climax at the end of the sixties in such works as Robert Morris's "sculpture" of steam rising from the ground, and with the emergence of Conceptual Art, in which the sculptural object ceased to exist altogether. In its place was pure idea, artistic thought not so much concretized as memorialized in framed documentation hung on the gallery wall.

4

One of Meadmore's first acts on arriving in New York was to introduce himself to Barnett Newman, who with Mark Rothko and Clyfford Still defined the nongestural branch of Abstract Expressionism, the so-called Color Field movement. Meadmore's encounter initiated a friendship that was to continue until the older artist's death in 1970.

In general, the aims of the Color Field painters were identical to those of the rest of the Abstract Expressionist group. But they pursued them in paintings consisting of enormous, open expanses of color. In Newman's paintings often a single color, so evenly, uniformly applied as to create an uninterrupted surface, is broken by one or two narrow stripes of contrasting colors running from the top to the bottom of the canvas. Newman's aim, shared by Rothko and Still, was for those colors and color areas to act directly on the viewer's emotions, transporting him to the realm of the sublime.

At the same time, however, other qualities in Newman's work influenced the rising generation of Minimalists, artists like Judd, Stella, and Morris. They were drawn to its impersonal surfaces, simple imagery, and lack of subordinate or related parts. These artists also reacted favorably to the wholeness or unitary quality of Newman's painting, something that facilitated perceiving it rapidly, almost instantaneously.

Meadmore had first seen Newman's painting during a 1959 visit to Tokyo. He had been struck not by the artist's philosophical outlook but by his approach to geometric abstraction. "For me, Mondrian [had] suggested the expressive possibilities of geometry and Barnett Newman extended them by eliminating the geometric feeling from his work," Meadmore said in a later interview.[10]

What Meadmore meant by this contradictory-sounding observation was that Newman had attained a kind of paradox. Geometry dictated the form and structure of his pictures, but it was not the "subject" of his art. In Australia, the example of Mondrian had led Meadmore to become, in his own words, "religious about horizontals and verticals." In other words, Meadmore felt that geometry had come to dominate the work, stifling any larger expressive impulse. In Newman's paintings he felt the opposite was true, that they expressed openness, expansiveness. The vertical lines existed not so much to contain as to articulate the painted areas. Central to this result was the way Newman's paintings were structured. "With Mondrian you had to start with the frame and work your way in. The bare area in Mondrian is usually in the middle. With Newman you started off with a line and then worked outwards."[11] Meadmore also admired Newman's sculpture, which he praised for possessing "a feeling of scale which went beyond [its] actual size," and, in the case of *Here III,* the "inexplicable proportions and scale in the interaction of the base of the work and its [vertical] shaft which is entirely reliant on the base for its meaning."[12]

DUOLITH V 1963
Steel
29″ × 57″ × 29″
Robert Thomas, Fort Lauderdale, Florida

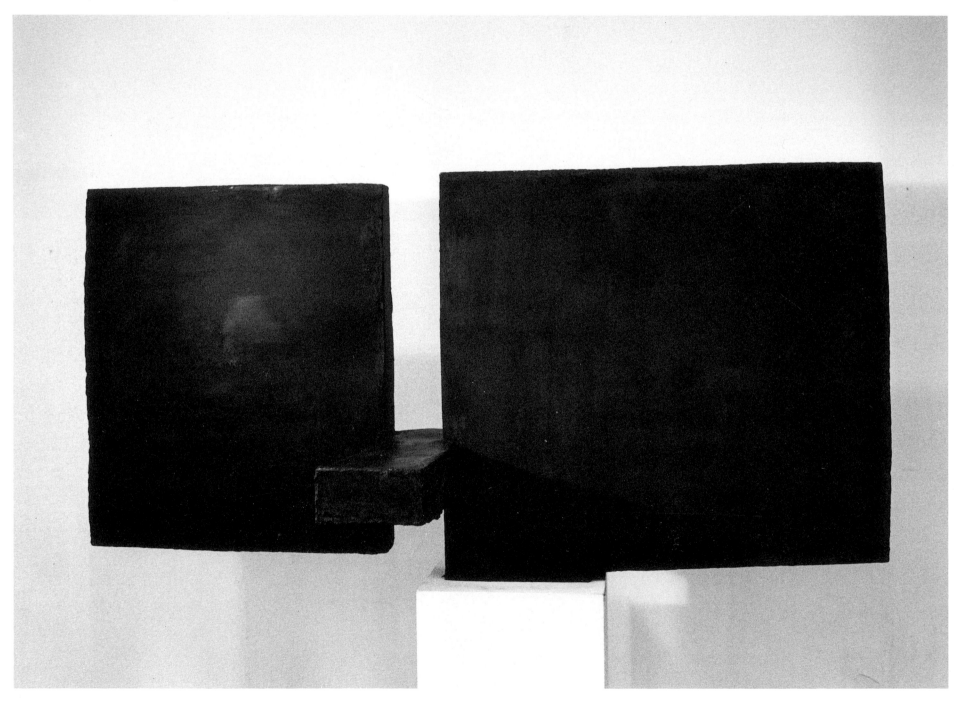

A more immediately influential encounter occurred when the Canadian abstract sculptor Robert Murray visited Meadmore's studio and saw the slab-plane sculptures. According to Meadmore's account of the visit, Murray asked why Meadmore had put the texture on it

I'd never thought about it before. At the time I made them in Australia, we were as far away as you can get from the center of the art world, and I don't think any of us were quite sure whether what we were doing was really art. Murray's question made me realize that as I made those pieces I was subconsciously thinking, "I've got to make sure this looks like 'art' so at least people know they are looking at 'art.' And the way you do that is you put texture on it because 'art' has texture."

It was only with his question that I became conscious of it. I might never have become conscious of it in Australia at all. Once I realized why I had been doing it, I immediately thought, "Well, if it isn't a work of art, the texture isn't going to make it into one." So I stopped doing it immediately.[13]

The work that followed represented a marked change in direction, the first of two over the next three years that would reach a culmination—and a dead end of

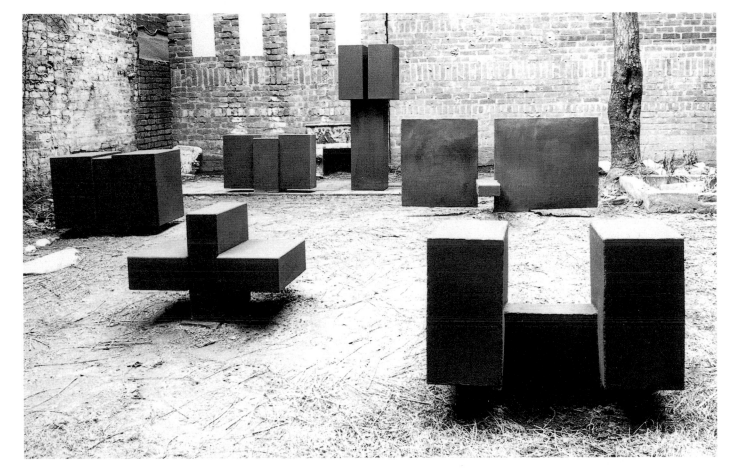

TRIO II 1964
Steel
23″×34″×13″
Private collection

TRIO V 1964
Steel
57″×21″×21″
Private collection

DUOLITH V 1963
Steel
29″×57″×29″
Private collection

TRIO IV 1964
Steel
23″×33″×21″
J. P. Klompé, New York

TRIO III 1964
Steel
22″×33″×23″
J. P. Klompé, New York

DUOLITH I 1963/64
Steel
23″×34″×25″
Private collection

sorts—in a series of sculptures that brought Meadmore as close as he ever came to making truly Minimalist sculpture.

In the first group of sculptures, those made between 1963 and 1964 in the immediate aftermath of his conversation with Murray, the Mondrian-derived aesthetic principle of relationships between opposing planes remains the same. Now, however, it is pursued to the exclusion of any inward or subjective impulse. While Meadmore retained the broadly planar configuration of his previous work—using forms far taller and wider than they are deep, and dispersed in a relatively shallow field—he used fewer elements. Where anywhere from three to a dozen was the norm in the previous work, three is now most common. In addition, they are enlarged and consistently more "squared up" and smoothed out and possess none of the burring at the edges seen previously. However, they are still not precisely geometric volumes.

At the same time, the individual volumes have been enlarged and the space between them re-

duced, altering the relationship between the two so as to emphasize surface, mass, and architecture over interaction with ambient space. Newman's influence is clearly evident here, not only in the spreading surfaces of Meadmore's forms but in the narrow gaps between them, sculptural analogues, perhaps, for the field-dividing and -activating stripes and "zips" in Newman's painting. The result is a new stasis and, in spite of their still being pedestal sculptures, a greater monumentality.

Beginning in 1964 Meadmore took this pursuit of formal rigor and the process of purification even further in a series of sculptures made over the next two years. They are now perfectly rectilinear. All edges and surfaces have been trued and faired to Minimalist impersonality. Abandoning the base for the first time, he makes the sculptures rest directly on the floor. The same small number of volumes is again used, but now they are massively amplified. The slab-planes have metamorphosed into blocks, an adjustment that alters all other relationships.

There is as well a new relationship to space. The internal spaces have disappeared completely as the blocks are made to abut one another in horizontal and vertical configurations. And, with the elimination of projecting elements and their consolidation into what amounts to a single mass, Meadmore's sculpture now no longer interacts with the space around it. Instead, its relationship to space is more forceful and direct than any of his work heretofore. It occupies space rather than interacts with it. Inflection and variation are achieved by modest adjustments in size among the blocks. These are austere, imposing, remote sculptures.

Appearances aside, Meadmore was not, at this time, an orthodox Minimalist. To be sure, he was aware of what was going on, even somewhat interested in it.

When I first came over here I went round to all the exhibitions and I liked everything. I thought everything I saw was wonderful and fantastic and amazing. The critical faculty was lost. I was just overwhelmed. And it took a while before I started looking at Minimalist stuff and saying, "Wait a minute. This isn't really going anywhere. This isn't

the way to go. It's making some didactic point about what you see is what you get, or something, but it isn't really developing a new form language." And that released me from it. There were other ways to go.

Among other things, Meadmore says, "I didn't agree with them in many ways, particularly with this business of no proportions. I mean I was concerned with exactly where things stopped and started and adjusting the proportions, and they had this thing: you put six cubes in a row and that's it."[14]

As an example, he cites *Criss Cross,* a sculpture of that period that resembles two superimposed boxes.

When you look at it you think these are two equal elements. This upper one is actually longer by an inch or so. Because if you put that join in the true center of that height, the bottom one looks heavier than the top one. And the Minimalists would never think about that. It would be foreign to their whole way of thinking. But this is a matter of observation and seeing what's happening and adjusting it until it did feel like it was in the middle. And when it feels like it's in the middle it takes on a very strange character, because you can check visually that the lower one is actually smaller, yet it feels right.[15]

CRISS CROSS 1965
Steel
75″ × 20″ × 20″
Collection of the artist

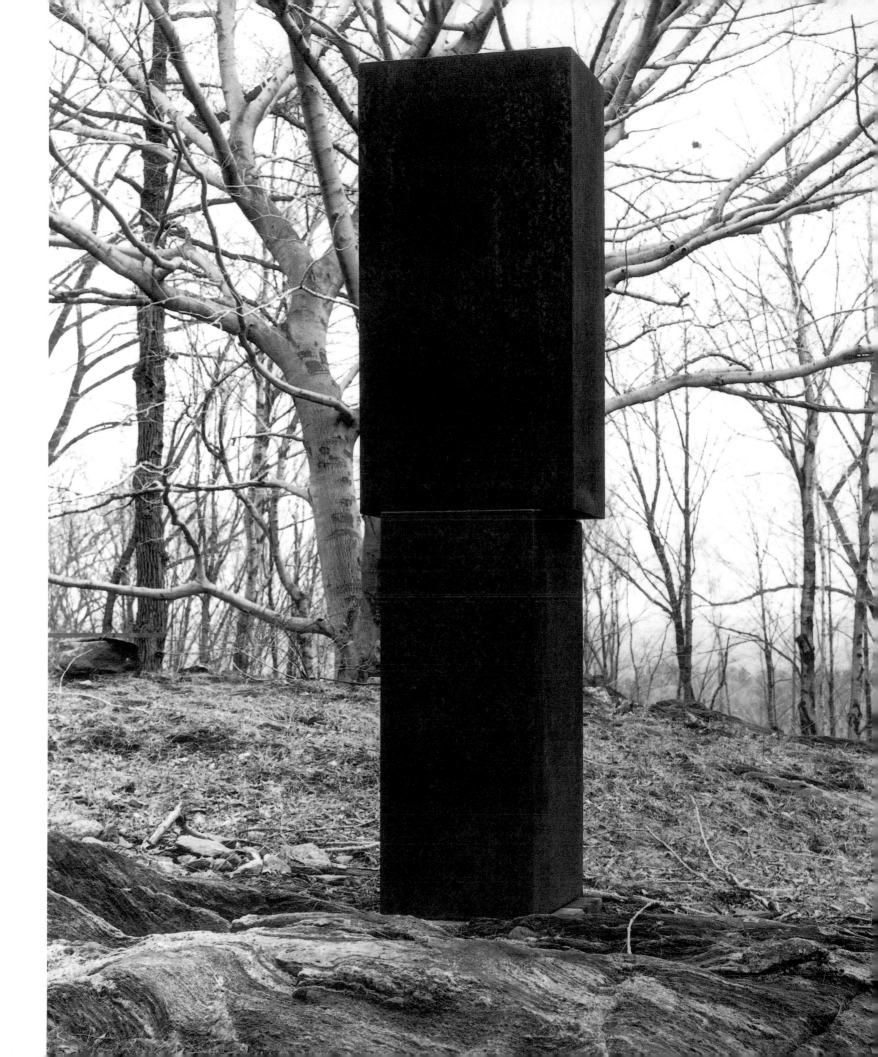

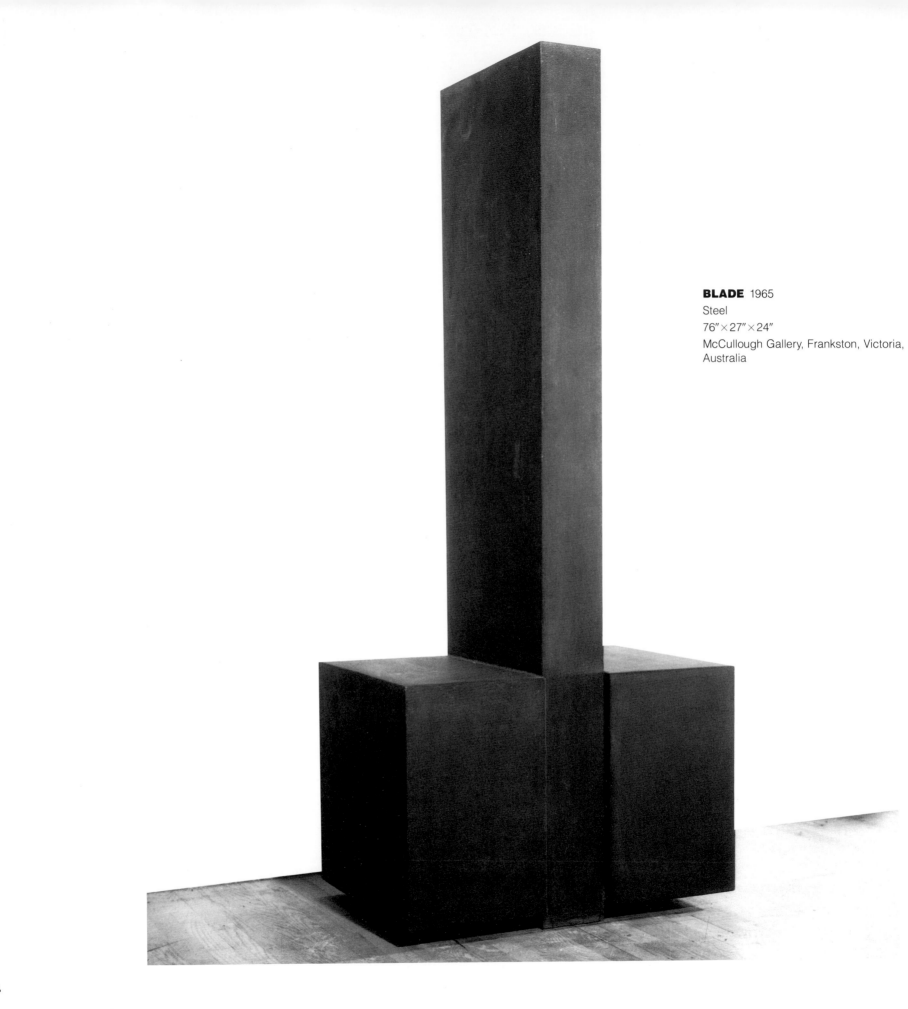

BLADE 1965
Steel
76″×27″×24″
McCullough Gallery, Frankston, Victoria,
Australia

Moreover, at the time Meadmore's sympathies lay outside the realm of orthodox Minimalism and more in the direction championed by the formalist critics Clement Greenberg and Michael Fried. "Greenberg was talking about painting and how they were all trying to get down to the essence of what painting was. Well, I felt very strongly that that's what I was trying to do with sculpture."[16]

Finally, Meadmore's first extended exposure to Minimalist art did not occur until he visited the *Primary Structures* exhibition at the Jewish Museum in 1966.[17] This show, organized by the museum's curator of painting and sculpture, Kynaston McShine, was the first museum survey of Minimalist art. Up to that point, Meadmore's work had largely evolved according to its own internal logic. If anything, Meadmore's most recent work had pointed up the limitations of the Minimalist aesthetic. He realized his work had become so reductive as to be almost mute. "I felt I'd reached the point where I was looking Minimal but I really wasn't. And I thought, well, at this point they're so minimal they're

practically lacking in any expressiveness."[18]

In fact, the combination of Minimalism's ascendancy and its uncompromising reductiveness precipitated a kind of crisis of values for Meadmore, giving him the resolve to move beyond it by following his own aesthetic lights. "The thing I realized was that proportions and all the things they were throwing out meant something to me. And I thought, I'm going to stick by what means something to me, or there's no point in being an artist. There was nothing left to do in sculpture if you took Minimalist doctrine seriously."[19] Indeed, despite superficial similarities between the two—their formal clarity, their basis in geometry, their preference for smooth, uninflected surfaces, and, above all, in their penchant for single, unitary forms—Meadmore will, starting in the early 1970s, depart substantially from many of the premises espoused by the Minimalists. Aside from matters of proportion, his work will acquire a monumental scale and a mode of address that is engaged in rather than detached from the frankly

public, occasionally heroic voice it adopts. It will thus manifest a desire to express ideas and feelings beyond itself of the kind foreign to Minimalist art. And after about 1970, Meadmore's sculpture also departs from Minimalism in being the product of improvisation rather than preconception. Unlike the Minimalists, Meadmore never begins with an idea developed in advance. His compositions are arrived at intuitively.

Meadmore agrees with the Minimalists' adherence to gestalt perception, the idea that a work of sculpture should be knowable in its totality from any one viewpoint. Like the Minimalists, he says:

It is important to me that the entire form of a sculpture can be deduced from any single angle, otherwise one is only seeing half a sculpture at any given moment. Not only do you have to get it to work all the way around, so it is "frontal" all the way around, as it were, but you've got to get all the views leading from one to the other in a logical sense. It's as if you look at someone from the side, it shouldn't look like a different person when you look at them from the front. This is a problem largely restricted to abstract sculpture. In the case of figurative sculpture, our knowledge of the subject combined

with the artist's eye gives us a reasonable idea of what the other side will look like.

But, he says:

The Minimalists felt that gestalt perception was only possible with a simple form such as a cube. My feeling is that this perception can be retained with relatively complex forms. Because my sculptures have a square cross section, it is relatively easy to follow the movement of the square throughout the sculpture. One of the things I'm doing is pushing that idea as far as possible. In other words, I want to know how complex you can get without losing a sense of the entire form.[20]

Yet there should be no confusion that Meadmore's sculptures demand a *single* viewpoint. His sculptures are indeed "alive" from every angle. When looking at one of his large outdoor pieces, a shift of a few feet in one direction or another can dramatically alter relationships, sensations of balance and apparent weight, not only of the sculpture as a whole but of its parts. This is especially true of the work since the mid-1970s, which consists either of multiple elements or a single mass branching out in several directions.

The only Minimalist sculpture with which Meadmore would seem to have any real affinities is that of Tony Smith and Ronald Bladen, both of whom made works on an un- or anti-Minimalist "heroic" scale. And, like Meadmore, Smith evolved his sculptures from geometric modules, a tetrahedron and octahedron rather than a cube and quarter circle.

Yet even this match is less than perfect. Smith accorded his modules a far greater role in determining the final appearance of his sculpture, a fact that results in both consciously awkward and rather pedantic sculpture. Smith's sculpture also alludes to concepts of geometric ordering and structure, an outgrowth of his training as an architect. Meadmore's uses these ideas as springboards to express energy and vitality.

In his looming, deliberately off-balance volumes, Bladen sets up an intense, exciting dialogue with the viewer that points toward the "Prop Pieces" Richard Serra made during the 1960s. But the need for a concealed counterweight in Bladen's sculptures distinguishes them from Meadmore's. However much it appears to move off center, Meadmore's sculpture remains balanced independent of such aids.

Finally, as one critic observed of Smith's sculpture, in a comment that is also true of Bladen's, "a good deal, perhaps too much of the strength of his best work depends on large size."[21] The same cannot be said of Meadmore, whose work is equally powerful in large scale or small.

5

To his surprise, Meadmore was not a part of *Primary Structures,* an exhibition that would help launch the careers of many of the artists included in it. According to Meadmore, Barnett Newman had tried to persuade Kynaston McShine to include him.

"He called him up and said, 'Look, you've got to put this guy in. It's very important that he be in this show.' And McShine just said to Newman, 'No locomotives.' And Newman repeated that to me and had no idea what he meant. And I don't either. That's all he said, just those two words."[22]

His reaction at being excluded aside, Meadmore still found the exhibition to be helpful, for it showed him a way out of the impasse he had created by making his work so drastically reductive.

It made me think, "Where do I go now? Do I go back to more complexity, to three elements instead of two? Or what about going in the other direction and using one element?" But you can't just make a column, that's not going to make much of a sculpture.

So then I thought, "What if I do make a column but bend it? That'll activate the single element." First I thought of bending it on the flat, but I realized it would be sculptural in only one dimension. So I put the bend on the diagonal. That way all the planes came through it. So the single column idea was really a way of getting to something more expressive without going back into complexity.

Meadmore's thinking was guided by an additional factor.

Seeing the show was a very emotional experience, because the more I walked around it, the more riled up I got, thinking I really should have been in it.

Looking at the catalogue when I got home, I thought it was interesting that David Phillips's sculpture and some of the other artists' should have curves in it when so much of Minimalism was about squares and rectangles.

Even so, I thought, "They've got it all wrong; that's not the right way to do it." And I started experimenting with curves, initially just out of frustration with this whole thing, in a spirit of "I'll show 'em." And I think that first piece I did, that *Bent Column* was actually better than anything in the show itself.[23]

In *Bent Column* of that year (1966), Meadmore took three new steps. For the first time he re-stricted himself to a single, uninterrupted volume, one that is, also for the first time, square in section. And he tilted it on two axes simultaneously. All these steps prefigure later developments. As Meadmore's sculptures go, *Bent Column* is relatively restrained, at least in tone. In its simplified form and modest inflection off the vertical, it lacks the forthright declarativeness of his previous sculptures or the dynamism and baroque boldness of those that follow.

But initially at any rate, Meadmore chose not to follow up on that idea. The advance of *Bent Column* was followed immediately by a modest retreat. A 1966 contact sheet of twelve black-and-white images—five single-volume sculptures photographed at varying exposures—shows how Meadmore elaborated on his insight in the immediate aftermath of *Bent Column.* Reading down and across (the order in which the photographs were taken), the first sculpture consists of a downward-facing semicircle with a rectangular element projecting upward

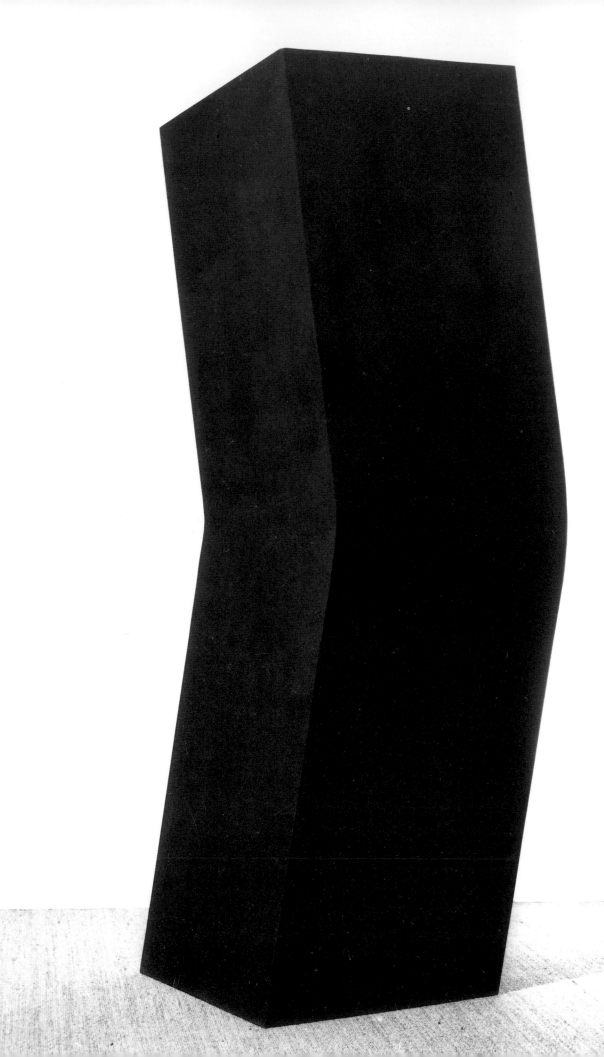

BENT COLUMN 1966
Steel
76″×27″×27″
Newport Harbor Art Museum, Newport Beach, California

from one end at about forty-five degrees.[24]

Below it is a C-like form, its loops lengthened and straightened out of their curves and the top one dramatically extended. The sculpture suggests a candy cane resting horizontally on its short side.

The third is what looks like a three-dimensional letter Q. It is a near-circle with a "tail" projecting not downward but ahead at ninety degrees to the body of the sculpture, and on the left side rather than on the right. In the two subsequent photographs a similar sculpture is shown lying down, its "tail" pointing upward.

The next is a sort of three-dimensional zigzag that looks like two J's linked at their loops, one upright and facing backwards, the other lying on its side.

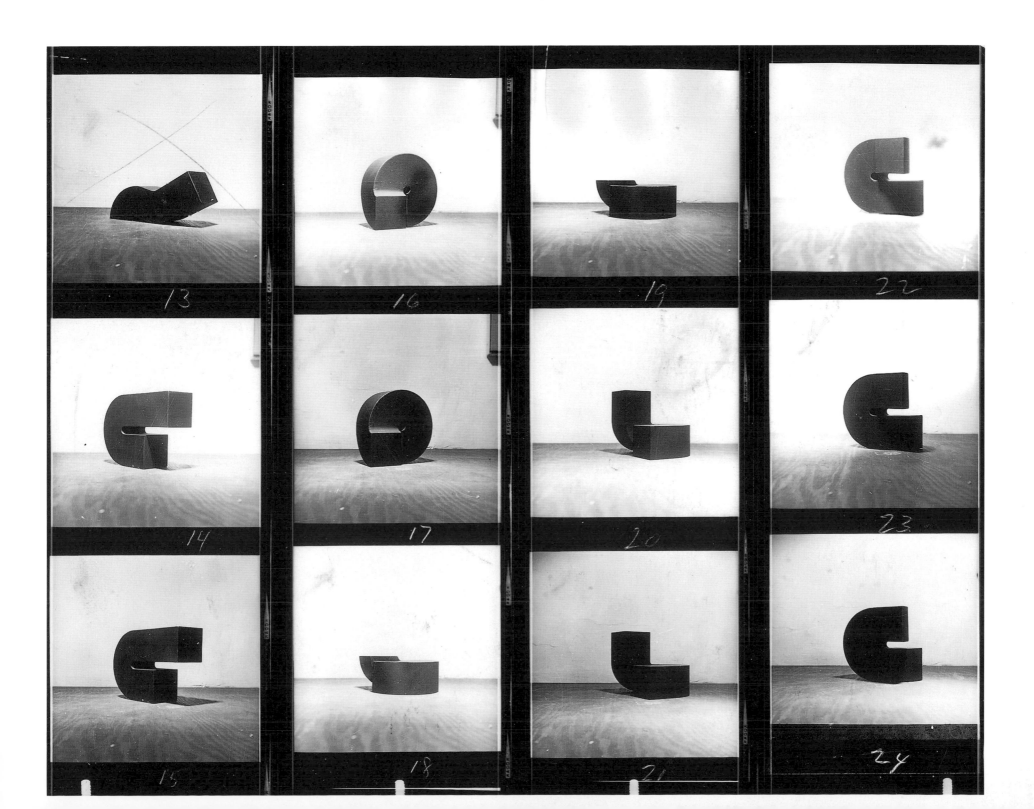

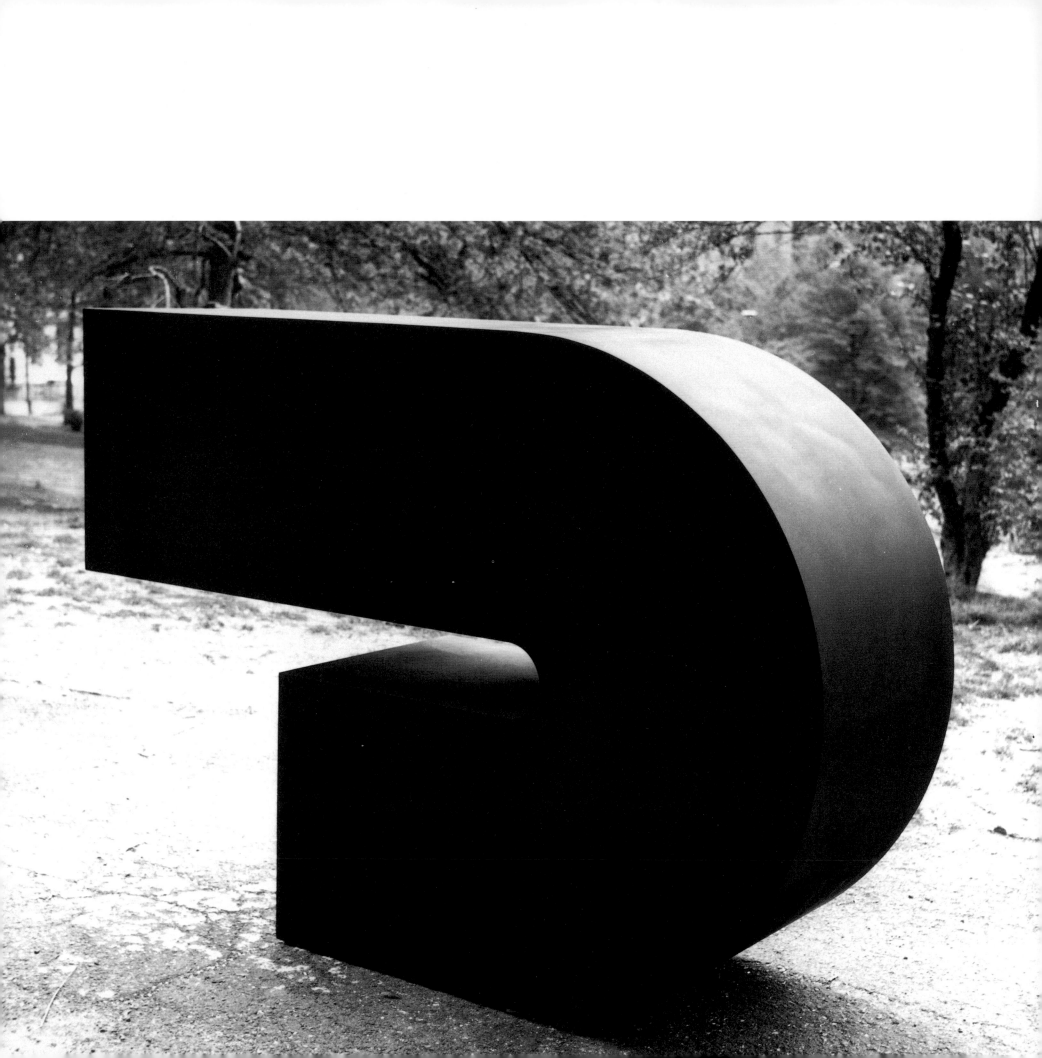

◁ **HANG OVER** 1966
Steel
54″ × 75″ × 24″
Private collection

TURN UP 1966
Steel
51″ × 54″ × 54″
Private collection

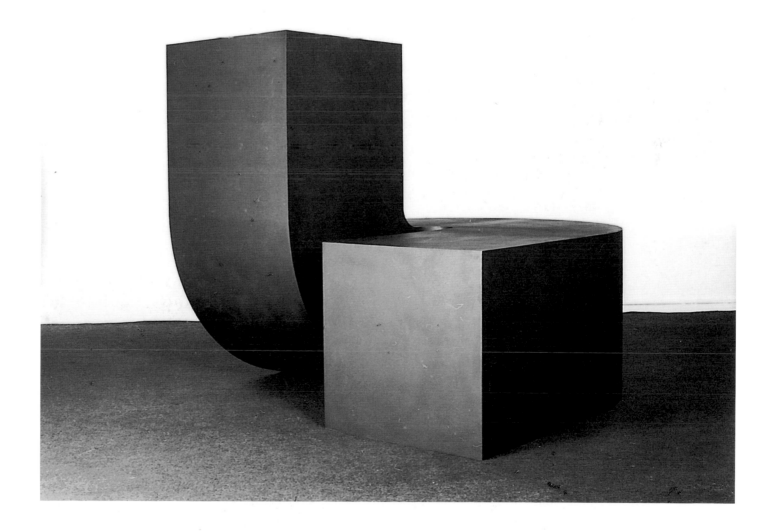

The final sculpture in the series resembles another C, this time with both loops not only straightened but twisted at ninety degrees to the broad front of the form.

Like *Bent Column,* all five sculptures consist of a simple, square-section volume. But thanks to their more pronounced curves, straights, and extensions, they are more dynamic forms, both within themselves and in their efforts to engage with the surrounding space, the first time this latter consideration had been an important one for Meadmore since the early 1960s.

In these new sculptures, Meadmore is out to endow a single form with the clarity and rigor of Minimalism and, at the same time, the complexity and expressiveness of Cubist-derived sculpture. In this they point the way to his subsequent work. In its single, uninterrupted loop through space, the second sculpture on the contact sheet, the "candy-cane" form, signals Meadmore's interest in developing a gestural or "drawn" character for his sculpture, while its seeming precariousness marks

the first instance of the artist's interest in questions of balance, gravity, and expressiveness attained through physical extension into space. For its part, the fourth sculpture photographed, the zigzag or double-J form, likewise strives to be more aggressively involved with space, foreshadowing an important future concern. In equal measure it occupies space in the way of Minimalist sculpture while, thrusting into it in the characteristic manner of constructed sculpture.

These sculptures point to the future in one final respect, namely that in this work Meadmore has evolved an innately monumental language. The sight of the plywood grain on the surface supporting these sculptures abruptly restores what appear at first glance to be objects at human scale or larger down to their actual size, that of models to be enlarged.

Much as they mark an advance in Meadmore's art, however, there are apparent limits in these sculptures. They curve on one plane only, limiting the viewer to one or at the most two viewpoints, leav-

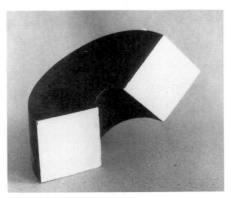

TURN OUT 1966 ▷
Steel
54″ × 54″ × 27″
Empire State Collection, Albany, New York

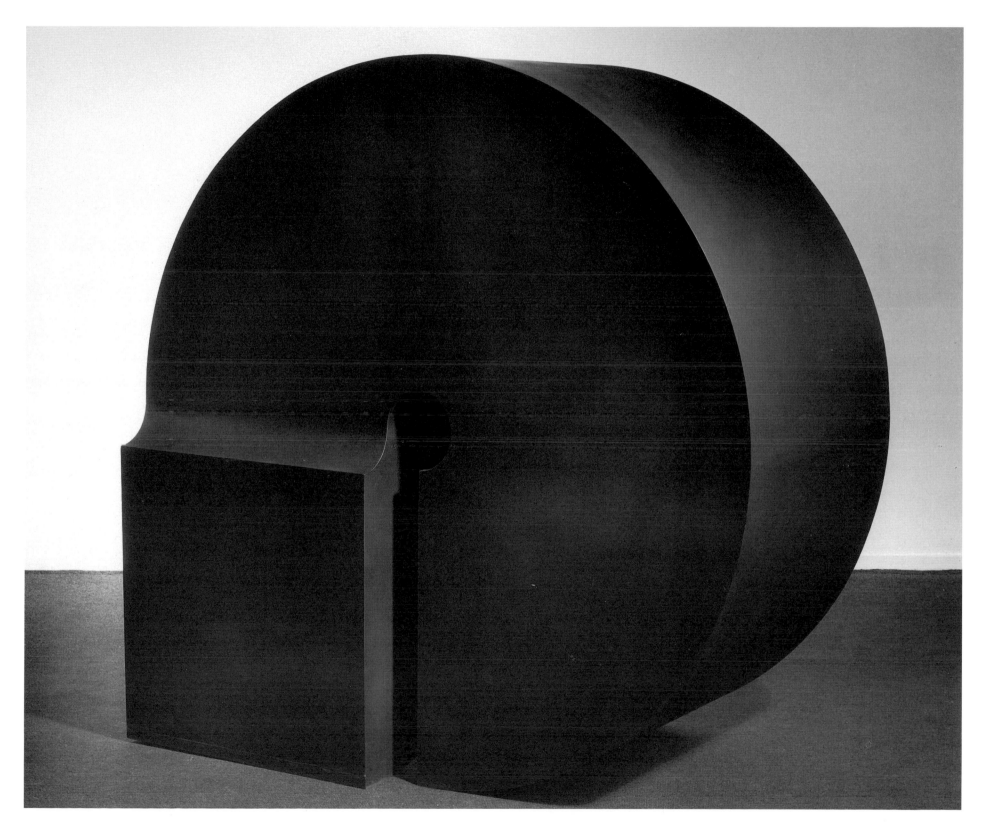

ing the artist a finite number of variations or elaborations on each idea, as well as a sharply circumscribed emotional range. The Q or double-J forms seem to represent efforts to overcome this problem of apparent two dimensionality through their abrupt changes of direction. Though the latter does so more convincingly than the former, there remains the problem of where the artist might be able to go with these two ideas. In each case, he seems to have said everything there is to say.

This point about limits is most apparent when one compares the "candy-cane" sculpture with works from the late 1960s and early 1970s such as *Upstart I, Upstart II, Double Up,* and, perhaps most dramatically, *Hence.* Though similarly shaped and proportioned, all are infinitely more ample in form and feeling through being more fully and imaginatively articulated as three-dimensional objects.

(The first sculpture on the contact sheet presents an altogether different problem: excessive anthropomorphism. It reads as a stylized snail or similar creature,

a sort of direct descendant of Constantin Brancusi's 1936 marble *La Phoque,* the semicircular part a "back" to the "head and neck" formed by its angled portion. Although Meadmore's later sculpture will evoke the actions of human beings, clearly to him the organic and anthropomorphic were present in too literal a fashion, for a penciled *X* scores the image.)[25]

Meadmore himself was clearly dissatisfied with this body of work. In á 1979 interview he described how it "quickly became limiting and a bit simplistically graphic."[26] His solution was to return to the example of *Bent Column,* which had yielded two insights. The first was the curve. The second idea was the module, the basic unit of form from which whole sculptures could be elaborated. Combined in the form of a curved module, these two insights would decisively reshape Meadmore's sculpture. "I think after I made *Bent Column* I realized this was a module that could be repeated in various ways. But I didn't immediately use that module. It took me a while to realize what I'd done."[27]

The module that now became the core of Meadmore's creative efforts consisted of half- and quarter-segments of a round, or doughnut-shaped form, placed end-to-end to form a single, continuous sculptural volume. But Meadmore's was a doughnut with a difference. Instead of being circular in section, it was square. Consequently, rather than being composed of a single unbroken skin, as in an actual doughnut, its inner and outer surfaces were formed by four planes meeting at right angles.

The chief difference between *Bent Column* and Meadmore's modules was that *Bent Column*'s degree of tilt had been determined by eye. Here, however, in keeping with the sculptor's desire for geometric rigor, the modules' square sections—their exposed faces or ends—were initially positioned at exactly 45 degrees to the horizontal. Slice the imaginary doughnut in half vertically, in other words, and those exposed ends would appear as diamonds—squares resting on their bottom corners.

Thus constituted, Meadmore's modules permitted four different

AWAKENING 1968 ▷
Steel
15′ × 27′ × 24′
Australian Mutual Provident Society, Melbourne, Australia

possible positions of one module in relation to another, thus opening up an array of sculptural possibilities heretofore unavailable to him.

Yet while this new method solved the fundamental problem—how to make a volume move through space along more than one axis, and in a way that gave the viewer a sense of the whole sculpture from any angle—Meadmore quickly discovered that even with four possible module-to-module combinations, his options were still frustratingly limited. All too soon he found he was repeating himself. Sculptural ideas would emerge from this process that were vexingly similar, in whole or in part, to existing ones. What he needed was almost a contradiction in terms: a modular approach possessed of the desired structure and rigor, yet sufficiently open-ended to provide an infinite range of compositional potential.

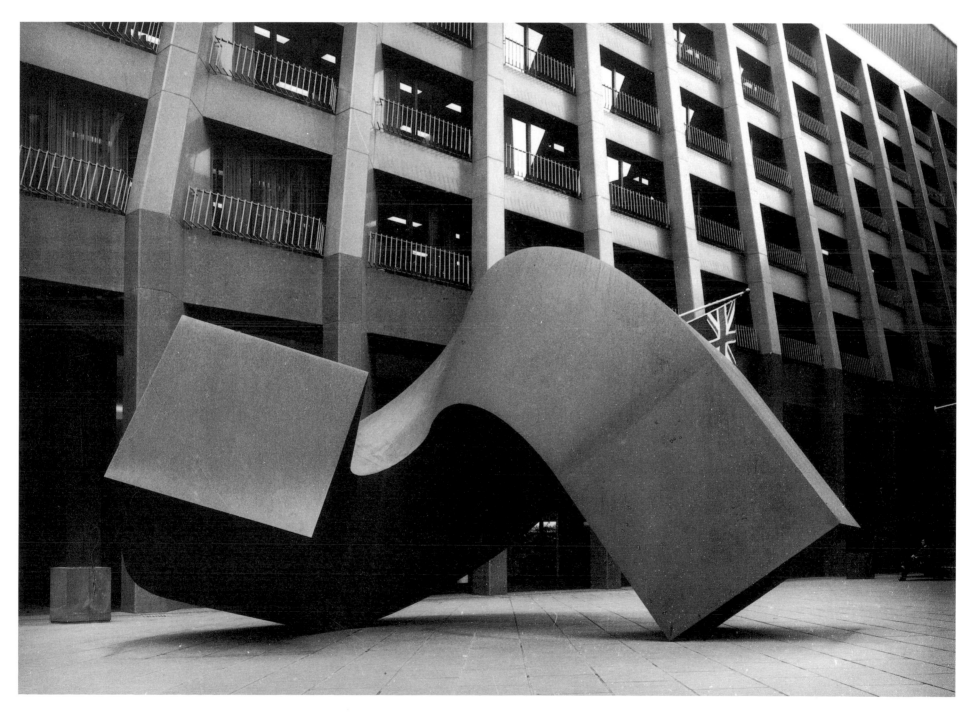

The solution to this latest problem lay in rotating the square section at 22½ degrees instead of 45. This proved to be a crucial step. By halving the angle of rotation, Meadmore doubled the number of possibilities open to him in composing his sculptures. Each module now had eight instead of four ways of relating to its neighbor. If two of these modules were placed end-to-end, edge-to-edge, and rotated in increments of 90 degrees, one set of configurations would result. If one module's opposite end were then joined to the other and the process of rotation

Three views of half circle module with square cross-section tilted at 22½° 1993
Etching
11⅝″ × 9″
Collection of the artist

begun again, a wholly new set of formal arrangements would appear. This had not been the case when the angle of rotation was 45 degrees. With this step, Meadmore had what he wanted—a limitless array of possibilities within a highly structured method.[28]

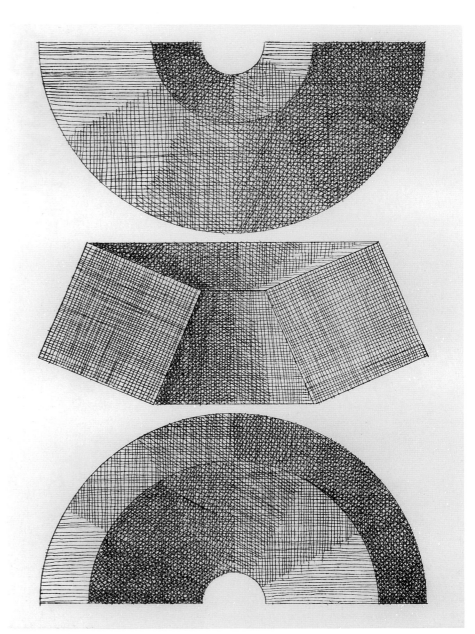

36

6

Once again, a small change had yielded substantial results. Between about 1967 and 1969, Meadmore produced a number of sculptures using this new, torsional module. In them the general configuration recalls, in whole or in part, a circle or nascent coil. Among the sculptures made at this time were *U Turn, Janus,* and *Split Ring.* In works such as *Curl, Spiral,* and *Virginia,* Meadmore's sculptures would extend horizontally in sometimes dense, serpentine formations. (One exception to this rule is *Up Ended,* in which an almost fully floor-bound horizontal of great length ends with an elevated circumflexlike flourish.)

In developing the possibilities of his new module, Meadmore made volumes turn and move through space in ways that were freer, more emphatic, and more expressive in character than previously. In the process his sculpture became richer in feeling and more ambitious in outlook. Combined with the shift from a vertical orientation to a largely horizontal one, Meadmore now brought about a wholesale transformation in the character of the sculptural object.

Bent Column had been a modestly inflected Minimalist box whose proportions, verticality, and "posture" had implied a human figure. Now, the combined actions of rotating the volume so that it was a horizontal, extending it, and introducing more complexity all resulted in fully abstract sculpture in which the sculptural volume functioned in the manner of a line moving through space. Mass was transformed into line, and line in turn signified direction, an impulse of movement.

As conceived by Picasso and Julio Gonzalez when they invented constructivism, "drawing in space," as the use of welded linear elements was termed, involved a simple denial of mass, a radical reduction of sculpture's bulk to a bare-bones scaffolding. In his new work, Meadmore simultaneously contradicts and extends that idea: contradicts it, because his "drawing" retains, indeed is constituted by the mass characteristic of premodern sculpture; extends it, because he sets that line in motion—thus imparting to it something of the velocity of a drawn line—yet without resort to kinetics or technological tricks. Meadmore's sculptures displace, occupy space much as had his Minimalist pieces and those recorded on the contact sheet, if only by virtue of their sheer bulk. Yet at the same time, they begin to move through space in a variety of ways, freely and gracefully.

Two factors act as a kind of counterpoint to the palpably sculptural, even physical experience of form moving easily through space. The first is a measure of opticality. The faceted forms of Meadmore's sculptures are articulated by the varied play of light and shade across their surfaces. In addition, their proportions—longer than wide—mean that when seen end-on they are read perspectively, edges and planes receding, a fact that has the effect of seeming to reduce their bulk while accelerating their journey through space.

Then there is the question of the blunt ends of these sculptures, a

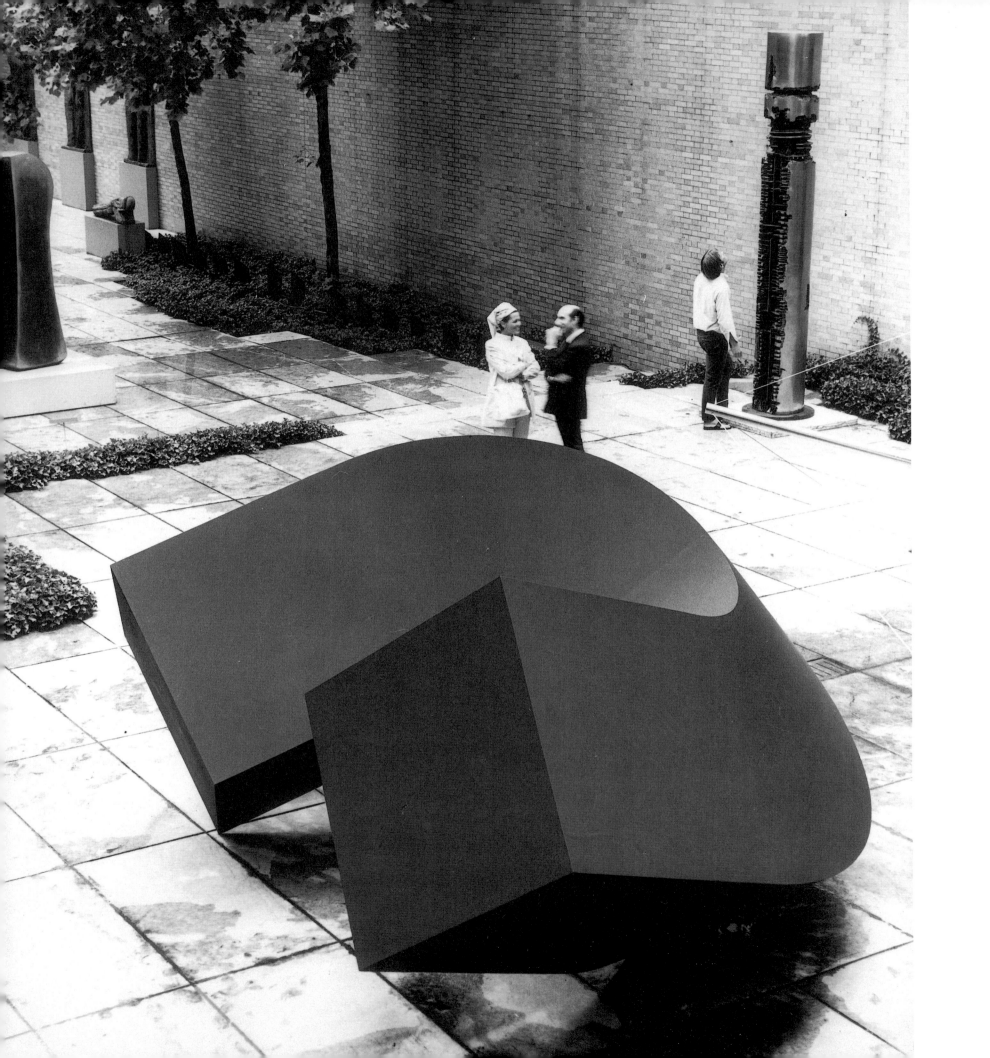

◁ **U TURN** 1968
Steel
16′ × 28′ × 22′
National Trust for Historic Preservation,
Nelson A. Rockefeller Bequest,
Pocantico Historic Area, New York

JANUS 1968
Concrete
18′9″ × 29′6″ × 23′
Collection Mexico City

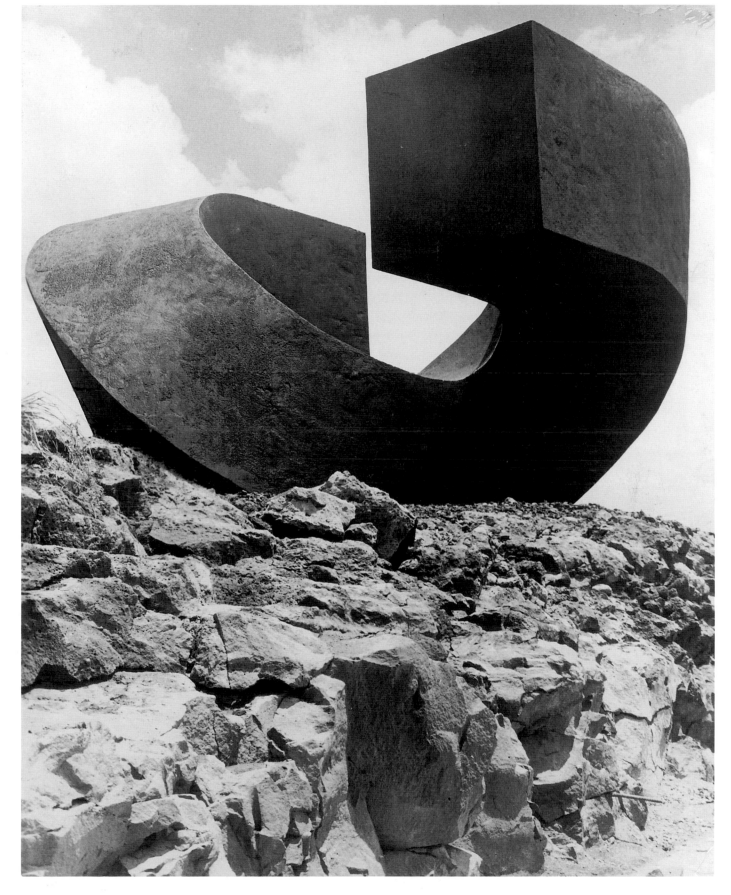

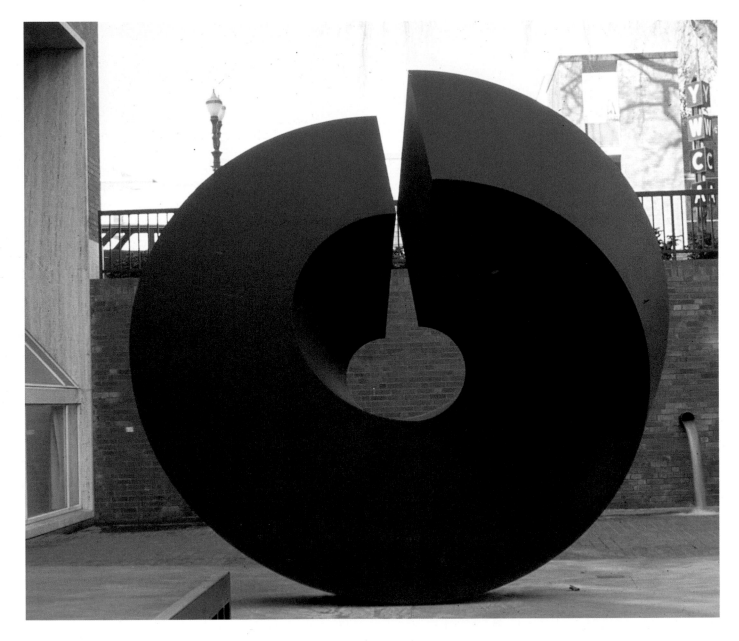

SPLIT RING 1969
Steel
11'6″×11'6″×11'
Portland Art Museum, Oregon

CURL 1968 ▷
Steel
12'×24'×11'3″
Columbia University, New York

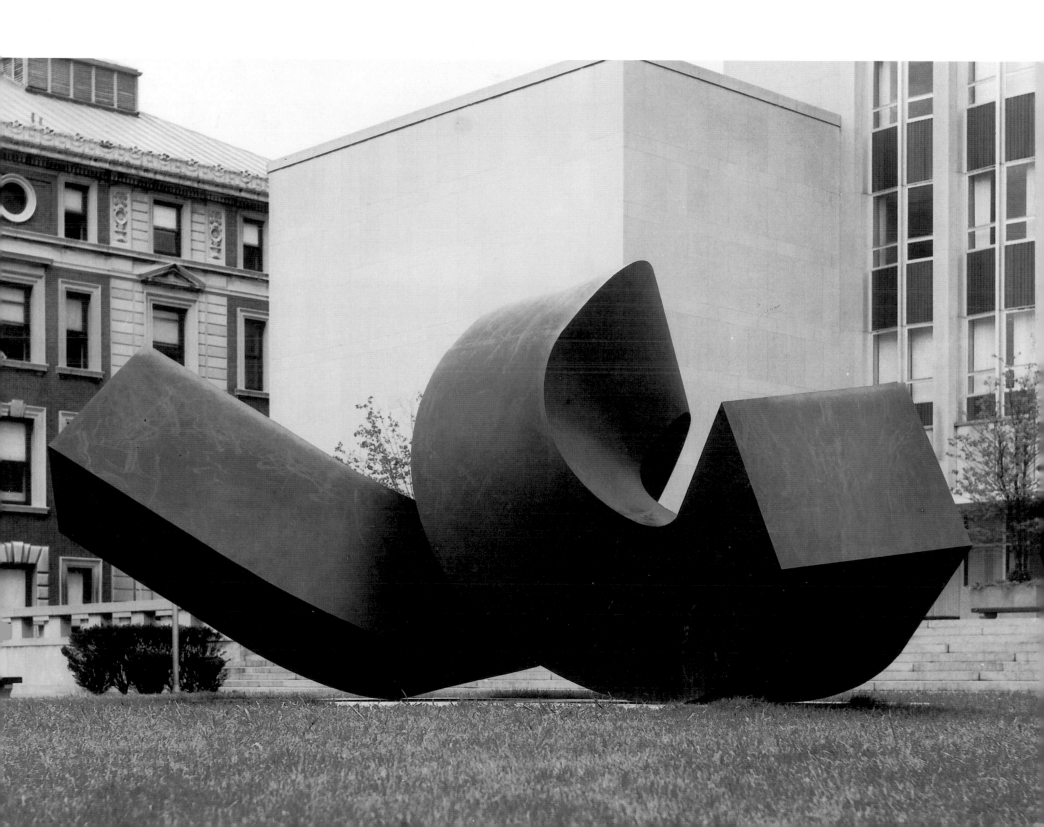

characteristic that is, to say the least, highly unusual. Minimalist doctrine had advocated the elimination of compositional hierarchies, but Meadmore's penchant for abrupt beginnings and endings may be considered just as radical and just as much of a break with older, that is to say European, conventions.

It is not only unusual; it is risky. Although the precedent of the partial figure from Rodin onward has made abrupt croppings of large masses in modern sculpture the norm, the practice still carries with it the risk of producing "dead" areas at the extremes of the sculpture. Far from being "dead," the ends of Meadmore's sculptures are just as active sculpturally as the internal masses. For one thing, the artist's attention to proportions means that he is extremely sensitive to exactly where the ends are. He has said he does not want any of his works to look like "a loaf of bread,"[29] that is, to appear chopped off at random, its energies dissipated. This attention to proportions automatically implies a relationship between a sculpture's extremities

and its center, since it is these that are being constantly weighed as the artist ponders questions of length and extension.

Moreover, coupled with the clear-cut edges and smooth surfaces, the blunt ends are the chief means by which his sculptures set themselves off from space. In them line, edge, and plane come together to delineate abruptly and clearly the end of the form and the beginning of space and to keep them clearly separate. They are a way of asserting the sculpture's status *as an object,* as something distinct from the space around it. This gives to these works of the late 1960s and will give to all Meadmore's sculptures thereafter a certain diffidence. Much as they aggressively engage with space, they hold back.

Meadmore was not the only sculptor making closed-form sculpture in the 1960s. Beginning with David Smith's introduction of volumes into his work in 1962 with his *Cubi* series, and continuing with the Minimalists soon after, there was a return to use of the closed-form sculpture among advanced artists of the day. The unexpected profu-

sion of such work led one critic to take note of what he regarded as the "rebirth" of such monolithic sculpture.[30]

Since the invention of open-form construction by Picasso and Gonzalez, so-called closed-form sculpture—the space-displacing monolith, sculpture composed of one or more enclosed volumes—had been written off as passé, part of an earlier, premodern tradition that had now come to an end. This view was perpetuated during the 1960s by critics such as Clement Greenberg and Michael Fried, who argued that open-form construction remained the only truly "modern" form of sculpture.[31] So universally accepted was this view—which effectively consigned monolithic sculpture to oblivion—that the critic Patrick McCaughey was prompted to ask, "What hampers monolithic sculpture from achieving [the same] status? . . . [W]hat conditions must be met by monolithic sculpture in order to produce work of quality and conviction?"[32]

Yet it is a mistake to tar the closed-form sculpture of the 1960s with the brush of back-

wardness, as one does by equating it with the work of Rodin and other pre-1925 modernist sculptors. The two have less in common than at first appears. Meadmore's preference for the term *single form* rather than *monolithic* in discussions of his own work is an indication of the different way advanced sculptors of the 1960s saw themselves in relation to earlier modernist sculpture.[33] For one thing, Smith's *Cubi*s, Meadmore's sculpture, and that of the Minimalists was just as aesthetically ambitious as the open-form constructed sculpture championed by Greenberg and Fried. (Otherwise Fried would surely not have been moved to denounce Minimalism so forcibly, as he was when he wrote his celebrated 1967 article, "Art and Objecthood" [reprinted in Battcock, *Minimal Art:* A Critical Anthology, pp. 116–47].)

But there is more to it than that. In both art and everyday contexts, the words *monolith* and *monolithic* describe a single unit of form, be it a figure sculpture, a work of architecture, or the elements in a structure like Stonehenge. And

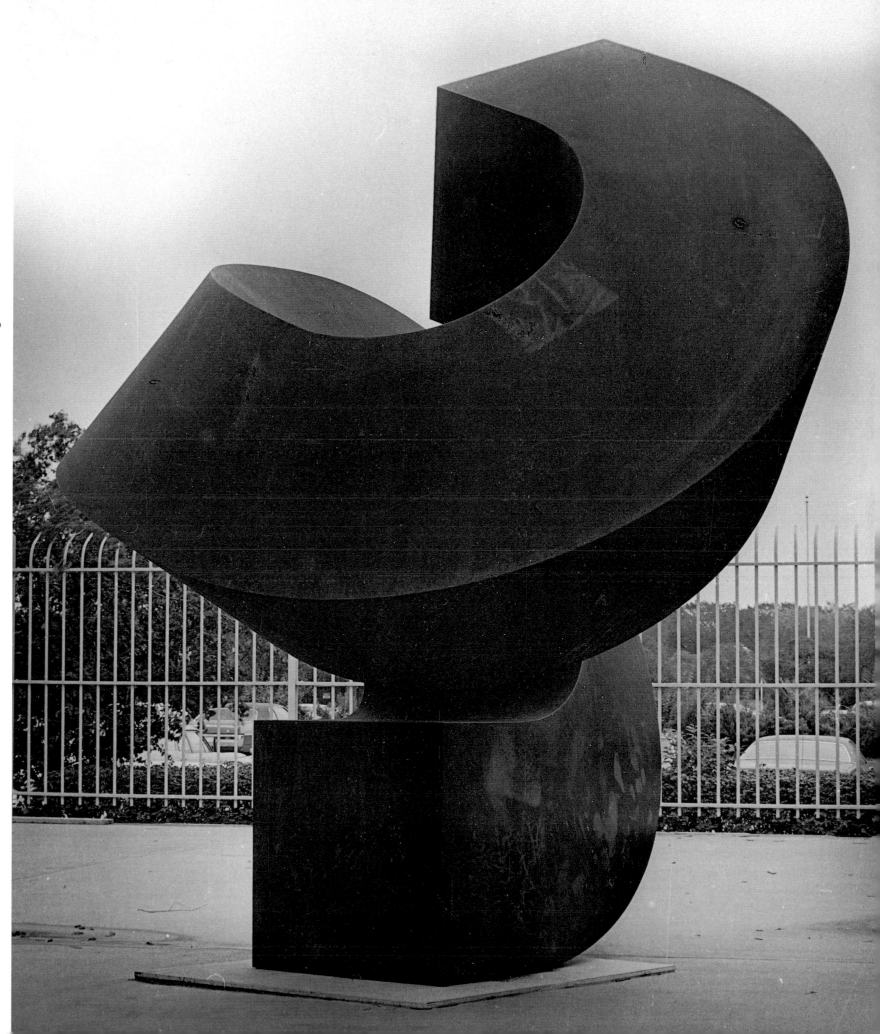

SPIRAL 1969
Steel
14′9″ × 11′ × 11′
Art Institute of Chicago

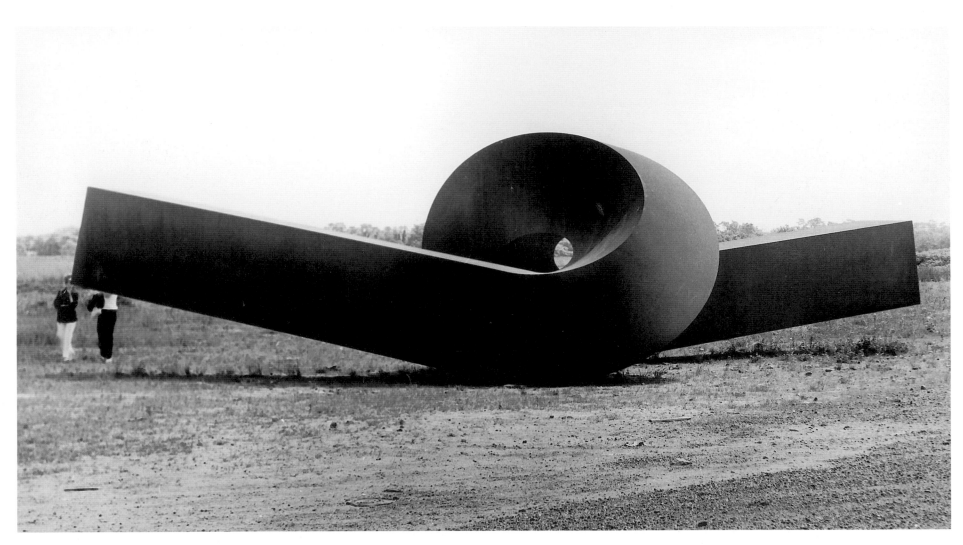

VIRGINIA 1970
Steel
12′ × 46′6″ × 20′
Australian National Gallery, Canberra

UPENDED 1969 ▷
Steel
8′ × 24′ × 7′
Santa Barbara Museum of Art, California

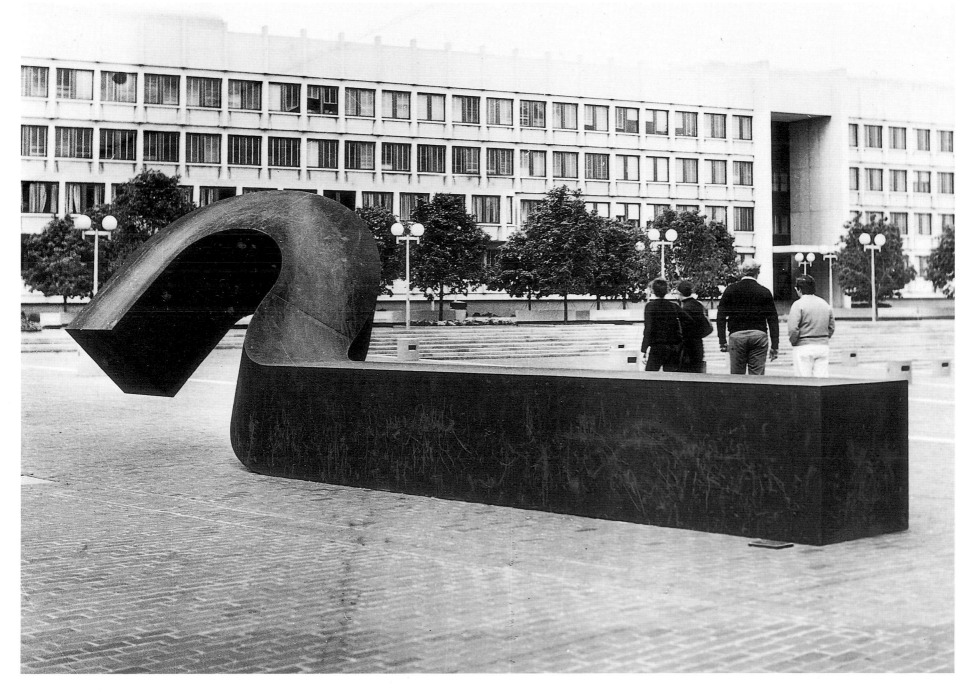

they suggest substantial mass, solidity, and scale, as well as a public, often symbolic mode of address. A low-to-the-ground Donald Judd box or a sculpture by Richard Artschwager in which a Judd-like, Minimalist cube is laminated with Formica to create the illusion of a table covered with linen hardly fits that description. For that matter, even though there are exceptions among Minimalist sculptors—Bladen and Smith among them—can we really call *any* of the closed-form sculpture produced in the 1960s and after "monolithic"? Viewed from a distance of thirty years, this return to closed-form sculpture reads more as a variation on such mainstream modernist tendencies as Abstract Expressionism and Constructivism than as an independent impulse.

This is because, whereas sculptors of the period may have returned the closed volume to the center of their work, in their handling of it they denied its monolithic characteristics or subordinated them to their immediate aesthetic imperatives. This was equally true of David Smith retaining his Constructivist style in his *Cubi* series, Robert Morris undermining his volumes' sense of mass by sheathing them in mirrors, or Meadmore vitiating bulk and ponderability of his own sculpture through the use of linear, gestural configurations. Thus, while closed-form volumes once again became part of the vocabulary of advanced sculpture for the first time in fifty years, the character and content of that sculpture was not, by itself, determined by those closed-form elements.

7

In the early 1970s Meadmore made a series of sculptures informed by a new and very different spirit. In sculptures such as *Upstart I, Upstart II, Double Up, Verge, Swing, Hence, Clench,* and *Push Up,* Meadmore crosses a threshold, infusing his work for the first time with many of the qualities that would come to distinguish it from his own and other sculpture of its time, not only in form and character, but in quality.

To begin with, these sculptures of the late 1960s and early 1970s are less closed, less inward-turning than their predecessors. Instead, they open up more and begin to reach beyond themselves, sometimes with startling aggressiveness and daring. Indeed some, such as *Hence, Verge, Swing, Double Up,* and *Twist,* are so opened out that they make one realize how much the curves and tight serpentine turnings are necessary to impart a focus and a sense of sculptural substance in Meadmore's work. They also highlight the risks of having a sculpture be, as these five are, little more than an open line in space,

a risk that Meadmore deliberately and successfully pushes as far as he can in these particular works. Meadmore's most open and attenuated sculptures, they are among his most succinct and elegant. Taken together, they highlight, as almost no other work, the opposition between line and mass that lies at the core of Meadmore's sculpture. In addition, they represent the ultimate expression, in their expansiveness and dispersal, of the lesson he had learned from Barnett Newman.

By opening up more now, by adopting more irregular configurations, and particularly by abandoning their tense coilings, Meadmore's sculptures change noticeably. They can no longer be read solely in terms of a beginning, a middle, and an end. Instead, they become more episodic, one moment appearing self-contained and at another simply appearing as one segment of an absent whole. In so doing, they become more abstract.

At the same time, all the sculpture made now denies its own physical

reality, seeming more weightless. The previous sculptures had related to the ground plane more or less as ordinary objects. Or, to cast this observation in the critical language of the day, the ground plane served no aesthetic purpose. Placing the sculpture on the ground in this case was thus like placing it on an oversized pedestal, considered at the time a backward-looking approach.

In certain works, notably *Virginia,* this impression was so pronounced that it all but ruined the work. *Virginia* sounds a bathetic note. It looks as if it was simply put down in the absence of any better idea of what to do with it. The same is true, albeit to a lesser extent, in *Up Ended.* In other words, the dynamism apparent in the internal relations of Meadmore's sculpture did not extend to their external relations, at least not this aspect of them.

Now, however, the sculptures touch the ground in fewer places. And more often than not the point of contact will be the edge of a curve. Only rarely will it be a

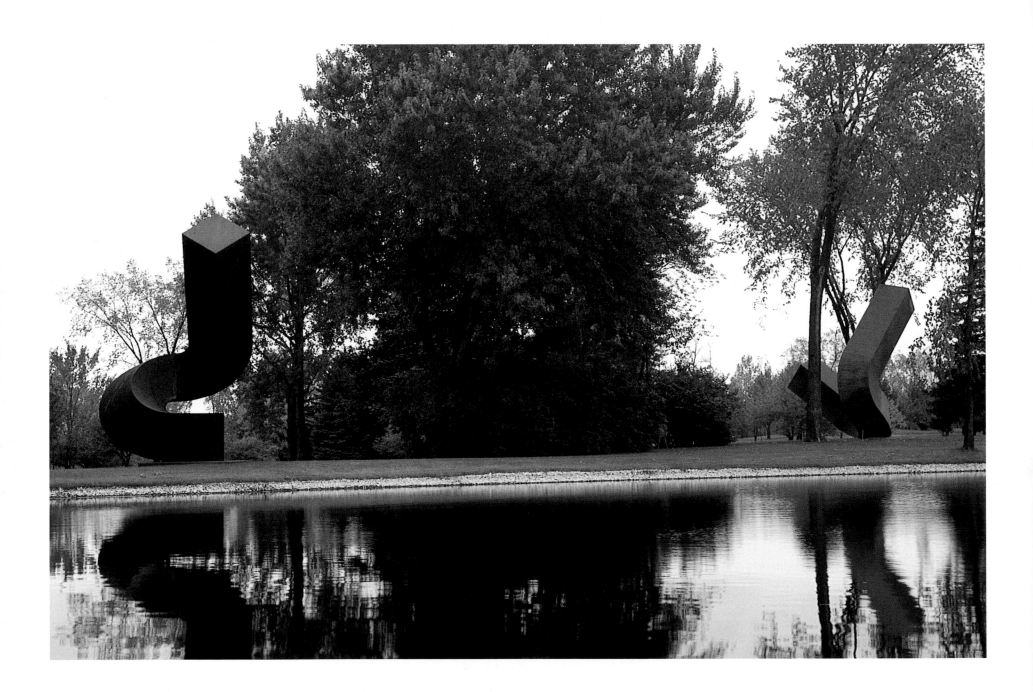

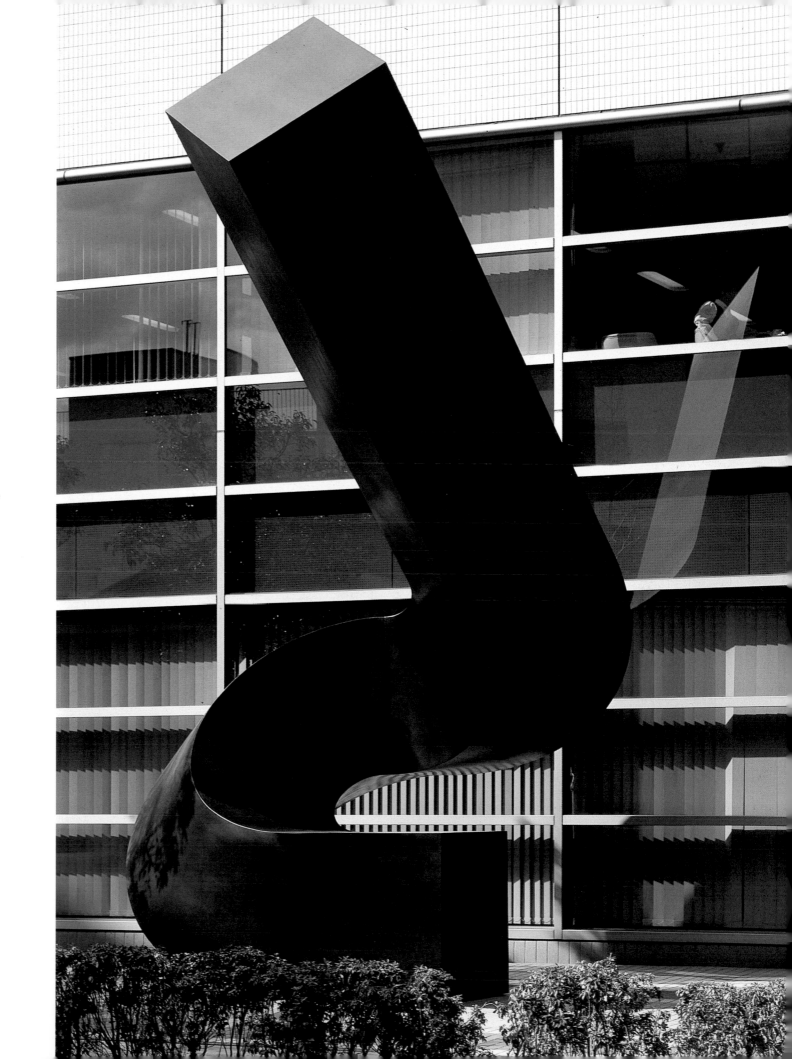

◁◁ **UPSTART I** 1967
Steel
20′6″×15′×13′
Milwaukee Art Center

◁ **DOUBLE UP** 1970
Steel
20′×15′6″×12′6″
Milwaukee Art Center

UPSTART I 1967
Stccl
20′6″×15′×13′
Sagamitetsudou (Railway) Company Ltd.,
Yokohama City, Japan

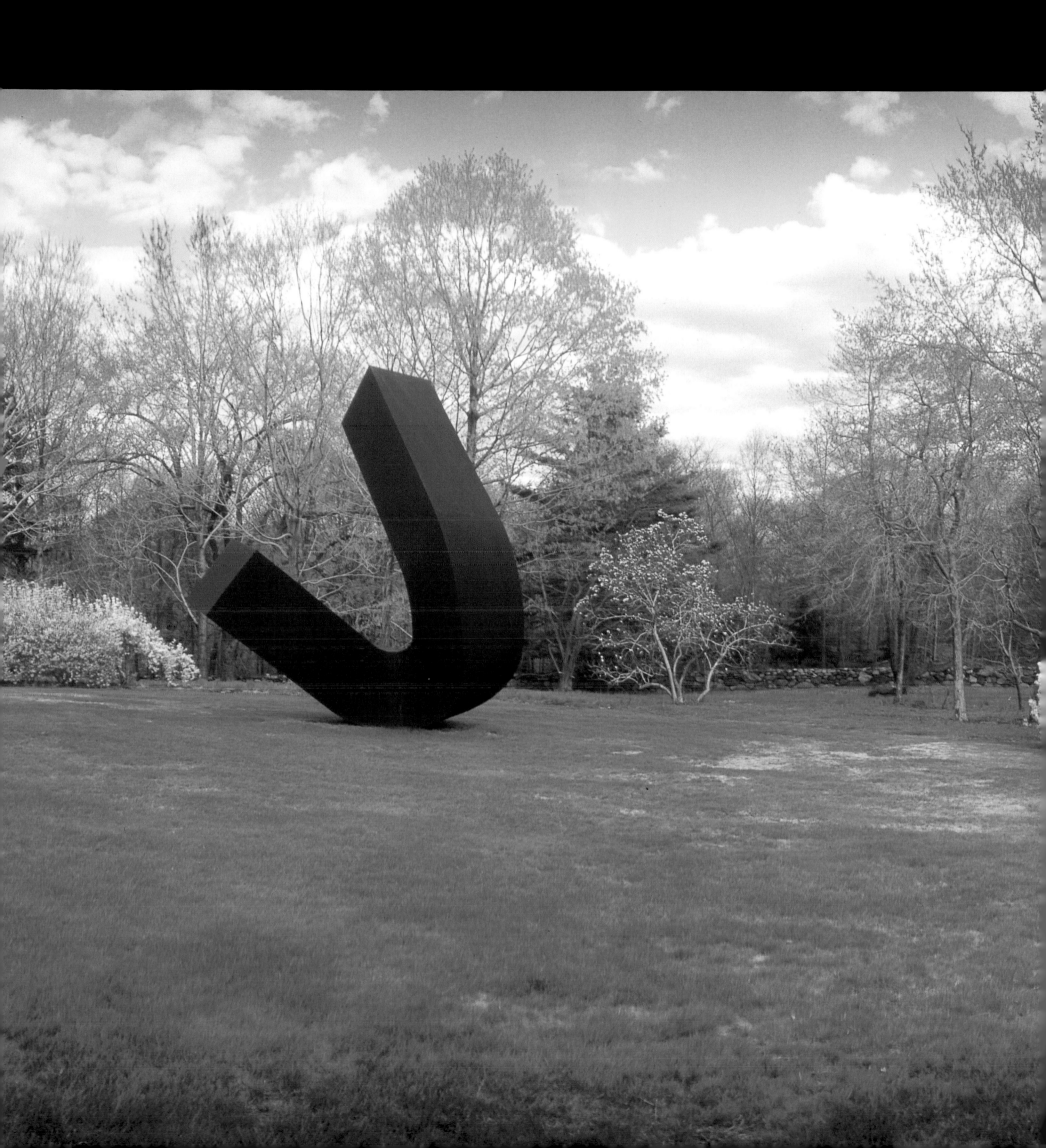

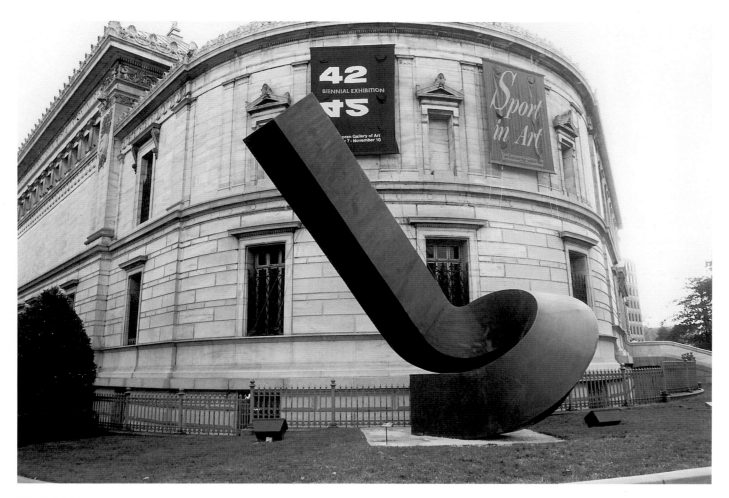

UPSTART II 1968
Steel
25′6″ × 18′ × 25′
Corcoran Gallery of Art, Washington, D.C.

OVERLEAF
◁ **DOUBLE UP** 1970
Steel
20′ × 15′6″ × 12′6″
National Trust for Historic Preservation
Nelson A. Rockefeller Bequest,
Pocantico Historic Area, New York

stability-suggesting, weight-affirming, bulk-supporting plane. Meadmore, clearly, was aware of the importance of such details.

When a sculpture meets the ground it should not appear to sink into it like a tree or a building. A building is part of the environment, but a sculpture is a presence inhabiting the environment. The conviction with which a sculpture makes contact with the ground is a large part of its strength.[34]

The cumulative effect of these changes is that Meadmore's sculptures have become more gestural. That is, in their form they suggest the rapid motion through space of a limb or a body, or the disembodied residue of such motion. They have more in common with purely aesthetic things, such as a drawn line, than with a recognizable object existing in the world even though, by virtue of their sheer physical bulk and size and scale, they are undeniably that.

Yet they go beyond the purely gestural to evoke a complex of sensations that engage the viewer on a number of different levels. There is, first, the strong sense of an almost musical rhythm. In con-

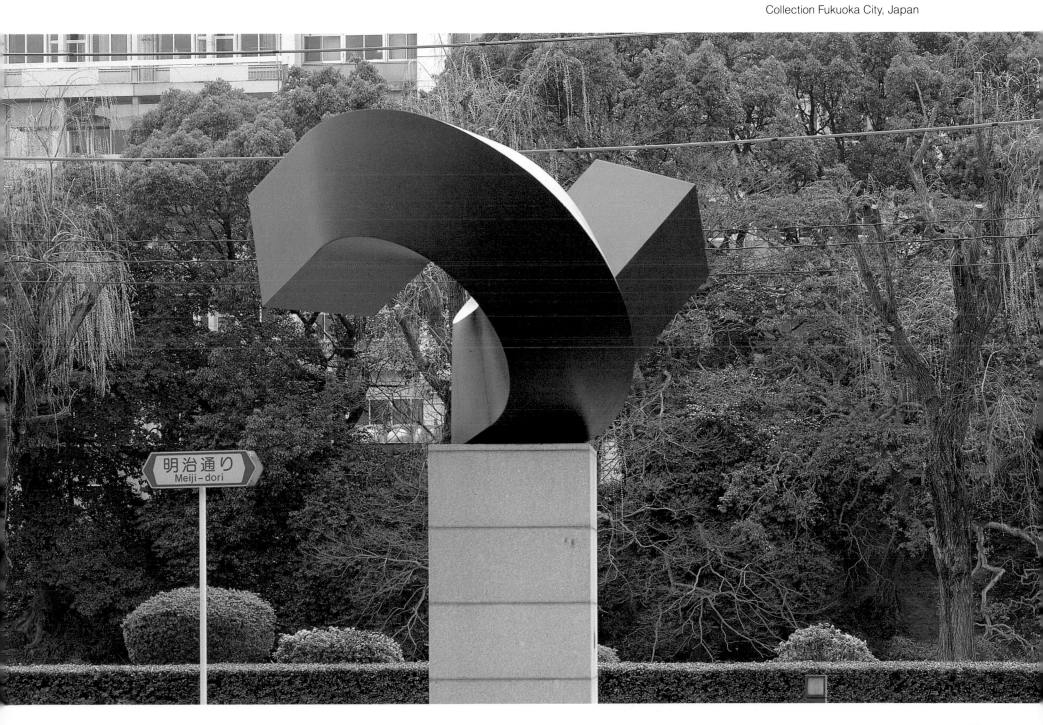

SWING 1969
Aluminum, painted black
9′×15′×12′
Collection Fukuoka City, Japan

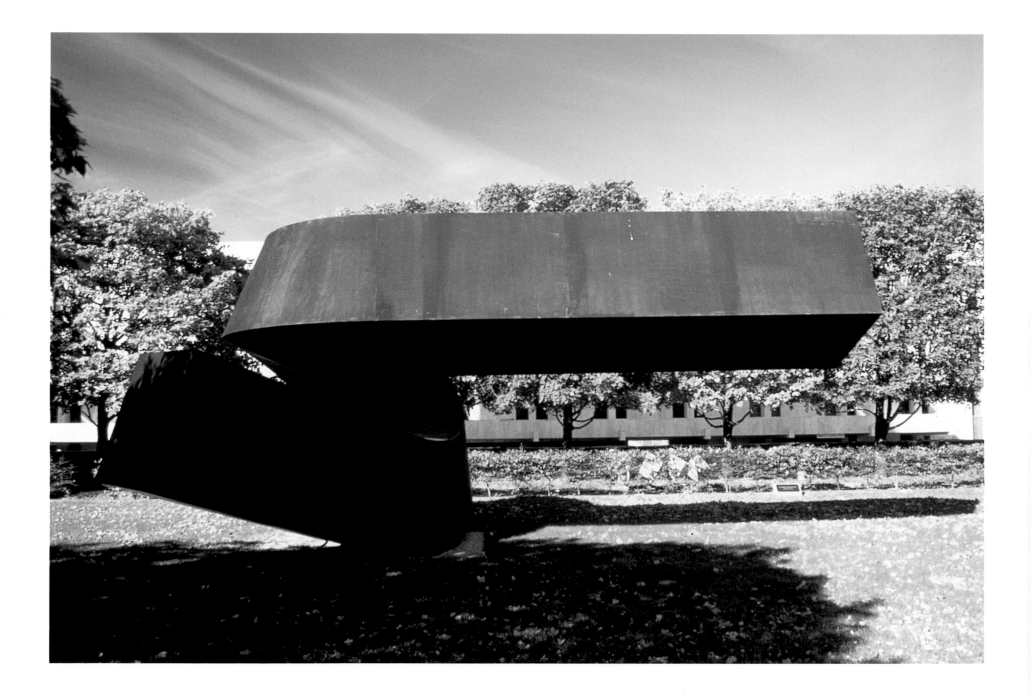

54

VERGE 1970
Steel
16'6" × 36' × 24'
Empire State Collection, Albany, New York

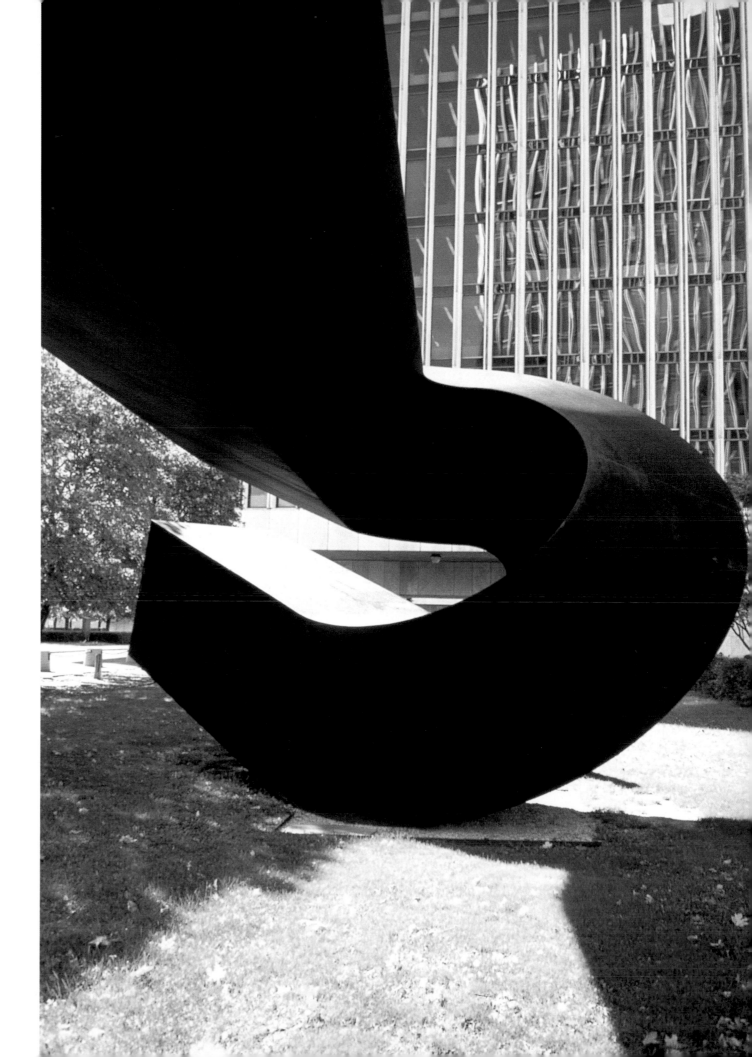

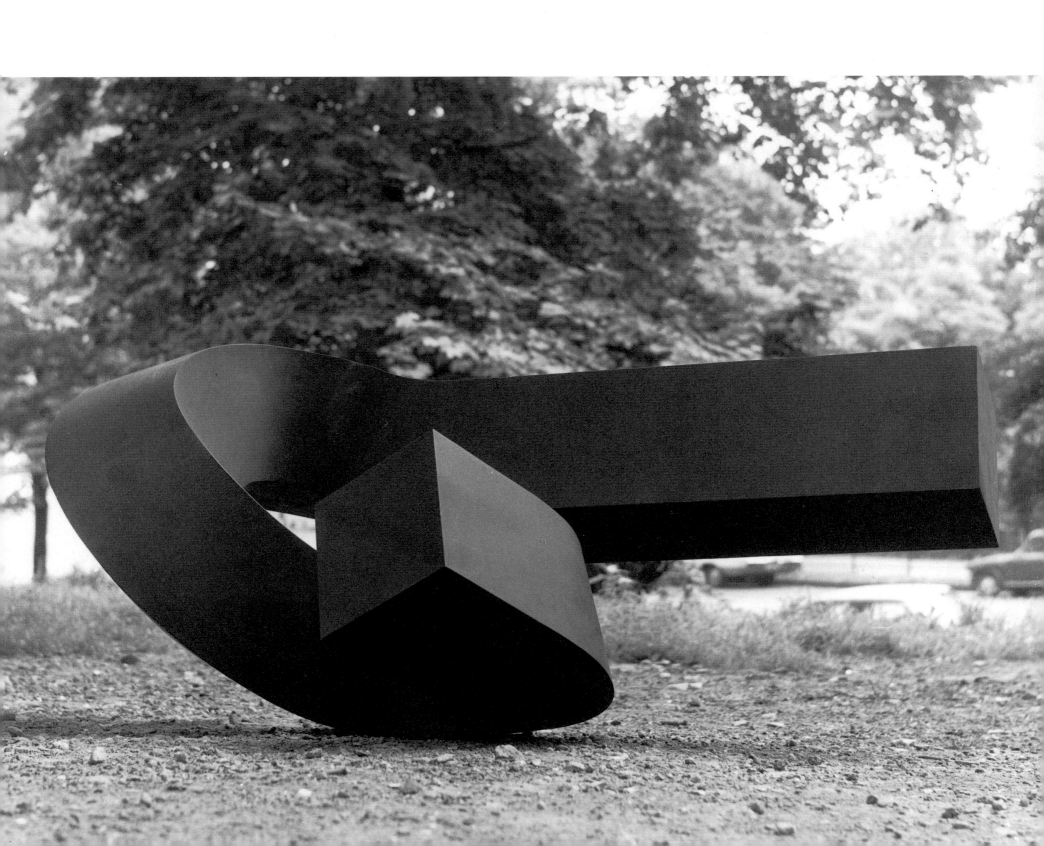

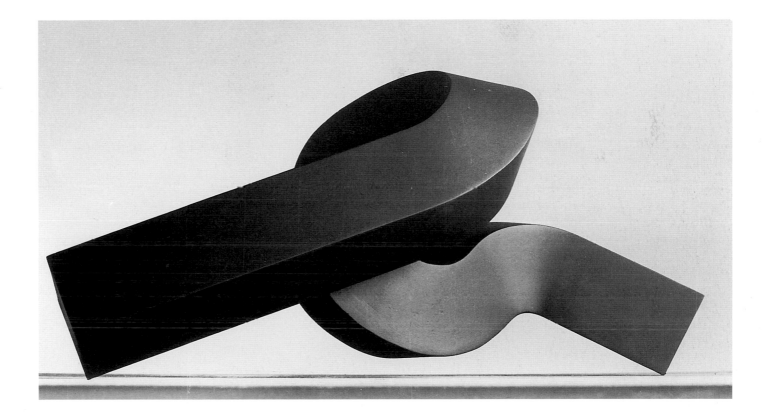

trast to the early work with its easy and uniform continuities, the internal dynamics of Meadmore's sculpture from this point on receive more concerted attention. *Out of There* and *Clench* are two examples of this new tendency. Rhythms now gather and are released, they pick up momentum and slow down, begin with sudden intensity and stop with equal abruptness. His sculptures simultaneously suggest uninterrupted flow and a caesura. They have a strong affinity with jazz, which is an abiding interest of Meadmore's. (He maintains an extensive collection of jazz recordings.)

This does not mean, however, that one must stand at one spot and read them left to right. In some sculptures (again, *Out of There* is one), the energy and rhythms might flow in different directions at once, or against each other. In every case their direction and character change depending on what viewpoint the spectator chooses, something that has prompted Meadmore himself to observe that his is a line "you can enter wherever you want."[35]

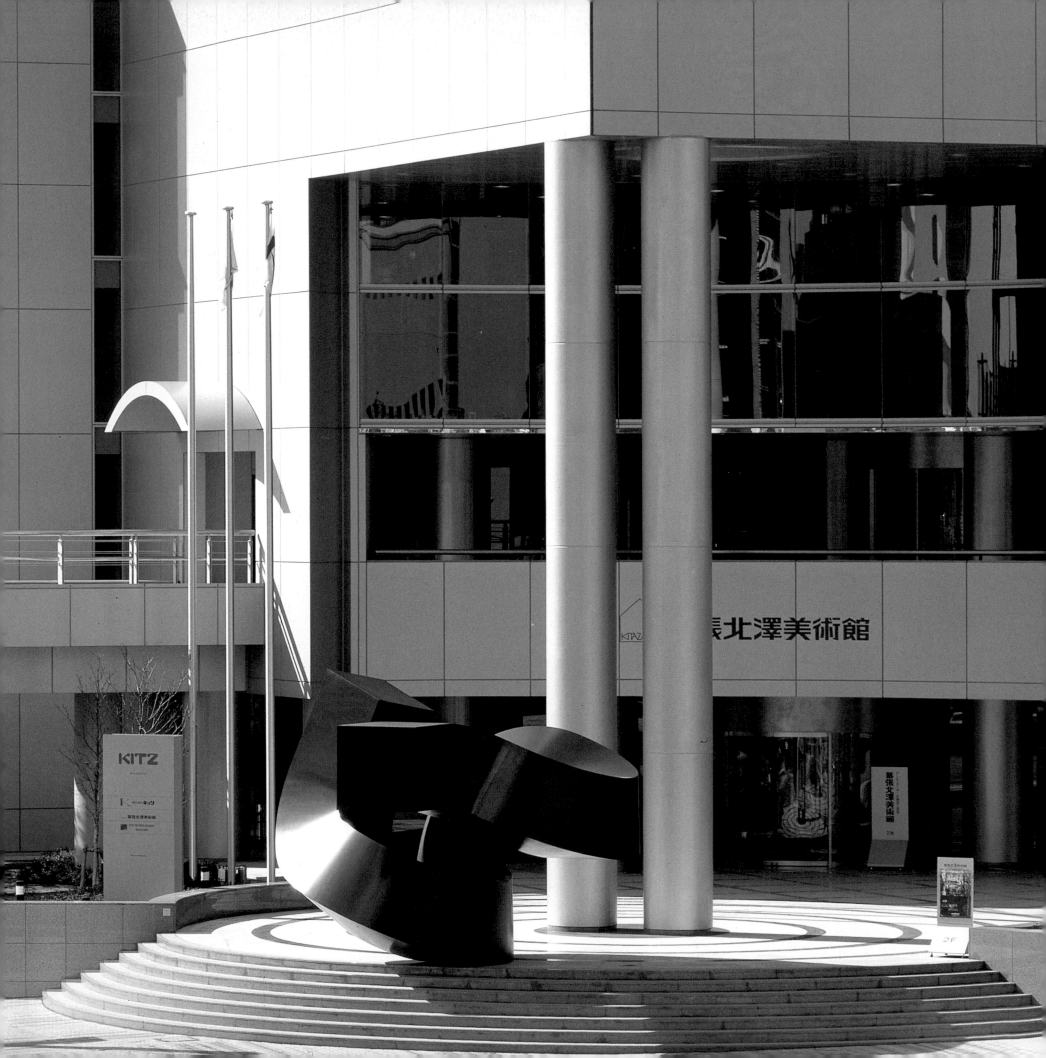

CLENCH 1972
Aluminum, painted black
15′ × 18′ × 18′
Kitz Valve Co., Makuhari, Japan

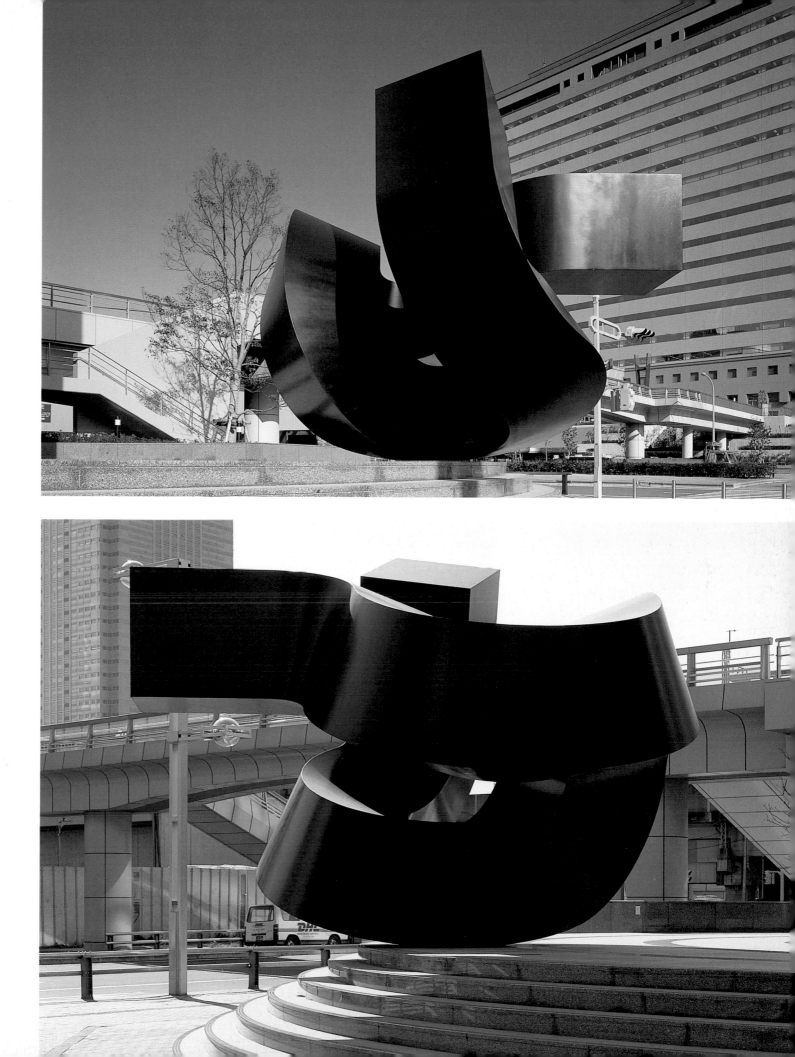

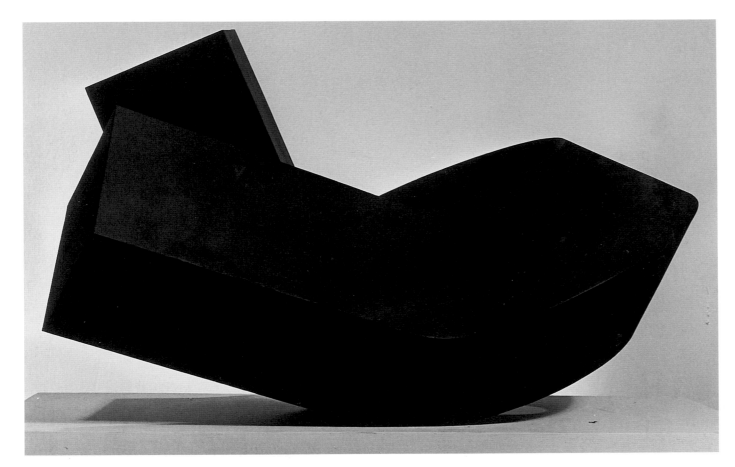

COTTER 1970
Steel
20″×37″×27″
Private collection

TWIST 1968 ▷
Cor-Ten Steel
19″×33″×15″
Natvar Bhavsar, New York

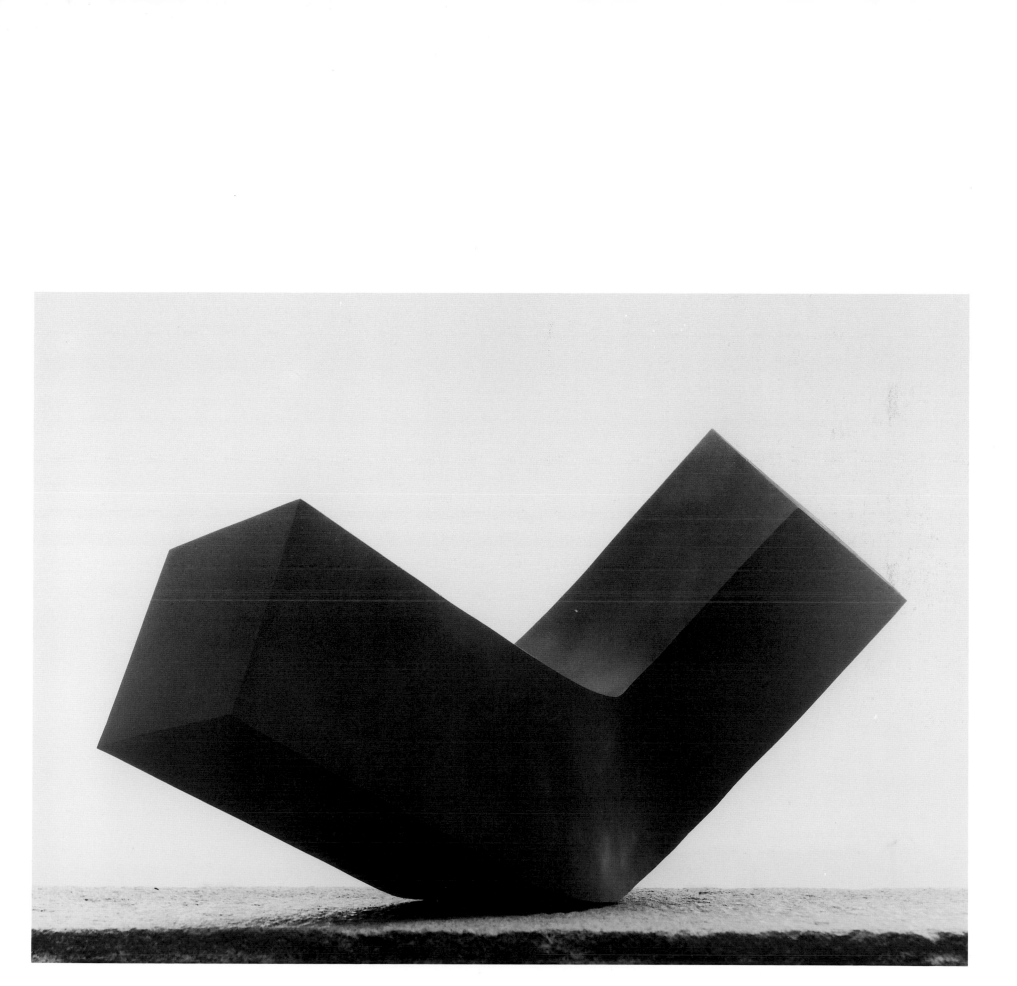

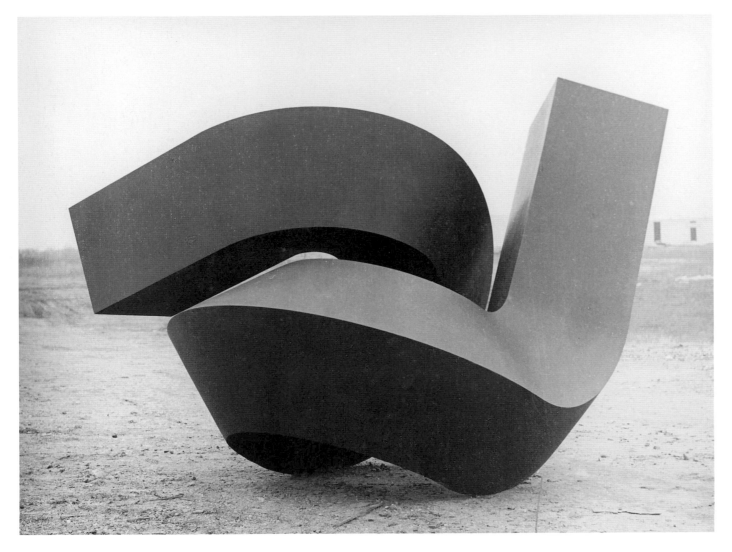

AROUND AND ABOUT 1971
Steel
7′ × 11′ × 7′3″
Private collection

SPLIT LEVEL 1971 ▷
Steel
6′ × 14′9″ × 6′9″
University of Houston

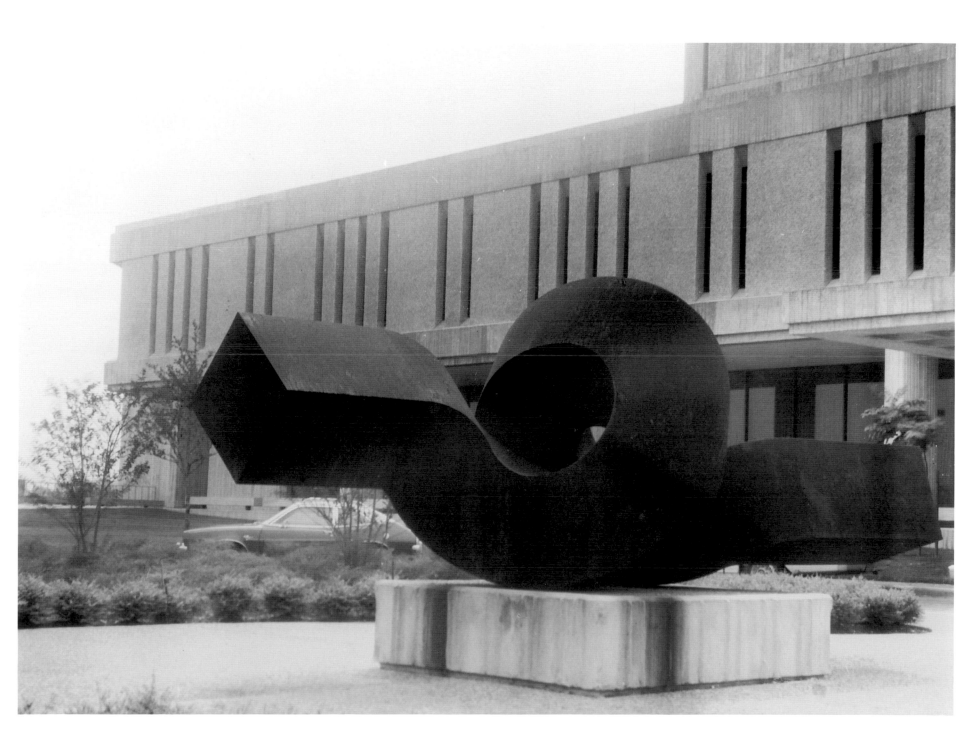

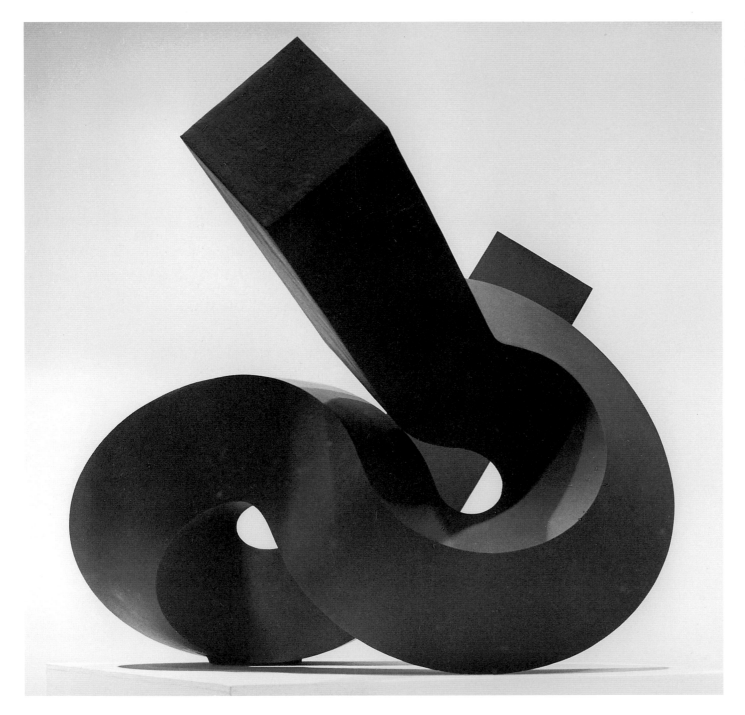

FLING 1971
Steel
34″×52″×40″
J. B. Speed Art Museum, Louisville,
Kentucky

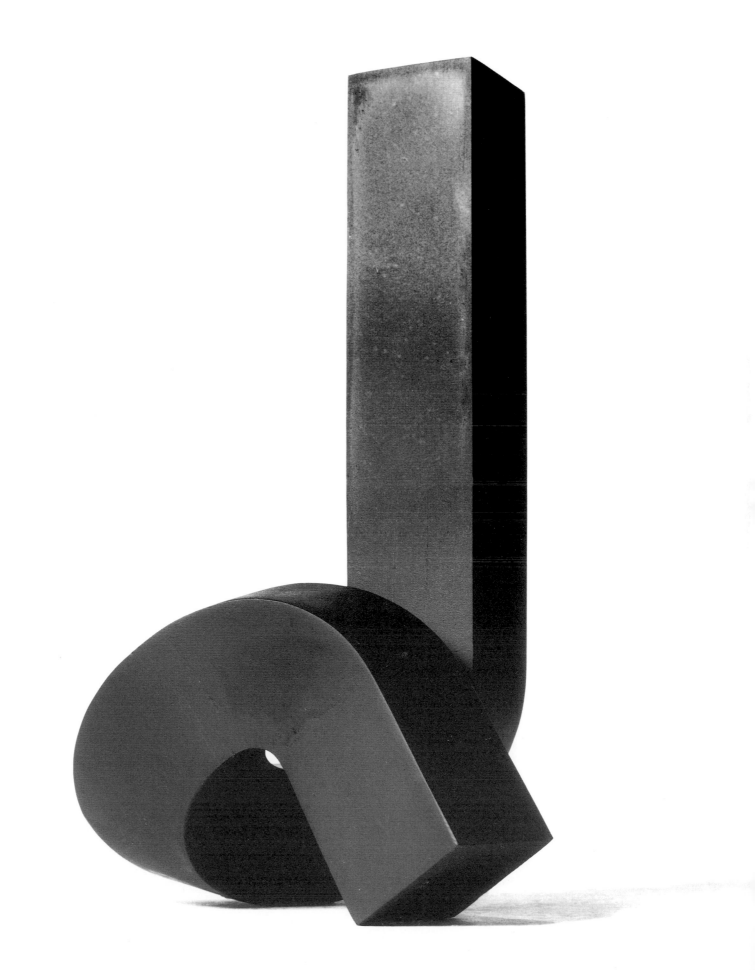

HEREABOUT 1971
Polyester
9½″ × 4½″ × 5″
Collection of the artist

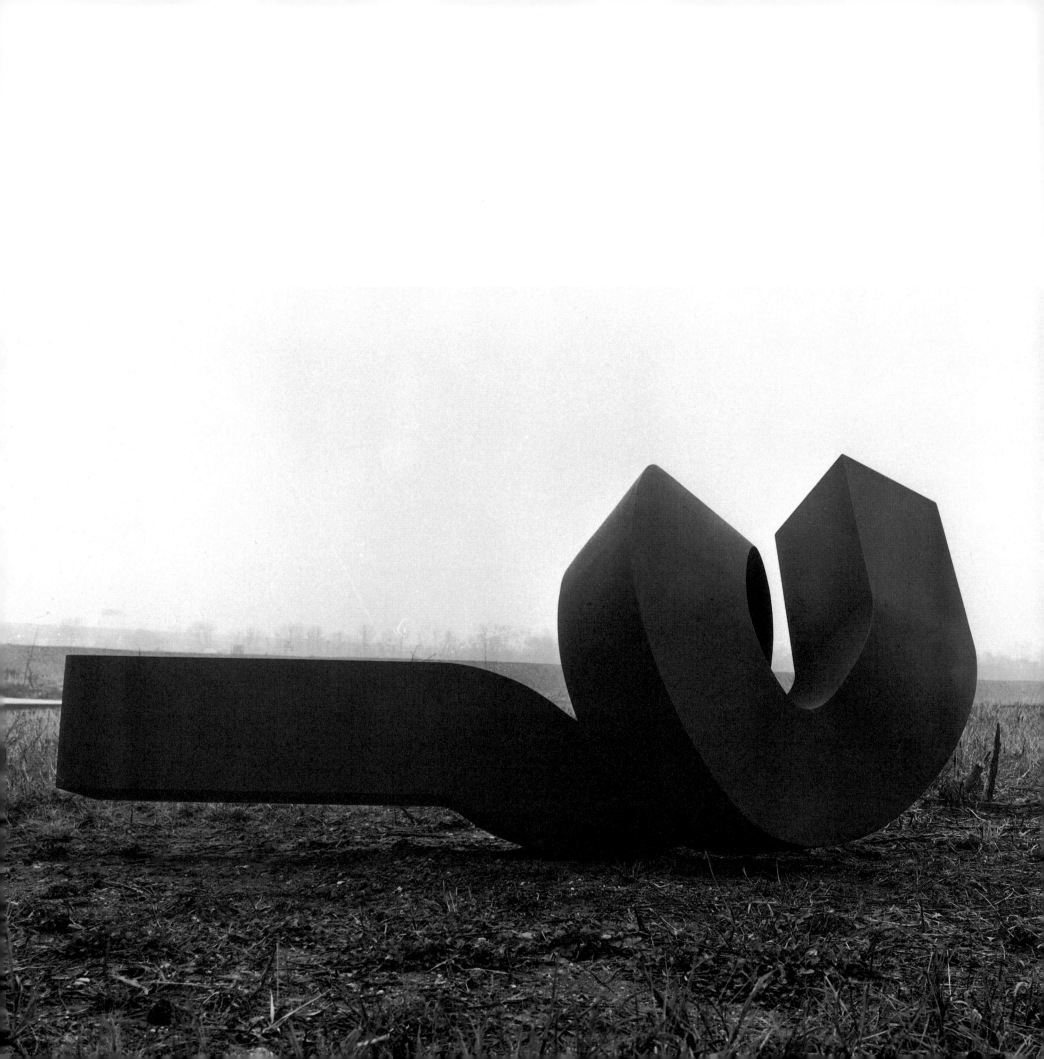

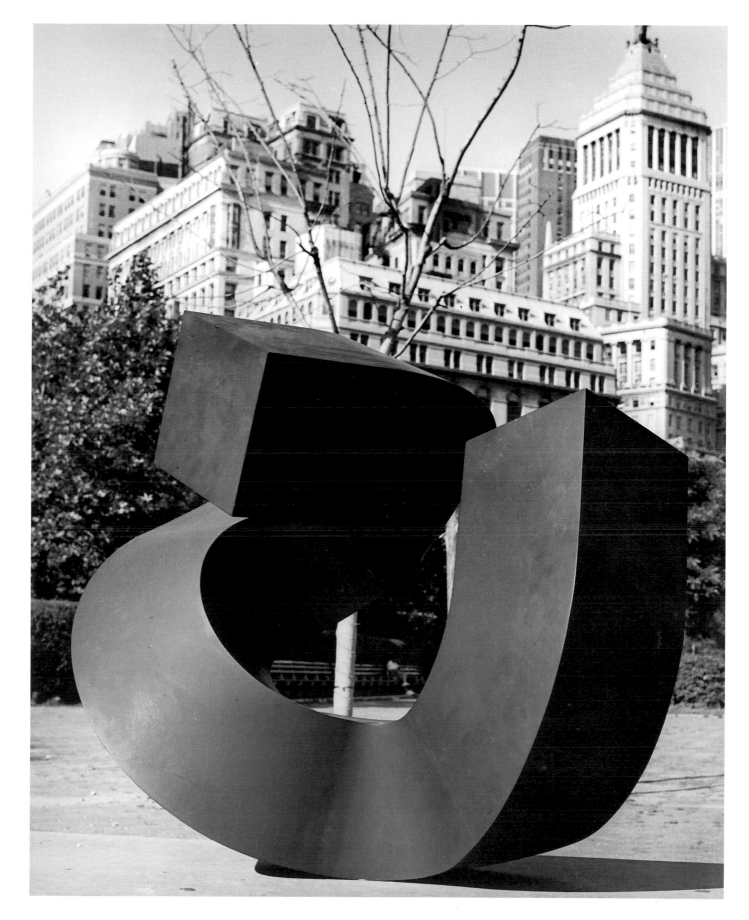

◁ **UNWINDING** 1972
Steel
27″×56″×34″
Private collection

GETTING AROUND 1972
Steel
28″×29″×22″
Private collection

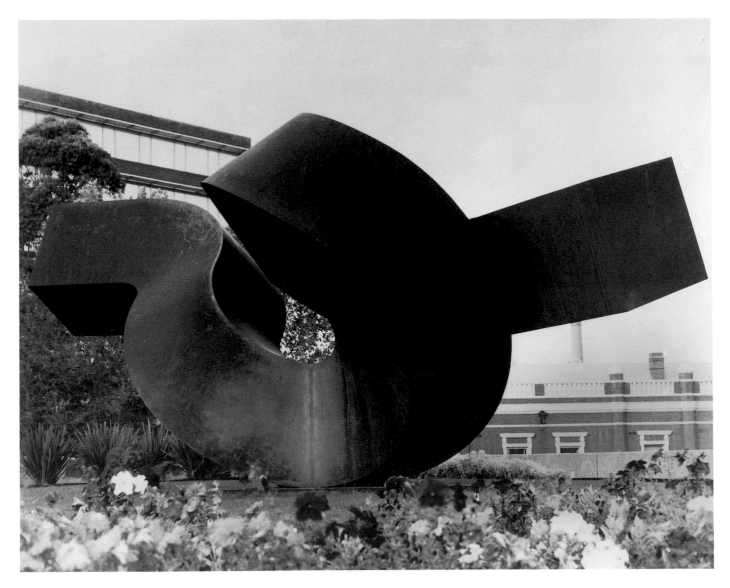

DERVISH 1972
Steel
15'7"×32'6"×16'3"
Victoria Arts Center, Australia

TRANS 1972 ▷
Aluminum, painted black
6'3"×8'4"×8'
Park 80 Associates, Saddle River,
New Jersey

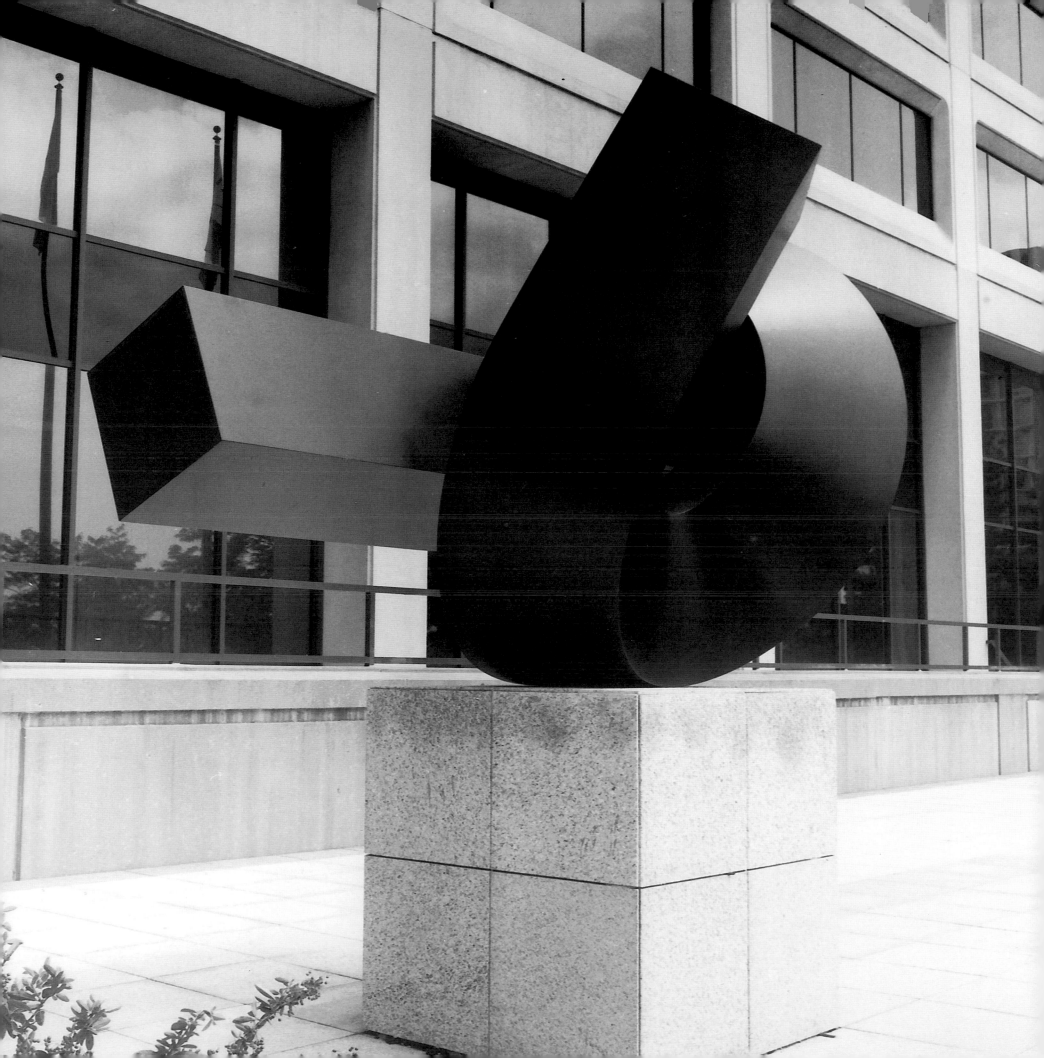

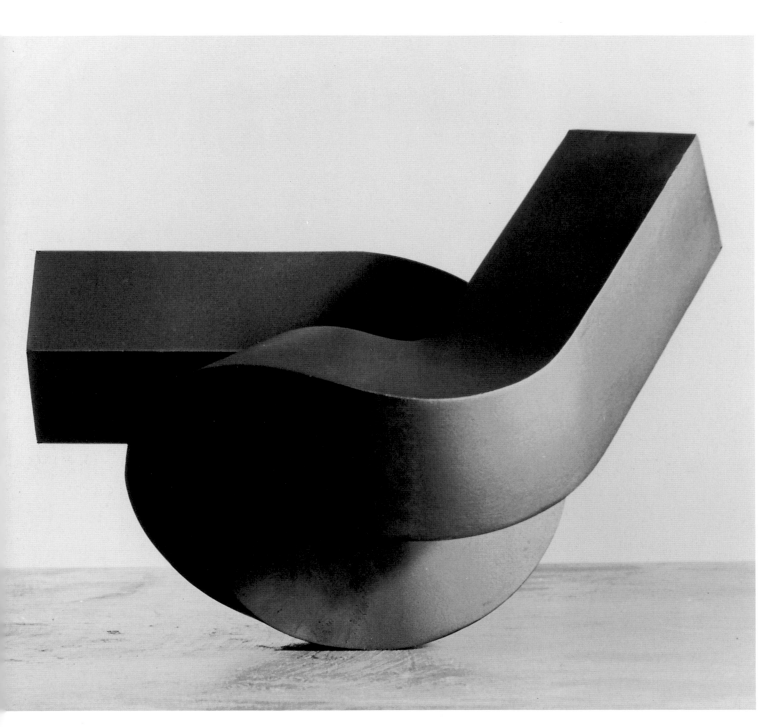

DIP 1972
Maquette
26″ × 40″ × 28″
Collection of the artist

SWASH 1973 ▷
Maquette
5″ × 8½″ × 5½″
Collection of the artist

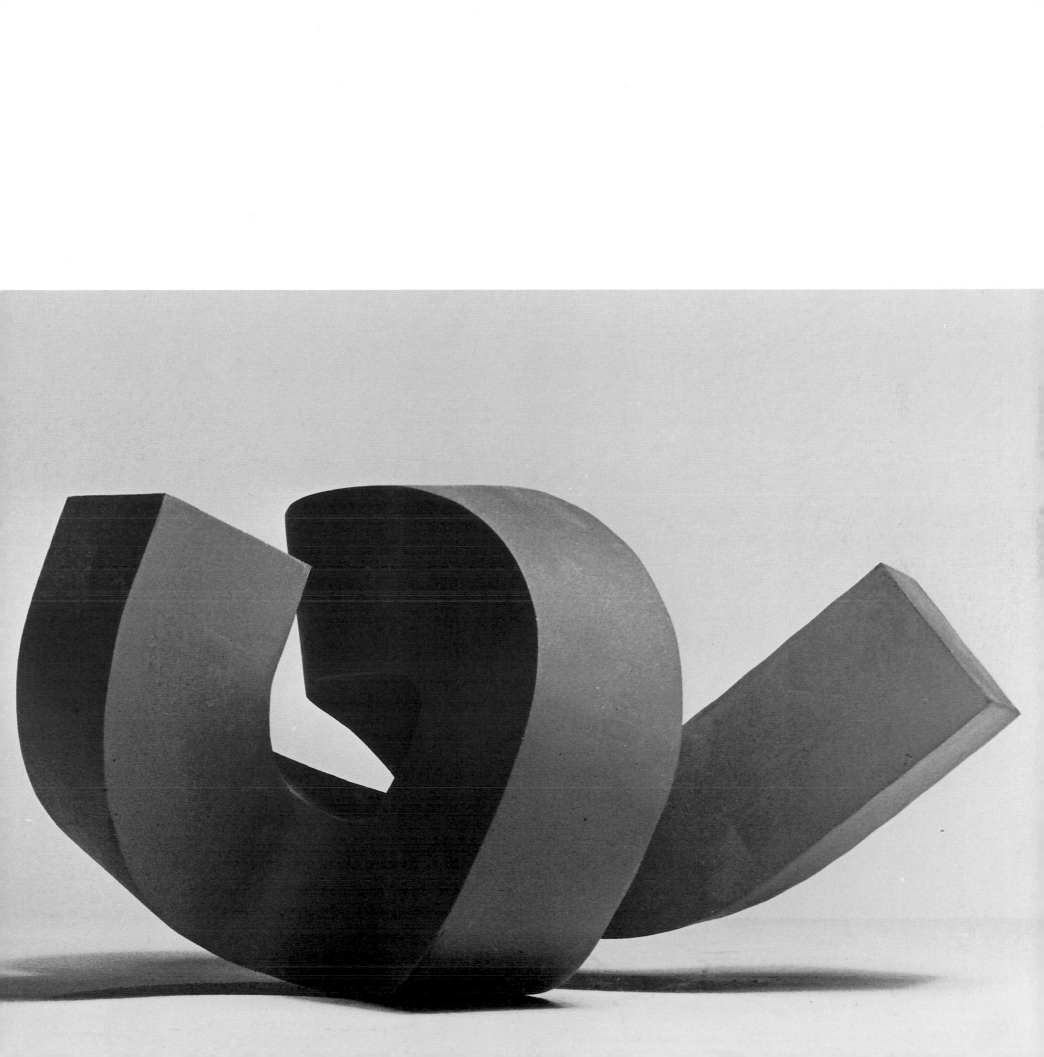

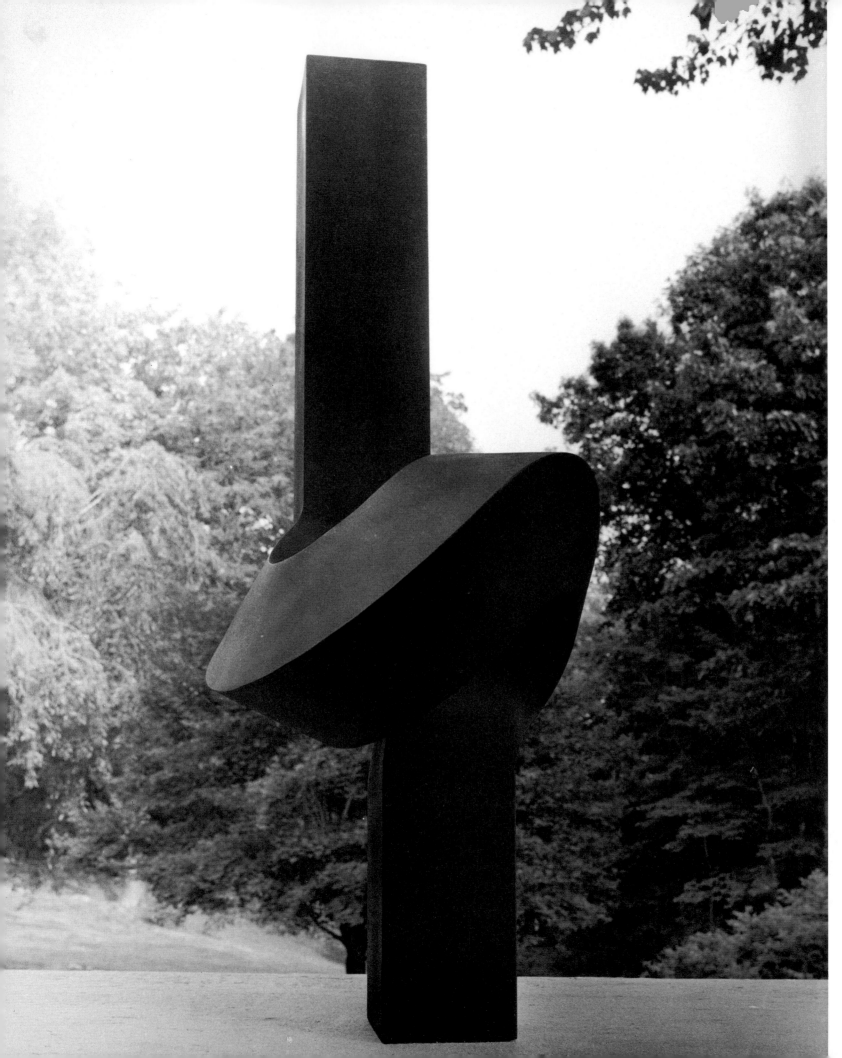

MEDITATION 1974
Bronze
39″×15″×15″
Collection of the artist

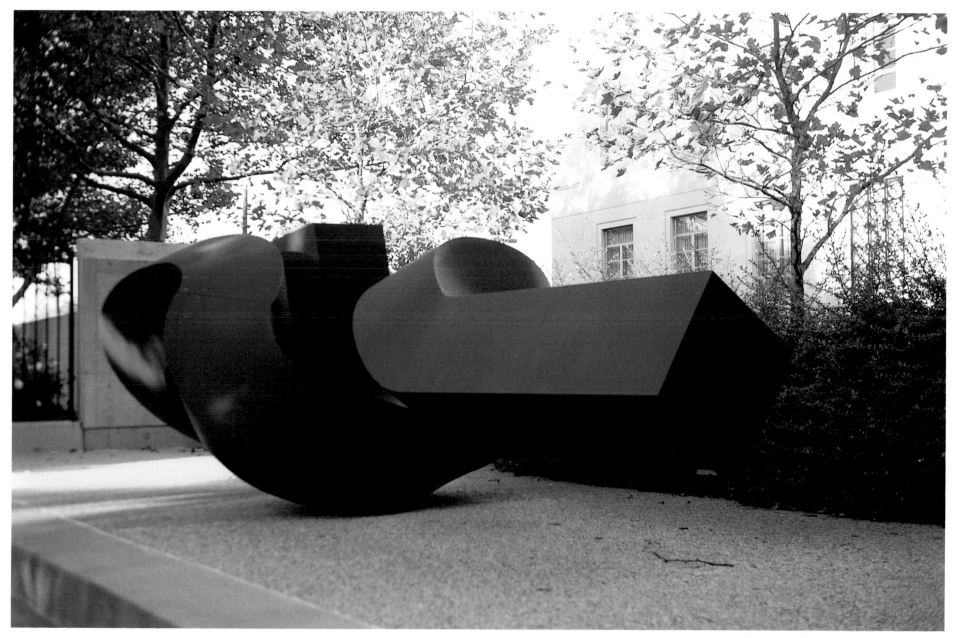

OUT OF THERE 1974
Aluminum, painted black
6'6"×9'6"×16'8"
Columbus Museum of Fine Art, Ohio

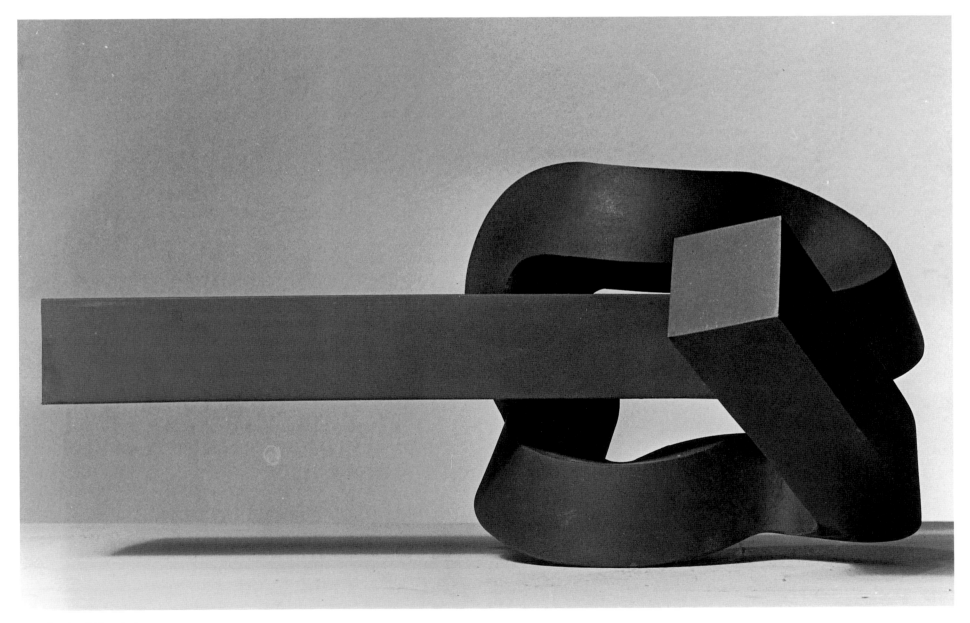

THROUGHOUT 1973
Maquette
6″×13″×10″
Private collection

HUNCH 1974
Polyester
12″×15″×15″
The Metropolitan Museum of Art, New York

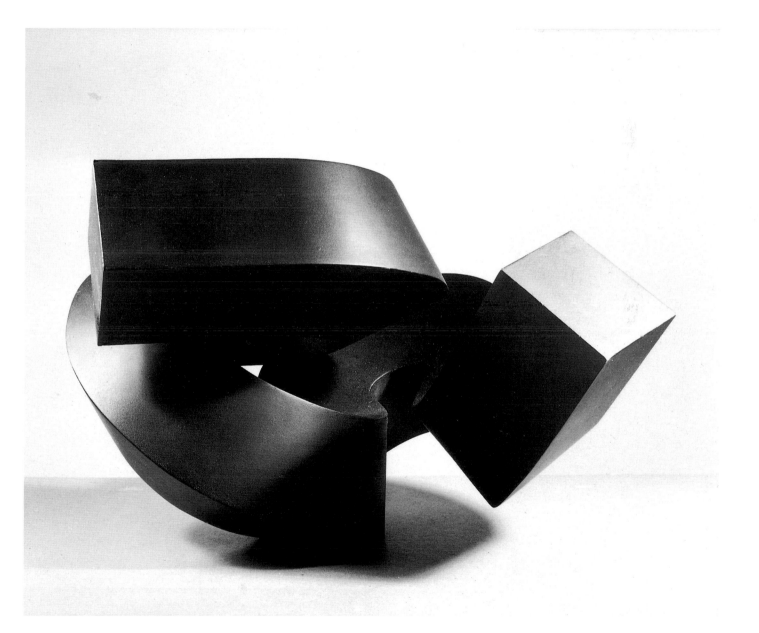

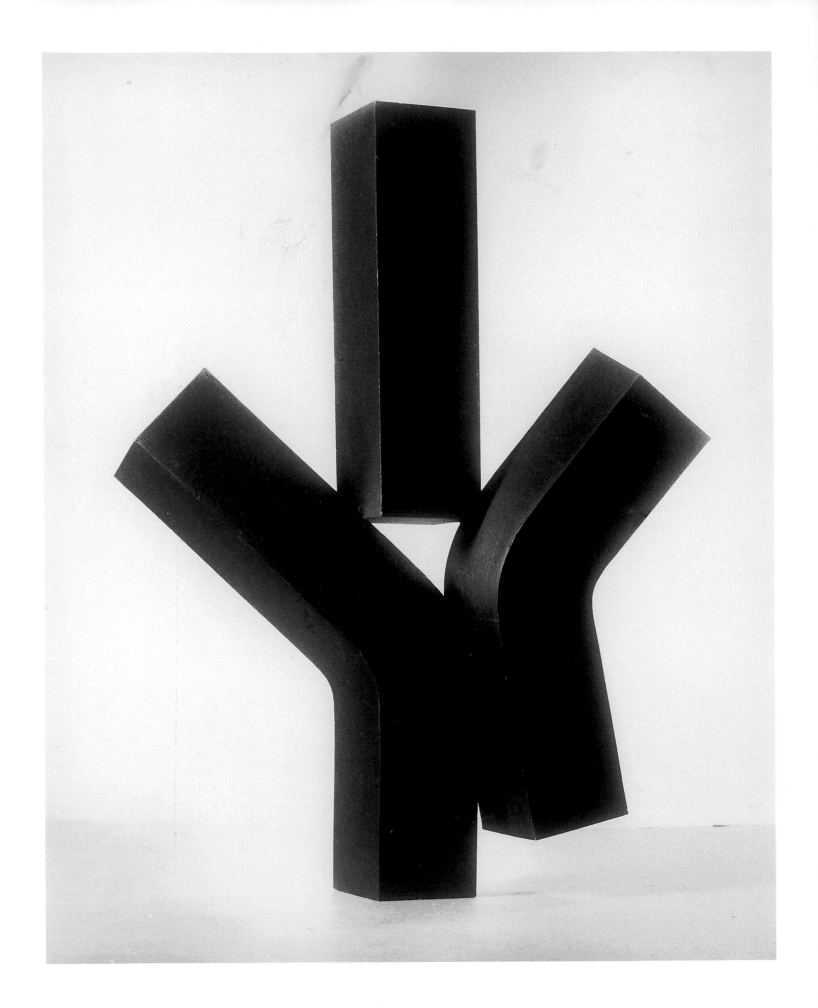

8

One of the insights offered by *Bent Column* of 1966 was the possibility of elaborating sculptures using a module. Until that time Meadmore had composed his sculpture spontaneously, relying on his eye and his intuition to determine size, shape, and proportion. *Bent Column* itself was created in this way. However, *Bent Column* represented a turning point in Meadmore's art. He saw in the sculpture itself—a single volume tilted on two axes—a basic unit of form that could be used as a kind of building block in the creation of larger, more complex sculptures. This realization, in turn, brought with it a change in the artist's working method, one that, in the work executed in the early 1970s, had yielded the richest sculpture of Meadmore's career.

From the late 1950s through the late 1960s, Meadmore had assembled his sculptures from sheets of steel first cut, then welded together to form a volume. The shift to modules meant that henceforth a three-dimensional result would have a three-

dimensional conception. Moreover, instead of totally dominating his material, making it bend to his wishes as was the case when he worked in sheet steel, Meadmore had now to place himself in a position where, to some extent at least, his materials dictated the final form of the sculpture.

This change also meant that whereas prior to the early 1970s Meadmore's sculptures were entirely preplanned, his approach was now fully improvisational. To be sure, the modules were a given, but beyond that everything was open. As Meadmore himself describes it:

Not only do I not know exactly what [the final form is] going to be, I haven't the faintest idea. It's totally improvised. . . . There's a tremendous freedom in the ways the modules go together, and all sorts of things can happen geometrically. I have a little mold with which I cast off hundreds of elements and I play with them like building blocks. . . . Each two elements [can] relate in eight different ways, so that an average piece containing about ten elements [has] thousands of possible configurations.[36]

And again:

"[It is] a little like working with a series of chords [in jazz], you just keep discovering all the things you can do."

Nonetheless, as with all such aleatory methods, jazz included, the rate of success—as judged by the artist, anyway—is small. "Sometimes something happens," he says of his method, "and mostly it doesn't."[37] By his own estimation, Meadmore keeps only one in one hundred finished models.

As the history of Minimalism shows, Meadmore was hardly the only artist of his day to base his sculpture on modular elements. Nor, of course, was he the first artist to make use of chance. However, he is unusual in that both methods coexist in his art and indeed are interdependent. Yet here again, Meadmore diverges in several important respects from the Minimalist use of modules and serial composition. He makes adjustments to his evolving forms even when this means violating the logic of modular organization.

◁ **DOGGIN' AROUND** 1977
Bronze
11″×8″×2″
Private collection

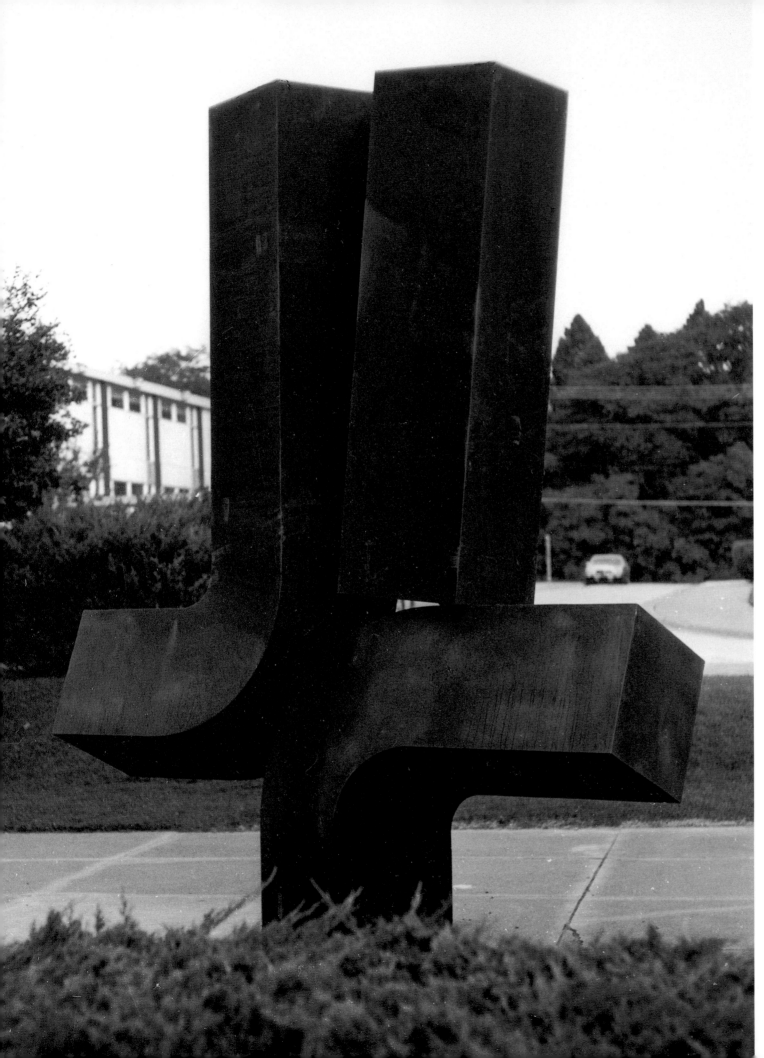

SOPHISTICATED LADY 1977
Steel
15′×12′×3′
Davenport Municipal Art Gallery, Iowa

A nascent sculpture is often extended or shortened by an amount unrelated to the cubic module, a practice that can appear inconsistent or arbitrary. Such breaches of logic were alien to Minimalist doctrine, as were the aesthetic considerations that might precipitate them. Perhaps most important, Meadmore's modules do not just form the sculpture but function as a kind of invisible armature for it. Although Meadmore uses modules, he is not interested in serial composition per se, as were the Minimalists. Rather, his modules are subordinated to the larger whole that they form.

Meadmore's use of modular forms—his use of geometry in general—differs in one further, all-important respect from that of his contemporaries. He does not use geometry to express geometry. Meadmore was not attracted to geometry because of its potential for expressing universals or essences, as were artists like

SLIDE 1977
Aluminum, painted black
97″ × 66″ × 15″
Private collection

Mondrian or Malevich. Nor is it for him, as it was for the Minimalists, a vehicle of absolutes or a mode of purely rational artistic thought. Instead, he views it as a plastic entity, to be shaped into an expressive form much like clay, plaster, wood, or any other sculptural medium. Meadmore himself put it in similar terms. "I feel that clay [modeling] and wood [carving] have become expressively exhausted, whereas the expressive possibilities of geometric forms are only beginning to be explored."[38] The point, then, is not to assert or express geometry, to state it as a value, but to go beyond it or, to use a term favored by Meadmore himself, to "transcend geometry." In other words, to use it as a springboard, a language or a grammar through which to express other ideas.

Meadmore goes about this process of "transcending geometry" in a number of ways. One is to avoid making a form that can be

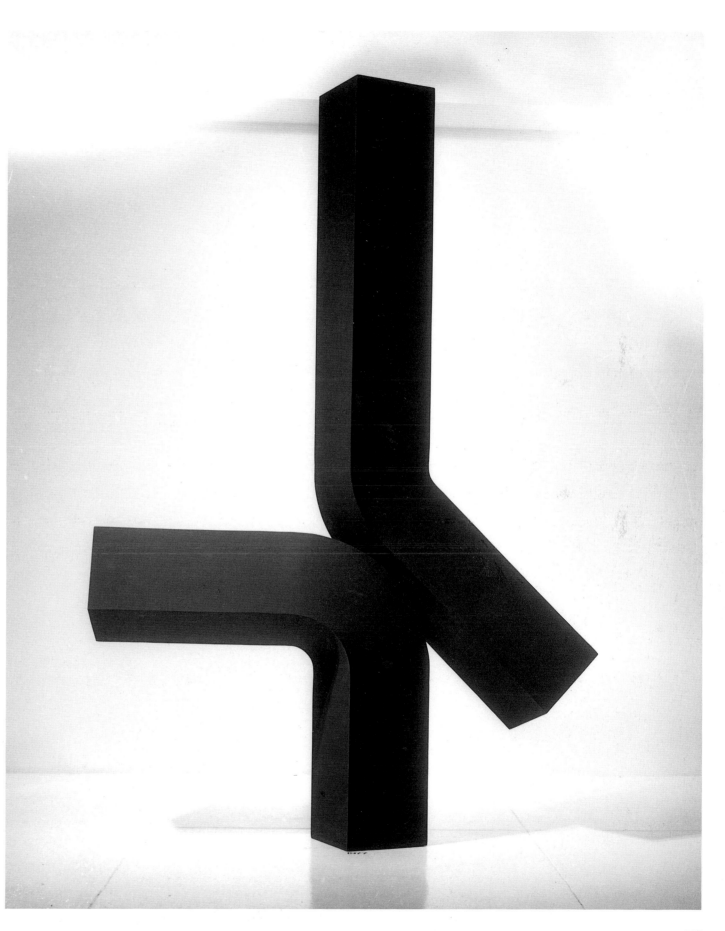

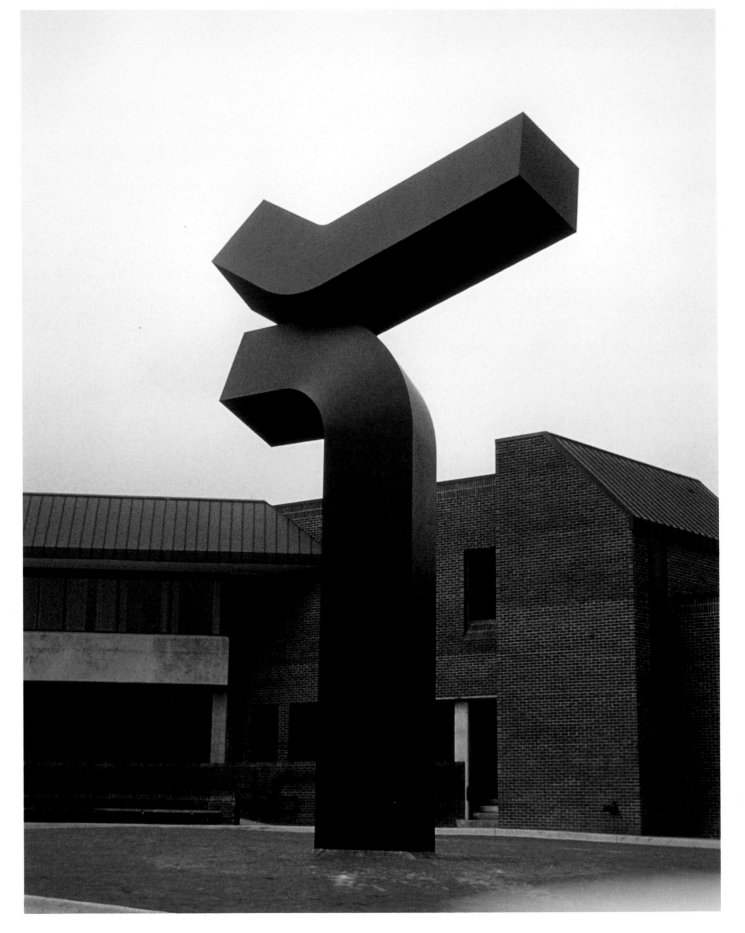

RIDING HIGH 1977
Aluminum, painted black
30′×17′6″×5′
Gallaudet College, Washington, D.C.

easily inscribed within the outline of an imaginary "pure" volume, such as a sphere or a cube. This was a limitation of the Q-like sculpture on the contact sheet, and of *Split Ring,* which in Meadmore's view suffered from the added limitation that its apparent focus on the near-touching of its two ends infected it with what he calls a "mathematician's cleverness."[39] It also means not creating forms whose movement describes a two- or three-dimensional grid, as the double-J sculpture in the contact sheet does the latter, and *Switchback* to a lesser extent the former. Finally, there is the matter of the eye. Meadmore adjusts shape, balance, length, extension of curvature, even turns the completed model over in his hand until he finds a point in which it both balances itself and exhibits the requisite vitality from all angles, all to ensure that geometry is sculpturally alive rather than aesthetically petrified.

In all these ways, Meadmore attempts to overcome geometry's qualities of stasis, containment, rigor, and sobriety. Yet there is no formula for doing so; success is earned with each work. It depends as much as anything on a careful orchestration of the energies Meadmore seeks to impart to his still forms. In some sculptures, such as *Branching Out* and *Switchback,* he narrowly misses. In the former it is because the multiple thrusts and counterthrusts are in conflict rather than in harmony, in the latter because they are too well ordered. As a result, both works lack vigor and are thus uncharacteristically timid.

In a catalogue essay for one of Meadmore's exhibitions in the early 1970s, the English critic Bryan Robertson eloquently described the effect of Meadmore's efforts at "transcending geometry":

It is a measure of the "forceful" impact of Meadmore's sculpture that his own selected grid or module is continually persuaded, through sheer imaginative pressure, to disclose sculptural forms that deny their origin within the logic of his module-as-point-of-departure. In do-

UP AND AWAY 1977
Steel
21′ × 20′ × 20′
Pittsburgh National Bank

ing so, a generalized sculptural form becomes a specific sculpture, with its own identity. . . .

The mystery . . . is in the way Meadmore imaginatively extends the "sculptural form" far beyond any circumscribed area of design into the multi-dimensional freedom of composition, so that the resultant sculpture does so much more than its origins could ever suggest.[40]

Robertson could well have been describing *Upstart I* and *Upstart II,* both of which begin with an almost pure cube form which, over the rising length of the sculpture, is transfigured into pure linear energy.

If Meadmore's aim in transcending geometry is to express "other ideas," what are they? Or, to put it another way, what is it that destines one model for the fabricator while dooming the remaining ninety-nine to oblivion?

What Meadmore calls "transcending geometry" is really the precondition of a larger aim, which is to impart a spiritual dimension to his

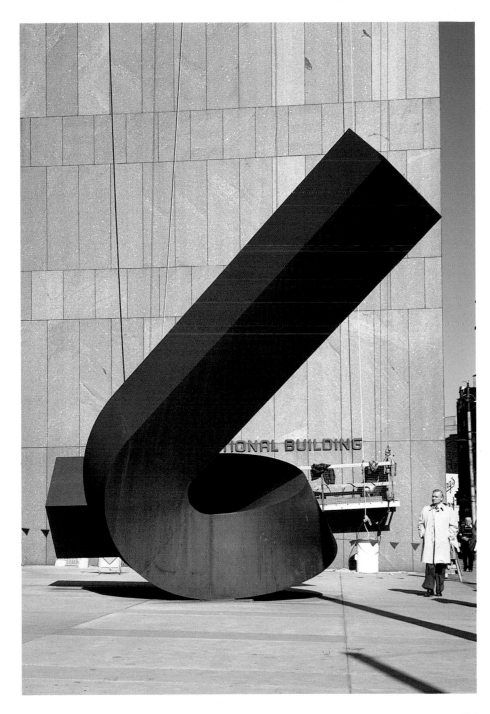

LEVER 1977
Steel
67″×52″×15½″
Private collection

sculpture, or a feeling that he sometimes calls "intensity." The latter is perhaps a better word, since the term *spirituality* in connection with modern art, particularly in recent years, has become so freighted with meanings that it is likely to be more confusing than helpful. The term is usually taken to mean the cluster of inchoate and often hazily formed aims and aspirations, often based on nineteenth-century occult doctrine, of artists ranging from Wassily Kandinsky to Mark Rothko who saw the work of art as a springboard to a higher metaphysical reality.

Meadmore agrees with the substance of the transcendental idea in modern art. "In all the arts (even music) we have a spiritual being (artist) dealing with physical materials or physical phenomena in order to convey a spiritual message," he says.[41] But he has something more down-to-earth in mind when it comes to expressing it in his own work. "I'm not interested in metaphors of infinity or anything else," he has said. "I have to start with a real object, a thing."[42]

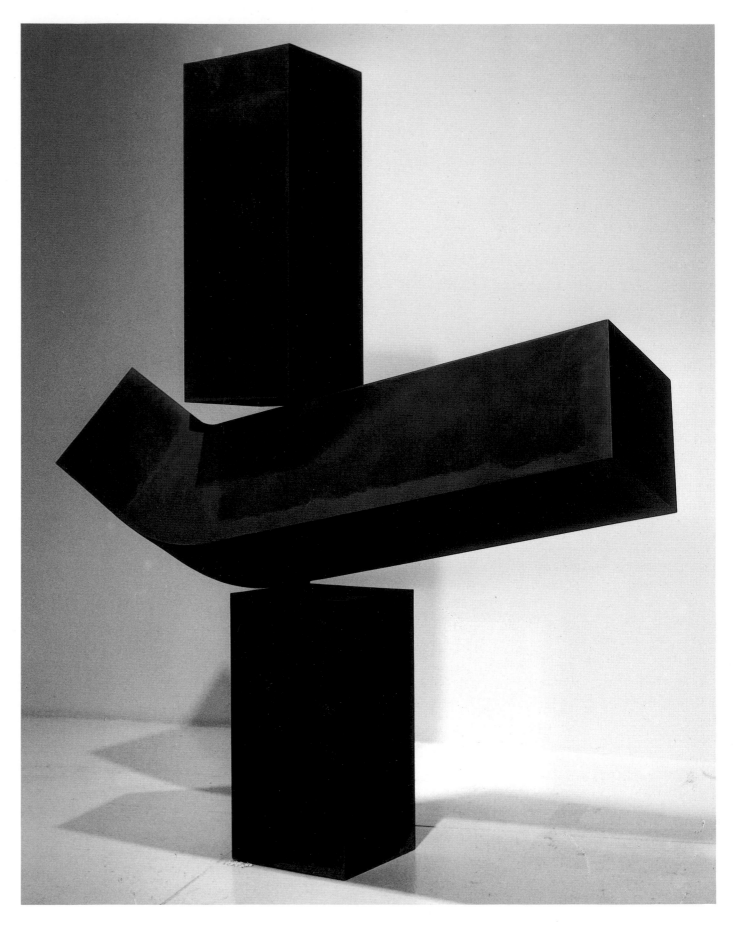

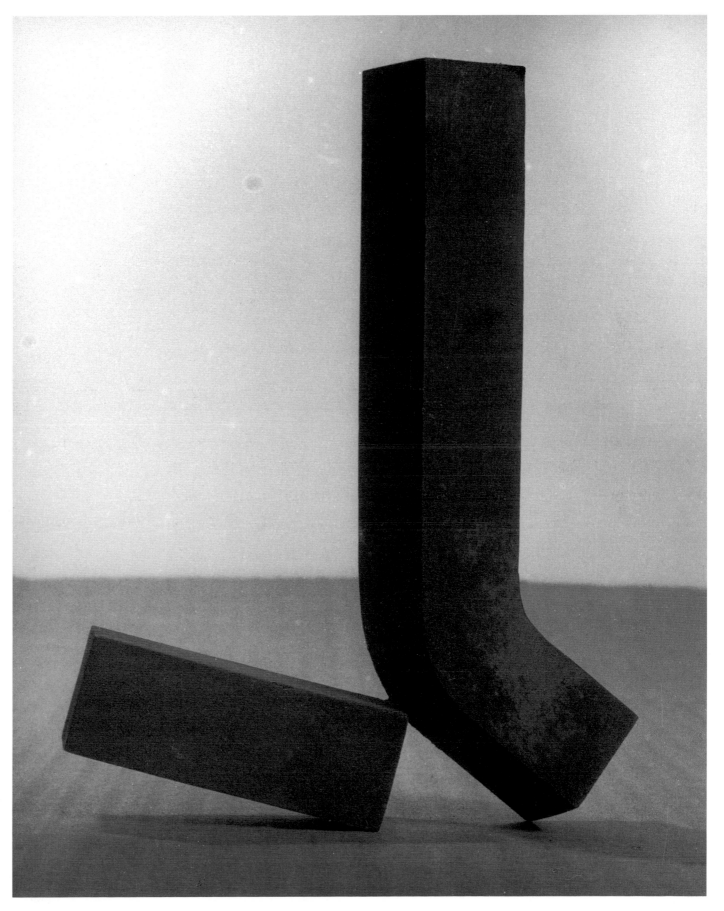

TOPSY 1977
Polyester maquette
5¼″ × 4¼″ × 1¼″
Collection of the artist

This observation is the statement of a point of view that separates Meadmore's approach to the subject of the spiritual from those of most other modern artists. Summed up in notes for a projected book on modern sculpture, it calls for "imbuing the physical with the intensity of the spiritual." He continues:

When we think of the spiritual in art we tend to think in terms of wispyness and vagueness, but one could also think in terms of spirit ordering matter, in which case the physical would be very much in evidence and demonstrating a spiritual order or an intensity beyond that which one would expect from the physical forms in question.[43]

Two ideas emerge from this statement. One, expressed in the words "spirit ordering matter," is the central, catalytic, interconnected role of the artist in bringing about this spiritual reality in art, something he does by giving birth to an object that did not previously exist through his action upon his materials but also by imparting something of himself in the process. "Art embodies the unique creativity of the artist; a sort of personal intensity," Meadmore wrote in the same set of notes. "In

a sense the artist creates a self-contained world in each piece and his oeuvre shows many aspects or phases of this personal world."[44] The other idea is indicated by his observation of "the physical [being] very much in evidence." The looming, robust physicality and power of Meadmore's work, its extroverted and animated character hardly accord with the mood of inwardness, contemplativeness, and quietude one associates with the word *spiritual*.

And, in a way, that is the point. Meadmore has spoken of his view of sculpture as people inhabiting space,[45] and the analogy tells us much about Meadmore's concept of the spiritual in art: a real, concrete thing that is nonetheless more than the sum of its parts, an object possessed of an intangible élan. Spirituality for Meadmore, therefore, is a quality of idealized presence that results from a successful interaction between the artist and his forms, rather than from a particular iconography conceived with a specific philosophical outlook in mind, as is the case with artists such as Mondrian or Rothko.

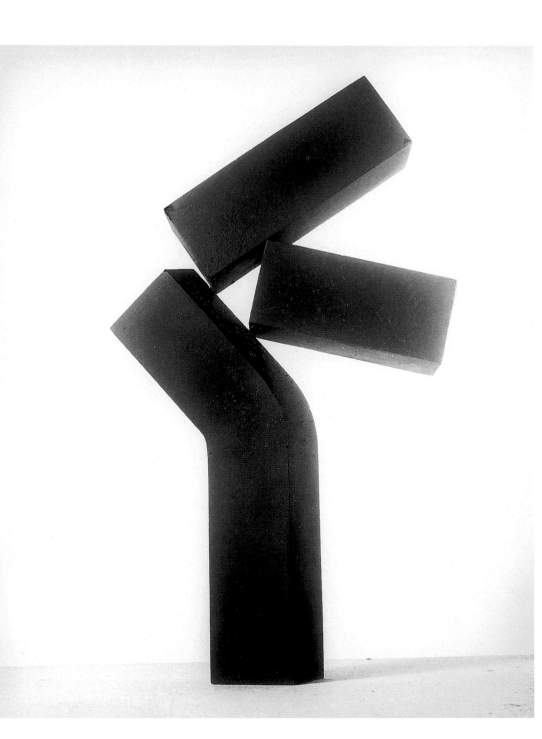

WEATHER BIRD 1977
Bronze
11″ × 6″ × 2″
Private collection

9

Inspired by the example of David Smith's *Cubi* sculptures, in the late 1970s Meadmore made a series of pieces in which the single form is exchanged for multiple parts, still square-section volumes, arranged in dynamic relationships. These sculptures usually consist of three elements: some perfectly straight; others bent at ninety degrees; the rest bent at forty-five degrees. Nowhere among them are the curling, curving, or coiled forms of previous years.

The angled volumes recall the seminal *Bent Column* of 1966 in that they are bent in only one place. Indeed, it is as if Meadmore's intervening sculpture had not existed, and that he had drawn an entirely different conclusion from *Bent Column*. It is as if, instead of seeing in it a module for a series of single-form works, he had decided to use the form of *Bent Column* itself as the basic unit in multiple-part sculptures.

The sculptures in question take one of three main forms: vertical, such as *Three Up, All of Me,* and *Cross Current;* horizontal, such as *Flippant Flurry;* or a hybrid in which upright elements are arranged in horizontal rows, such as *The Saints, Truckin',* and *These Foolish Things.*

A different sort of action informs this work. After expressing sensations of compression and release of tension in the earlier pieces, Meadmore now dramatically slows the pace. Instead of individual action, he expresses collective motion, that of acrobats tumbling, ballerinas in slow motion, marchers marching, or some other form of ritualized, yet dynamic, action. This gives these sculptures a different mood from those that preceded them. They are less intense, more playful, and range in feeling from the insouciance of *The Saints* to the grave elegance of *Three Up.* The calligraphic quality of the earlier work remains, but now the concentrated energy of Western expressionism has been exchanged for something closer to the deliberateness of Eastern brush painting.

This new series marks a significant departure for Meadmore in that he appears to be challenging many of the premises of his previous work. Most obviously, these sculptures represent a return to the multipart, relational sculptures he had abandoned in the mid-1960s for single-form sculpture, but with the difference that now the elements exist in a looser, more active relationship to one another than previously. From this, another change becomes apparent, a return to the Cubist-derived method of composition against which the Minimalists had reacted when they chose to place elementary volumes in isolation or in rows. In fact, Meadmore's new sculptures present us with yet another paradox, enclosed volumes arranged according to a Cubist-Constructivist syntax.

Perhaps because of the need to impose some kind of unity or order on his elements—however much he may have wanted them to express continuous, spontaneous motion—geometry is more apparent here, in the form of hints of a vertical-horizontal grid with which the elements or individual parts of the sculptures align themselves.

85

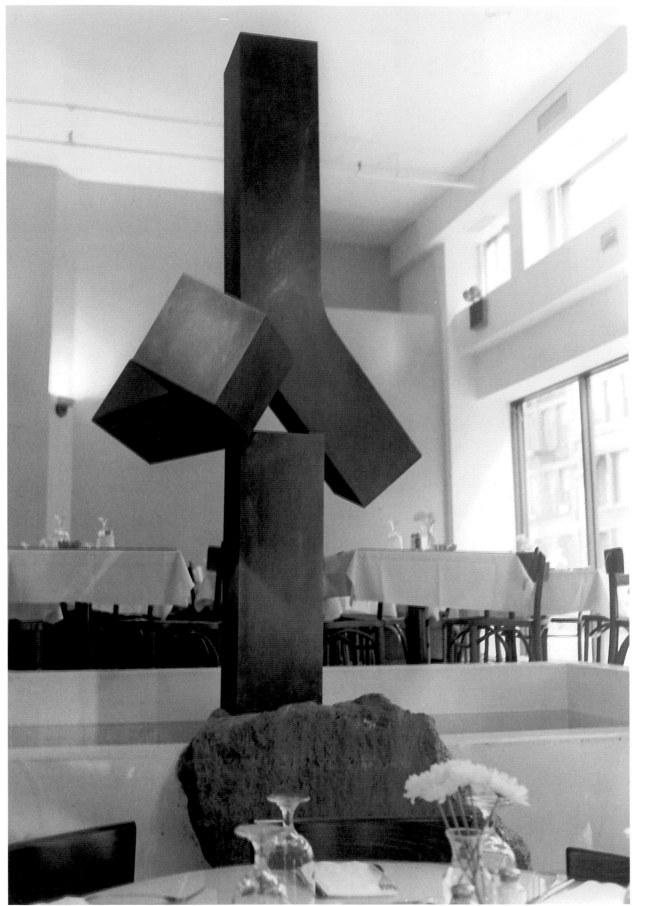

THREE UP 1977
Steel
8′×4′2″×3′9″
Caramba! Restaurant, New York

ALL OF ME 1977 ▷
Steel
8′×6′8″×1′5″
Heidelberg Distributing Company,
Cincinnati

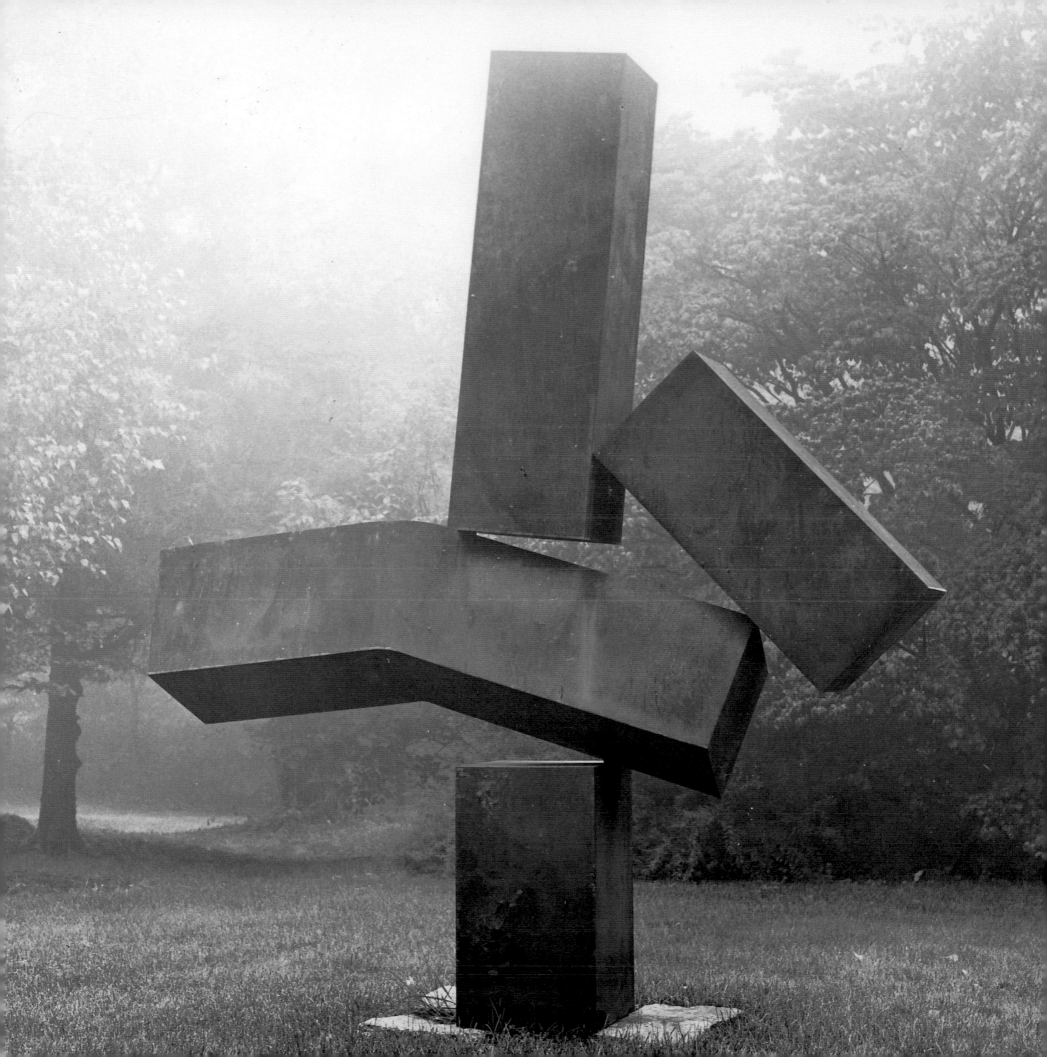

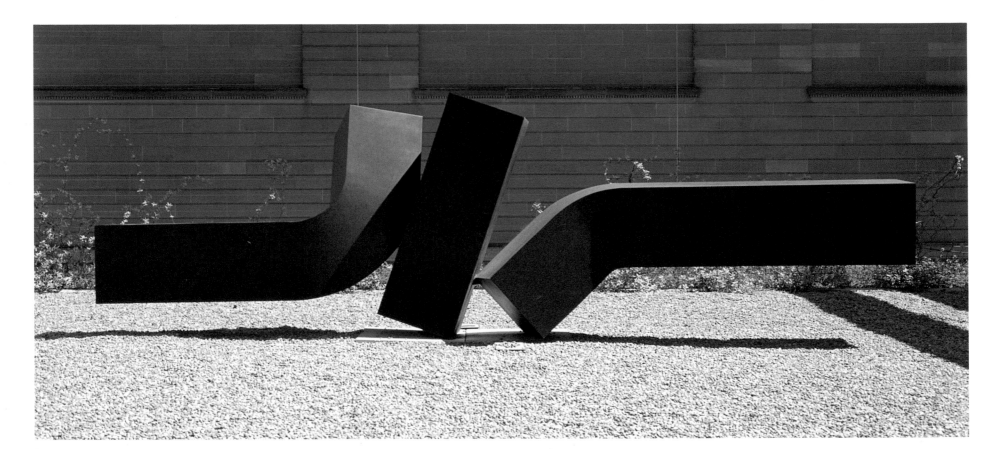

In this they recall Meadmore's earliest sculptures, the Lassaw-like reliefs he made in Australia. Yet in these latest works Meadmore is anything but "religious about horizontals and verticals" as he had been in those earlier days when he was strongly under Mondrian's influence. Rather, the grid exists as a shadowy presence, a passive rather than an active element

in the design. The emphasis in these sculptures is on the free interplay of parts, not on structure.

And to this end, Meadmore introduces a degree of illusionism. In this group of sculptures Meadmore uses the welder's torch to position his elements to suggest forms operating free of the constraints of gravity. This effect is a function of a new working method

where, in a manner reminiscent of David Smith, Meadmore lays the parts out flat on a work surface instead of moving them in space using his hands. Once again, he is achieving a three-dimensional result from a two-dimensional method.

No doubt because of this different approach, these sculptures are more "transparent"—more spread

FLIPPANT FLURRY 1978
Steel
6'10" × 23' × 5'
Art Gallery of New South Wales, Sydney, Australia

FLIPPANT FLURRY 1978 ▷
Steel
6'10" × 23' × 5'
Sterling Winthrop Inc., Collegeville, Pennsylvania

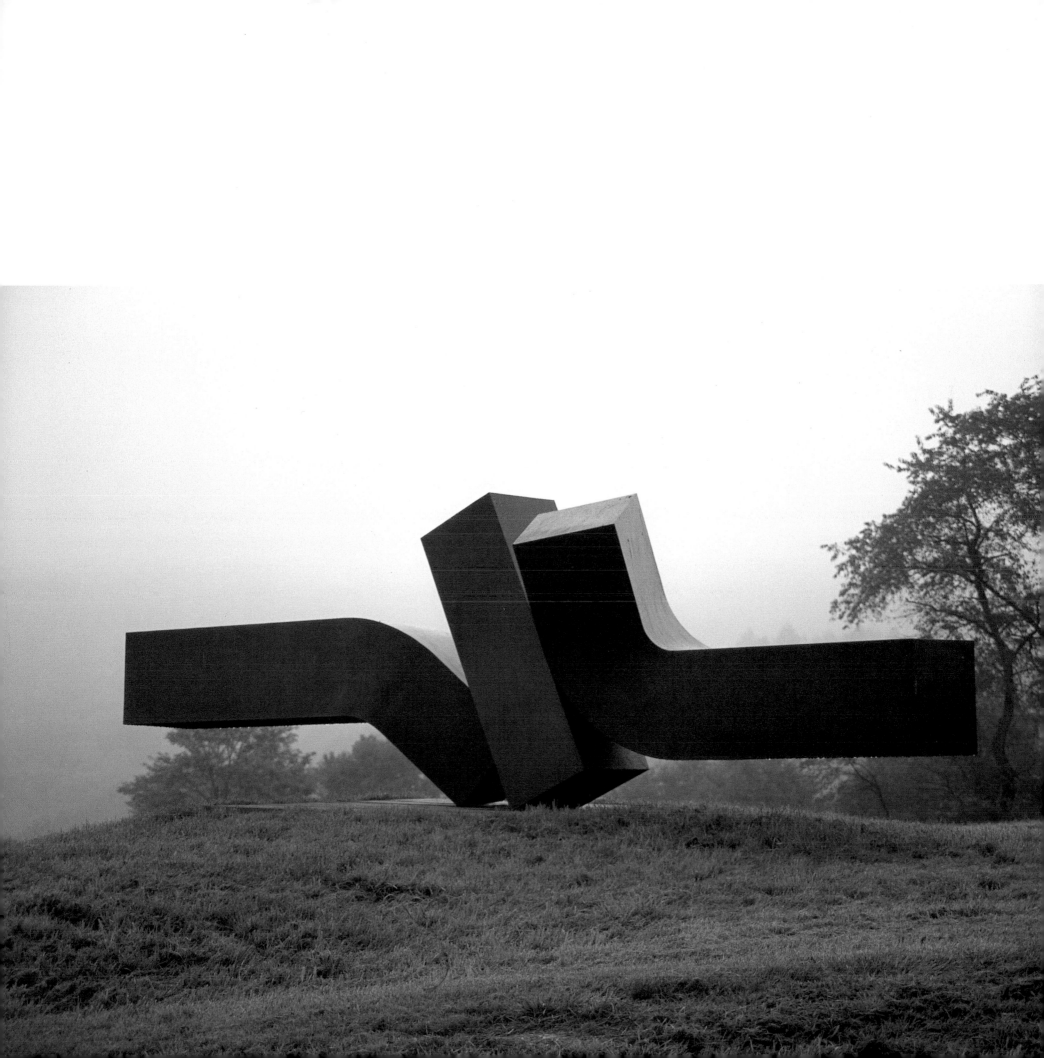

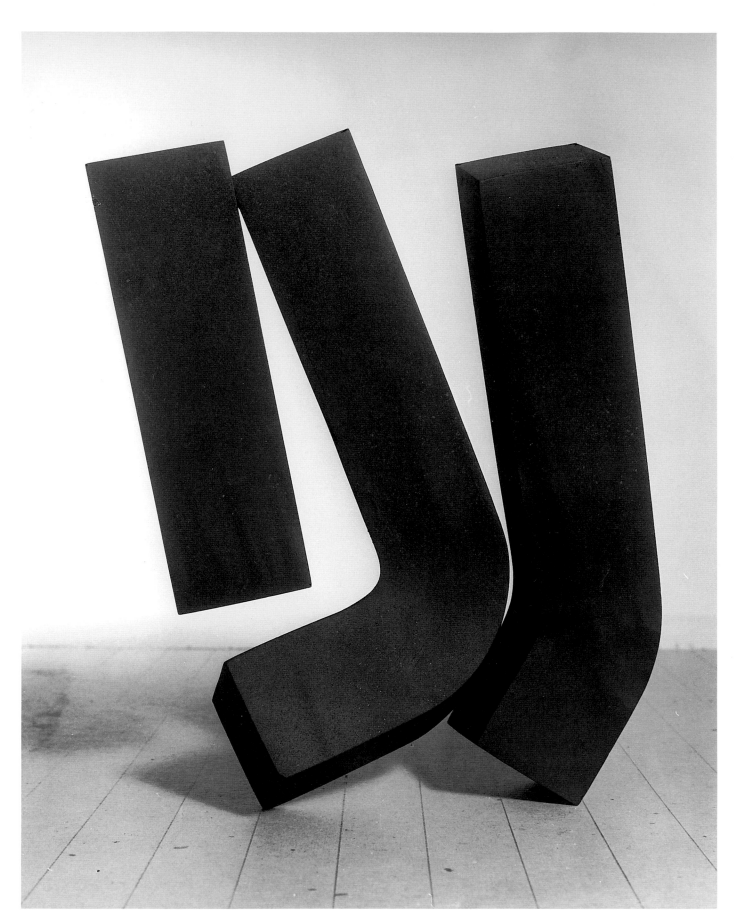

THE SAINTS 1978
Bronze
8″ × 6½″ × 3″
Ellen C. Goldberg, New York

**Six-foot model for six-hundred-foot
skyscraper sculpture** 1978
Wood, painted black
6′ × 15″ × 15″
Collection of the artist

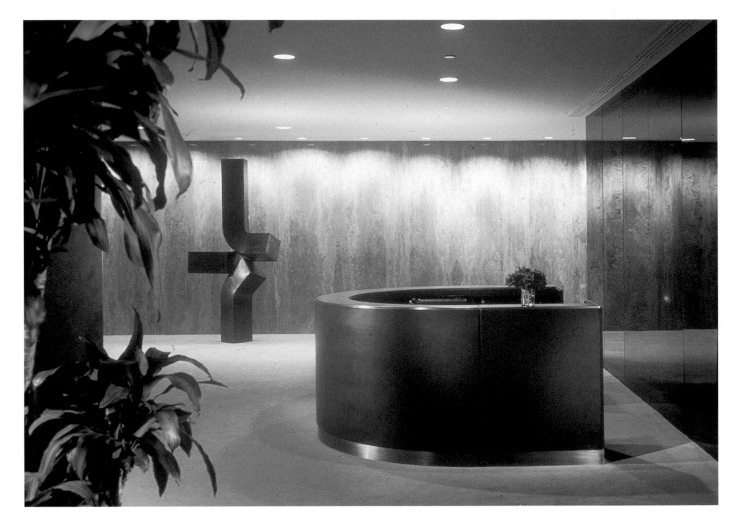

CROSS CURRENT 1977
Bronze
8′ × 4′ × 1′2″
Smith Kline Corporation, Philadelphia

TRUCKIN' 1978 ▷
Bronze
6½″ × 7½″ × 2″
Collection of the artist

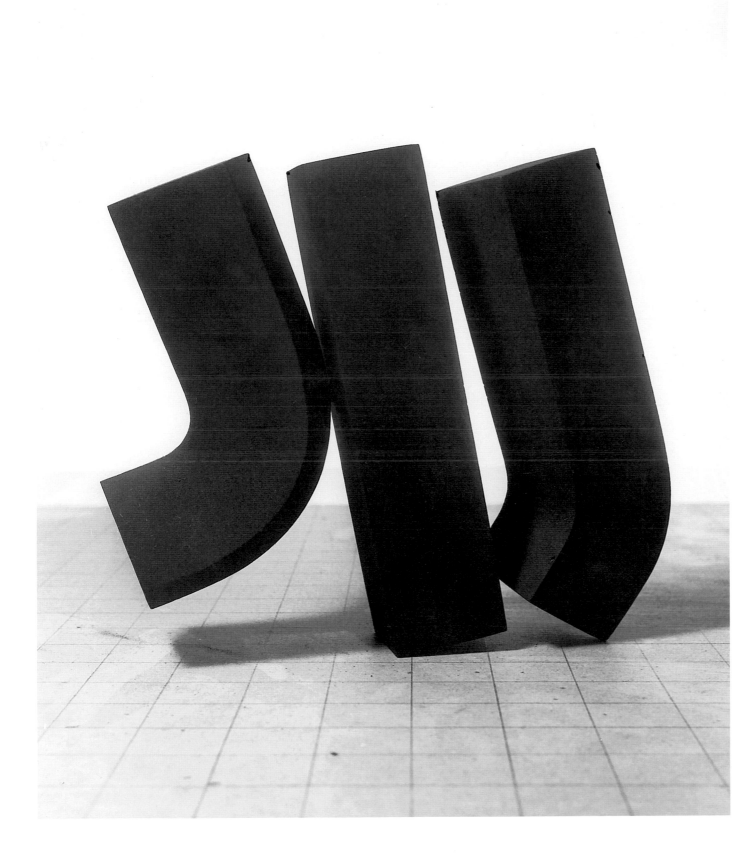

out and attenuated—than the compressed, serpentine, unitary pieces. They read primarily two-dimensionally, from one viewpoint. However, in terms of address, we are not back to those early sculptures photographed on the contact sheet. They are, in other words, not strictly two-dimensional. The three-quarter torsion of the elements ensures that they occupy space, however shallowly. In addition, their thrustings into space and their apparent weightlessness enliven them. Finally, there is Meadmore's creative use of the voids. Interior space—to the extent that one can speak of such a thing in sculpture that has no definable "inside" or "outside"—becomes as important an aesthetic factor as form itself. In this series of sculptures, as in his others, then, Meadmore still manages to "transcend geometry."

Since the early 1980s, Meadmore has again shifted gears, now producing sculptures in which characteristics of single- and multiple-form are fused. These are, in fact, single-form sculptures, but not of the linear kind. Instead, modules similar to those used in the multiple-part works have been

93

THESE FOOLISH THINGS 1978
Bronze
7½″ × 11″ × 2″
Collection of the artist

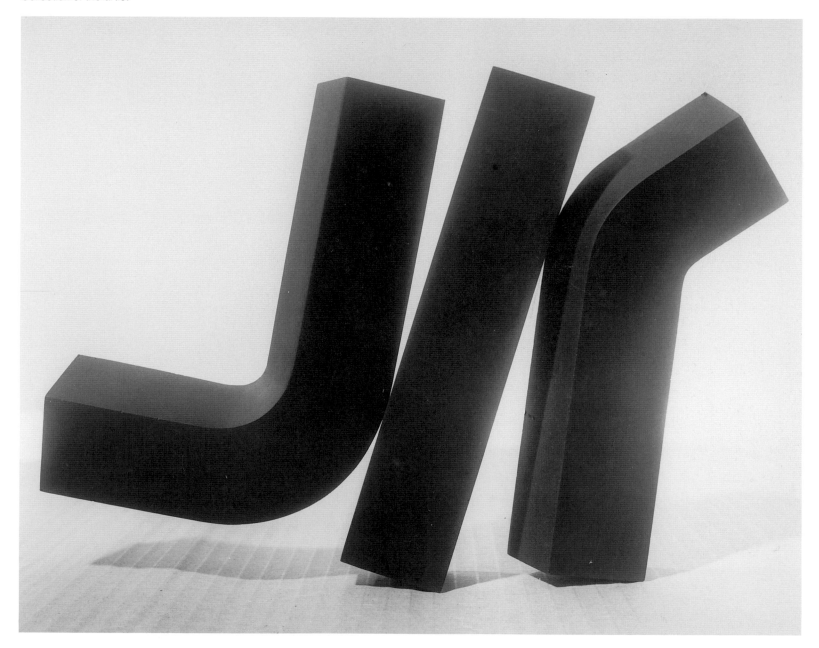

UNDECIDED 1979
Aluminum, painted black
84″ × 90″ × 19″
Private collection

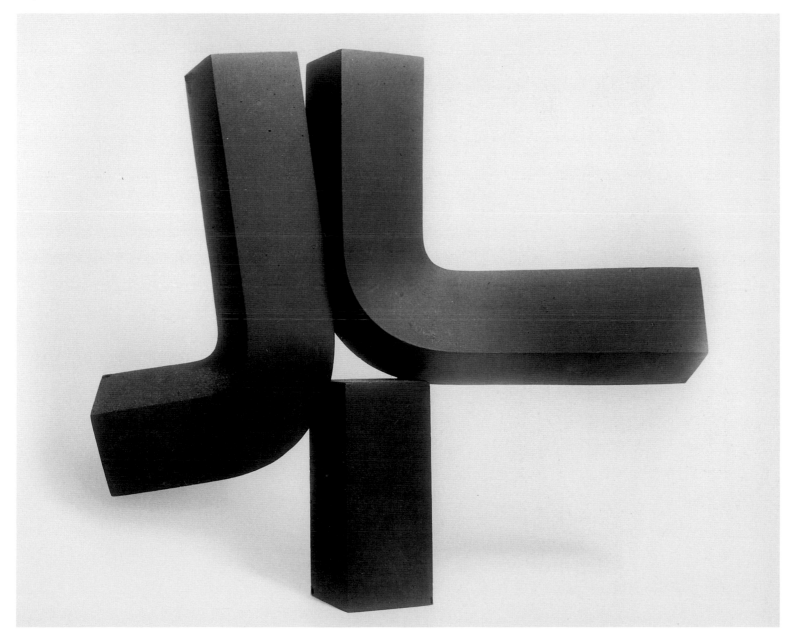

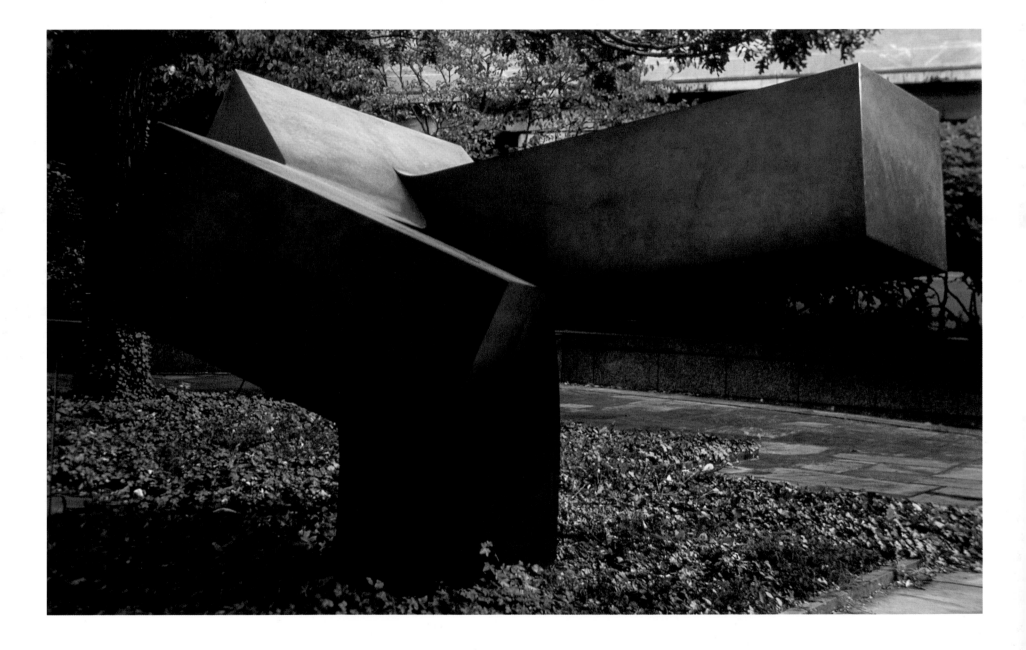

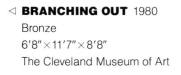 **BRANCHING OUT** 1980
Bronze
6′8″×11′7″×8′8″
The Cleveland Museum of Art

SWITCHBACK 1980
Bronze
27″×15″×9″
Libby-Owens-Ford, Toledo, Ohio

combined—aligned along their
lengths, really—to form what
looks like a single slab from which
individual elements radiate and
bend.

Some, such as *Branching Out,
Switchback, Upcast,* and *Cre-
scendo,* suggest matchbooks
whose contents have been
splayed this way and that. How-
ever, it quickly becomes apparent
that unlike such an object, if all
the bends and curves were to be
flattened out, Meadmore's sculp-
tures would not resolve them-
selves into a single plane. Others,
such as *Touchdown* and *Tip Toe,*
are more individual in character.

One immediate problem Mead-
more faced in choosing such a
course was the potential loss of
dynamics in the shift from a mode
of sculpture that was primarily lin-
ear to one featuring broad and

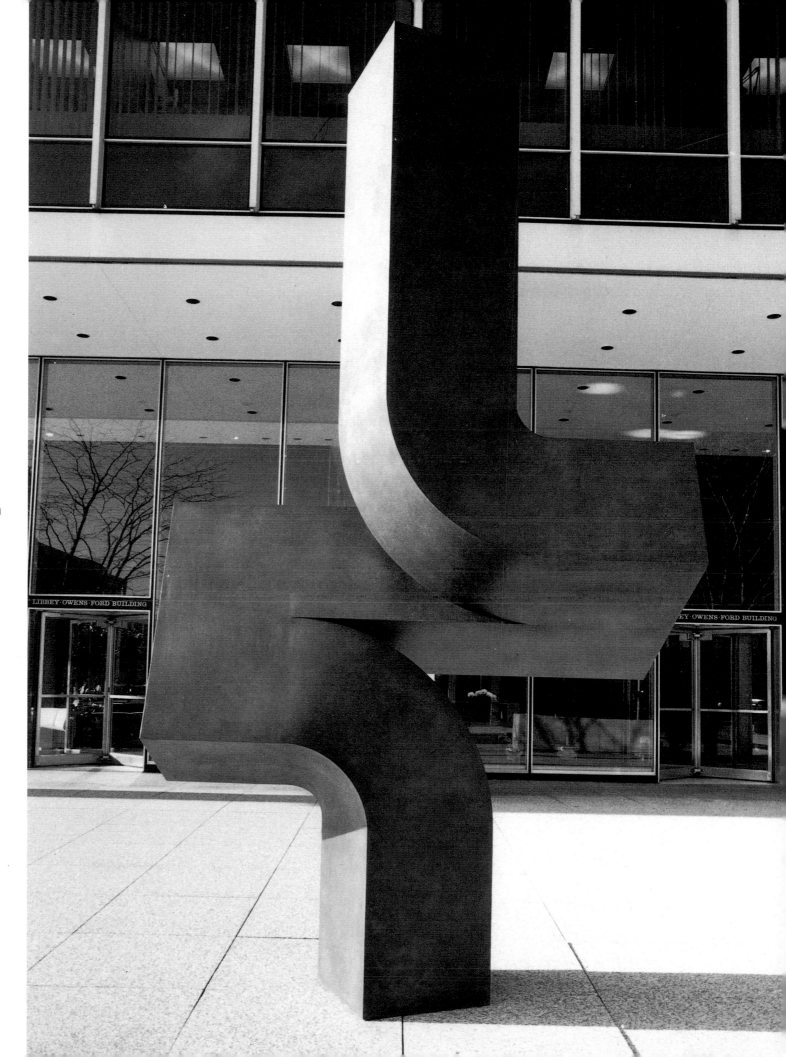

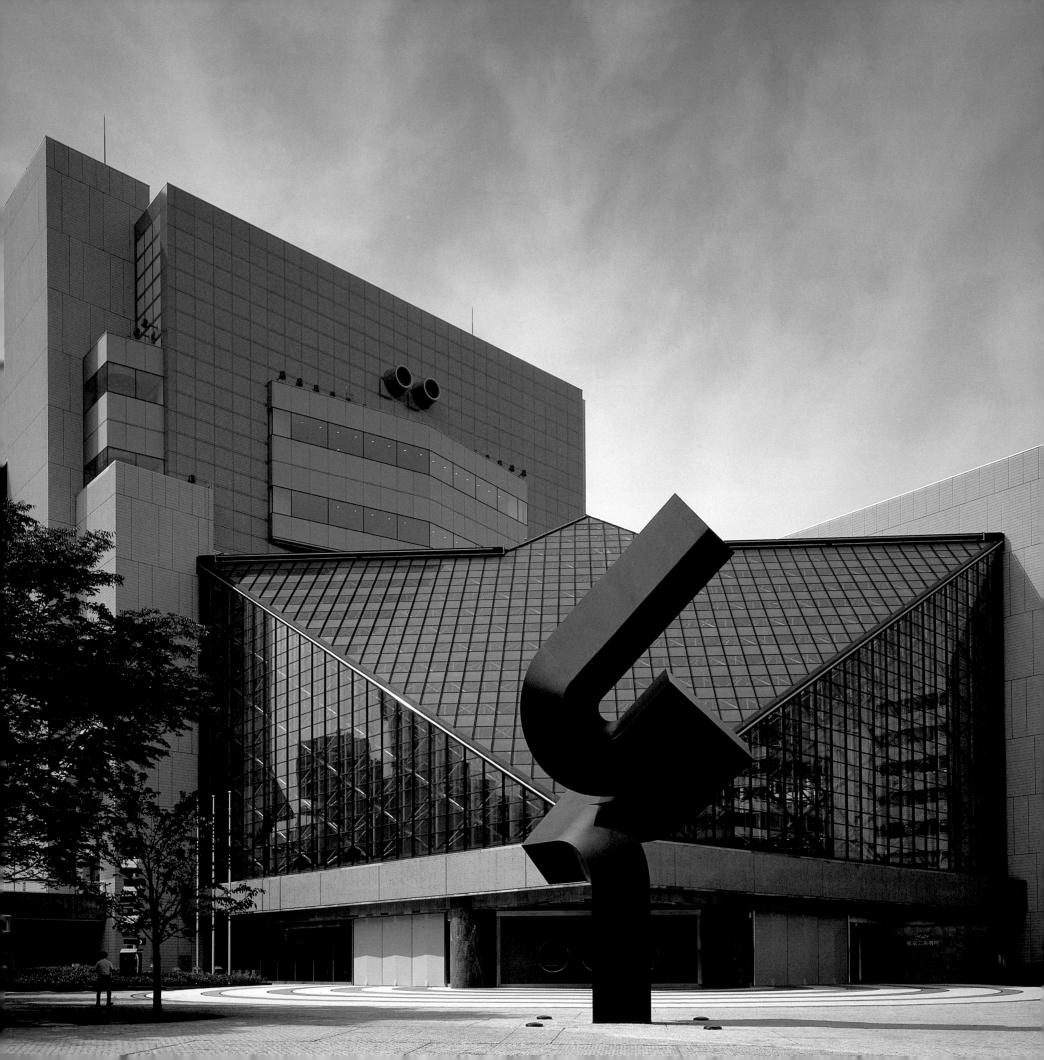

CRESCENDO 1989
Aluminum, painted black
38′ × 18′ × 3′
Metropolitan Art Space, Tokyo

TIPTOE 1988
Bronze
23″ × 28″ × 22″
The Fusion Group, Fort Lauderdale, Florida

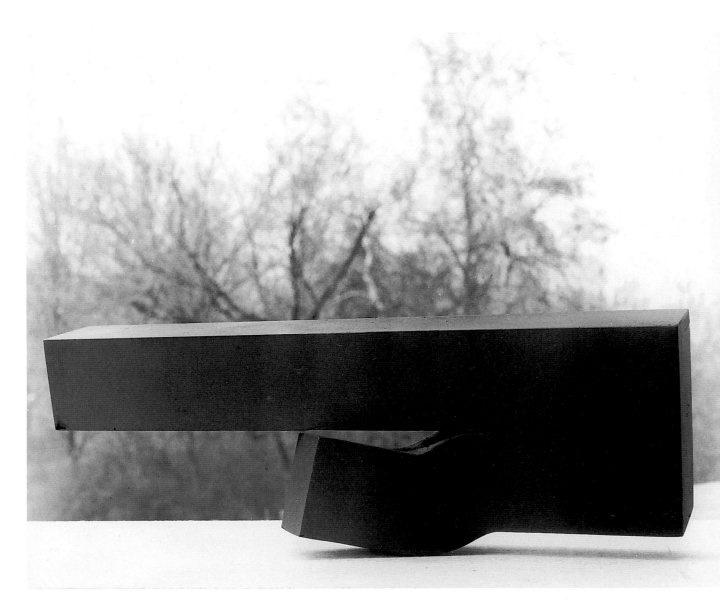

TOUCHDOWN 1984
Polyester maquette
3½″ × 11″ × 2½″
Collection of the artist

potentially inert planes. Lines are the emblems of motion, planes the emblems of rest. The problem facing Meadmore here was how to impart to the latter the energy of the former.

Another risk was the temptation to solve this first problem by making the sculpture overly active. This is the main drawback of *Open End,* which has so much going on as to be at war with itself. Coherence is the price paid for abundant sculptural action in this work.

In spite of the fact that Meadmore achieves some impressive effects with the cantilevered C form at one end, this very characteristic— forces working against each other in a single form—can also be a source of strength in the best of these sculptures, introducing a new kind of energy in Meadmore's work. Besides the gestural and musical energies mentioned above that animate Meadmore's sculpture, there is their ability to express physical energy, the feeling of the human body in motion. Most often the association is of the body straining against itself, as in a bronze ballerina by Degas. This quality is apparent throughout

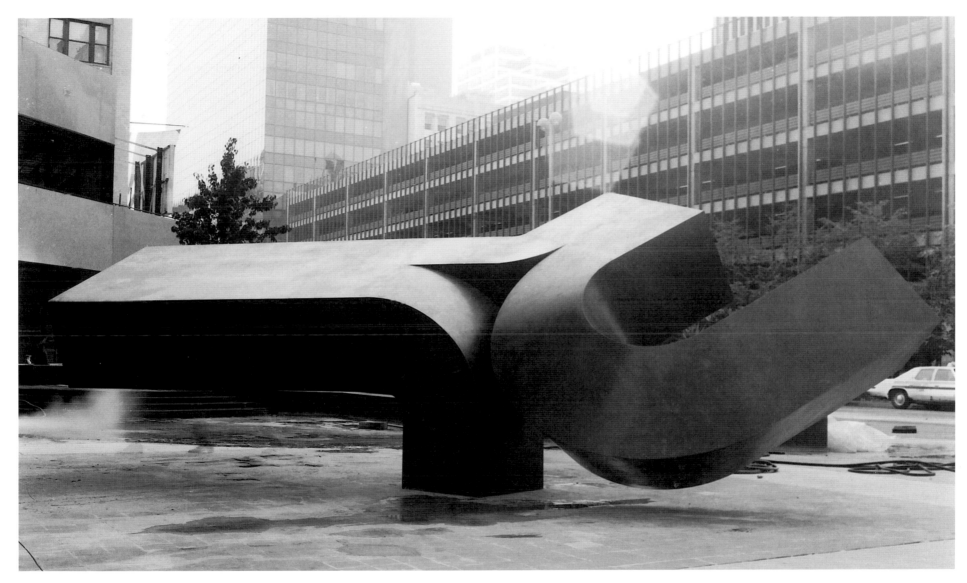

OPEN END 1983
Bronze
10′ × 26′ × 11′3″
Linclay Corporation, Cincinnati

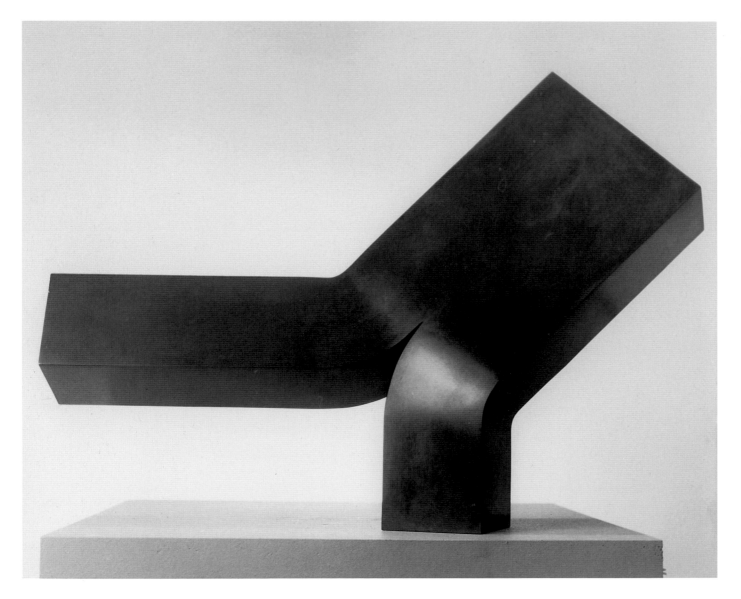

NIDOR 1980
Bronze
18″×27″×6½″
Dr. Theodore J. Edlich, Jr., New York

LOWDOWN 1983 ▷
Bronze
19″×31″×27″
Robert Thomas, Fort Lauderdale, Florida

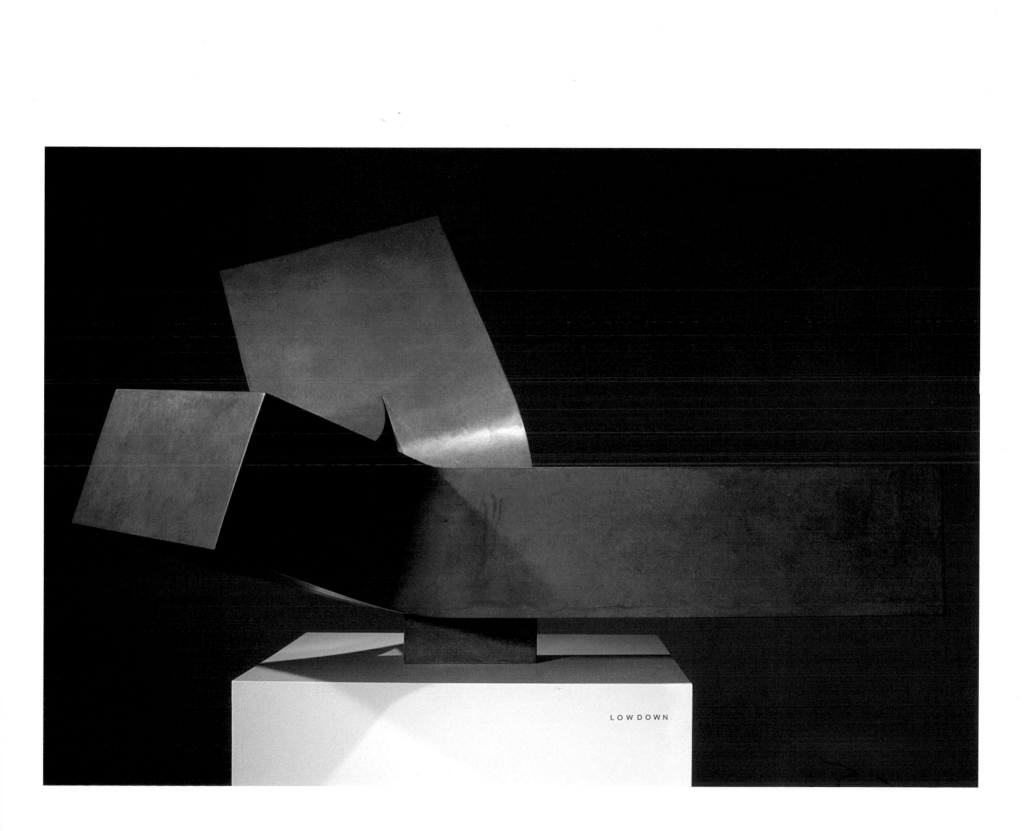

LOWDOWN

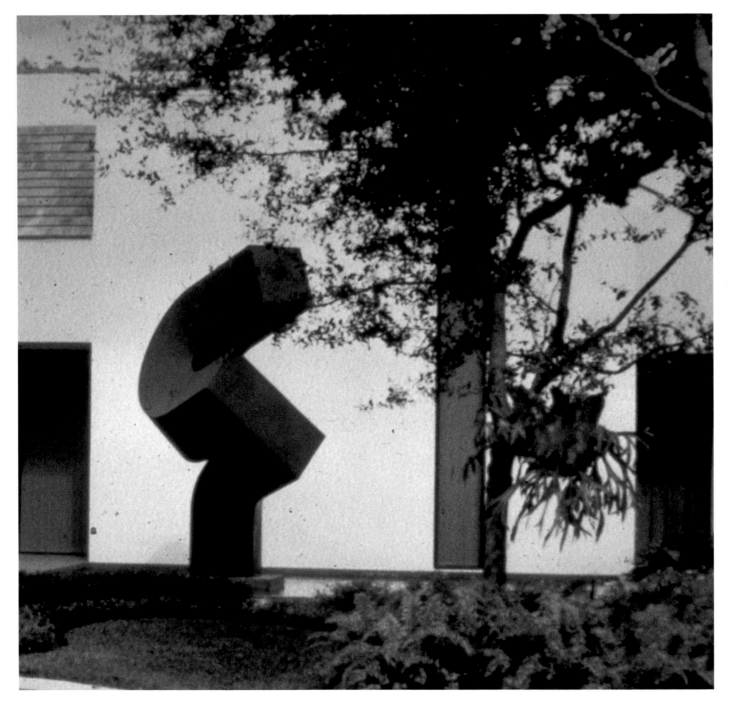

UPSWING 1980
Bronze
15′×9′3″×5′10″
Mr. & Mrs. Leonard Luria, Miami, Florida

SOLITUDE 1980 ▷
Bronze
17″×34″×9″
Private collection

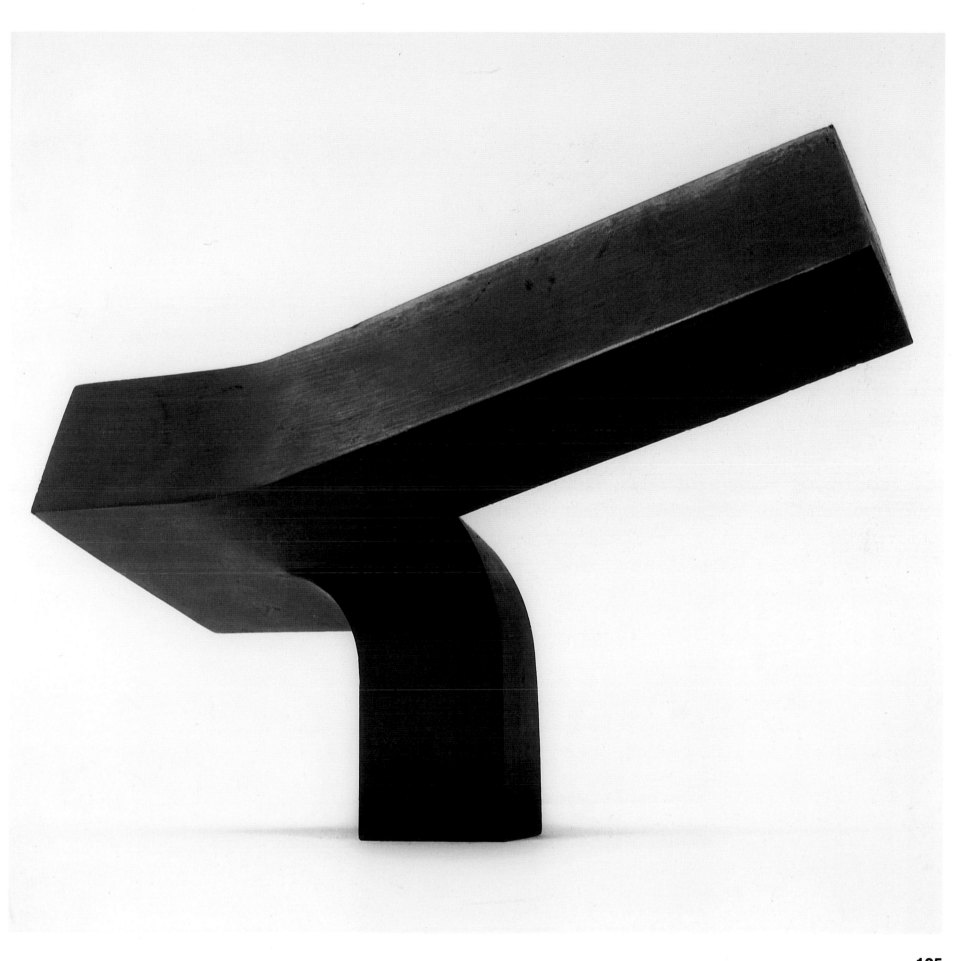

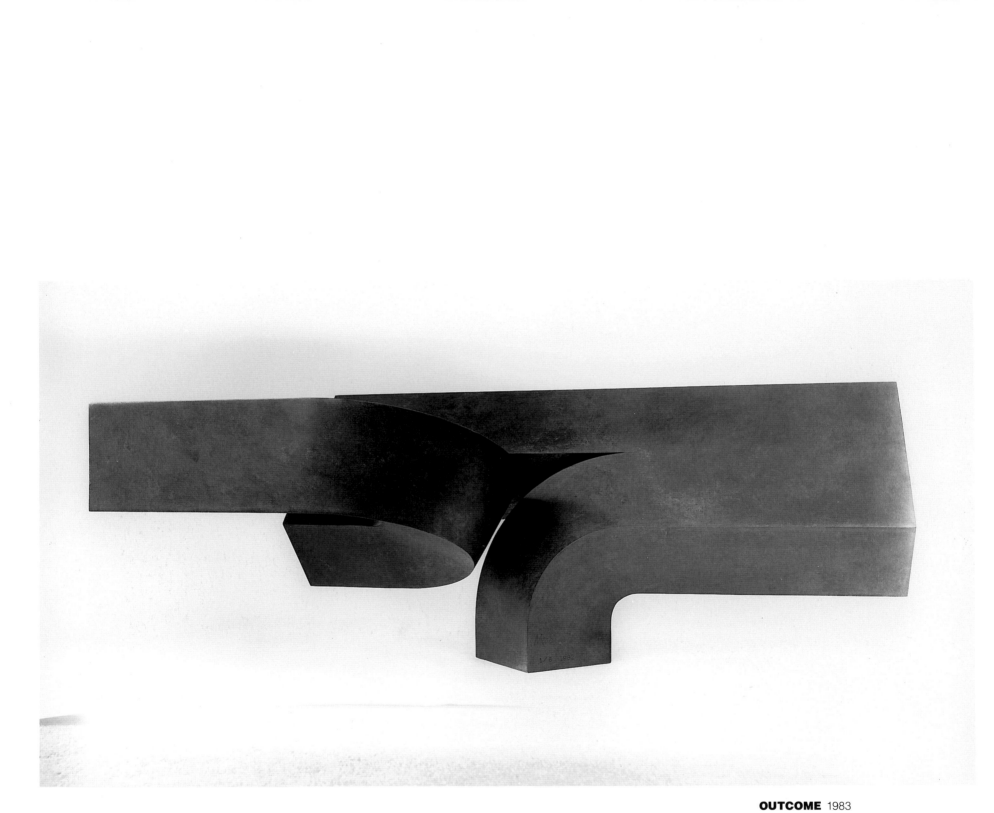

OUTCOME 1983
Bronze
14″×37″×18″
Private collection

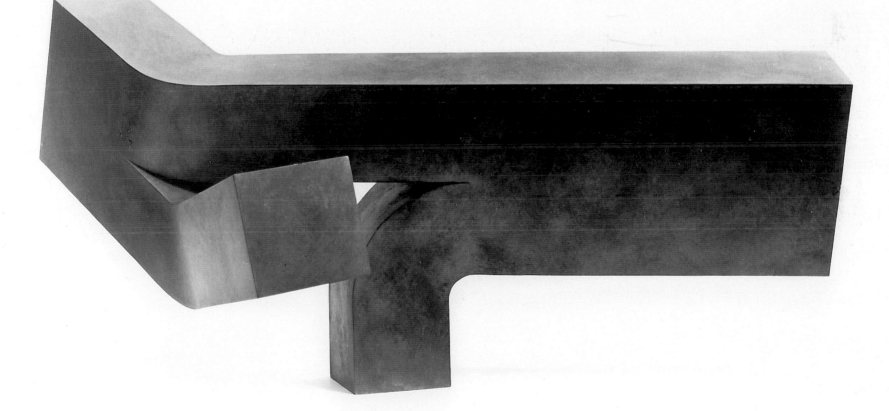

HEREWITH 1983
Bronze
21″×42″×21″
Private collection

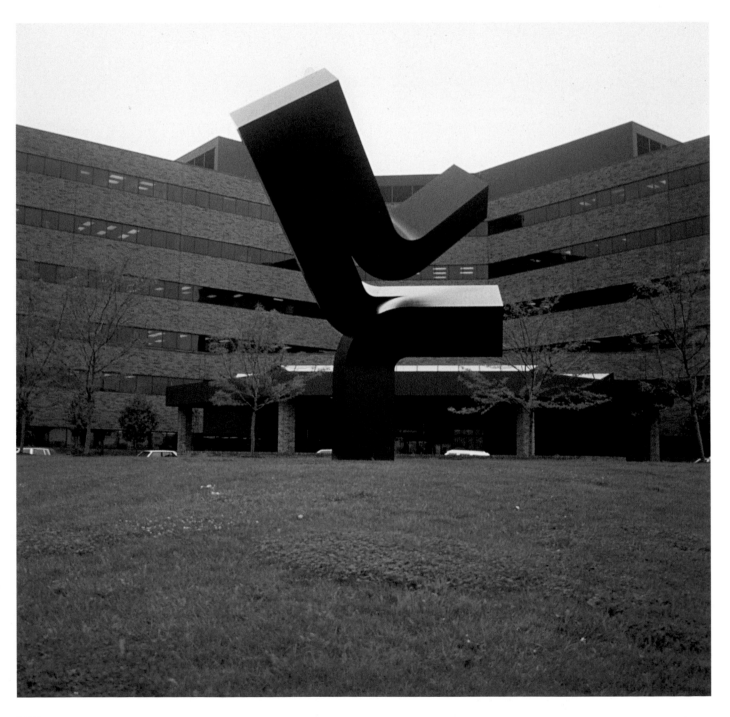

UPCAST 1985
Aluminum, painted black
30′×21′×17′
McCauley Health Center, Ann Arbor,
Michigan

Meadmore's work and is rein-
forced by titles such as *Awaken-
ing* and *Push Up.*

But in these larger works, partic-
ularly in *Upcast* or *Upbeat,* the
feeling is of two separate bodies
straining against one another, ev-
ery muscle at maximum tension.
In these the historical link reaches
further. They recall certain Renais-
sance and Baroque sculptures
such as Pollaiuolo's *Hercules and
Antaeus,* Giovanni Bologna's
Rape of the Sabines, and Bernini's
Rape of Proserpina. Central to all,
and to Meadmore's, is the sensa-
tion of internal forces in conflict,
large masses poised aloft, and
the energetic penetration of space
by radiating members.

Yet it needs to be stressed that in
Meadmore's work these ideas, the
gestural, the musical, or the physi-
cal, are not communicated illus-
trationally but through a fully
abstract language. The penciled
X that scored the first, too literally

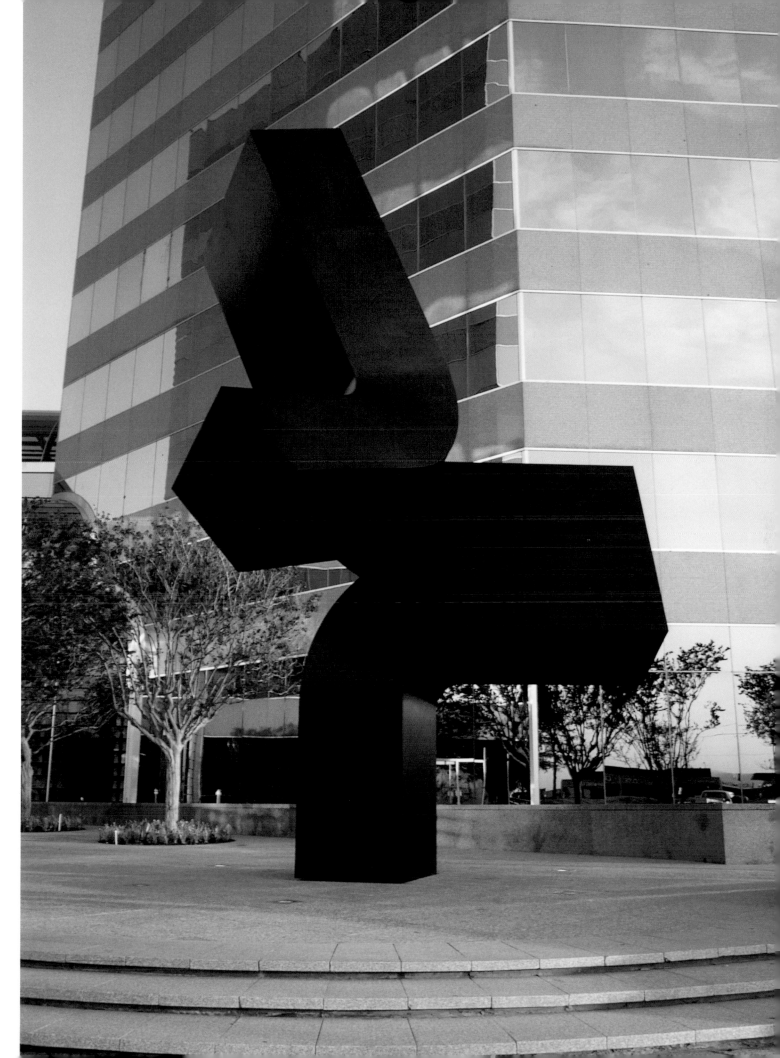

UPBEAT 1984
Aluminum, painted black
31′ × 22′ × 13′
MEPC American Properties,
The Colonnade, Dallas

anthropomorphic sculpture on the contact sheet made his commitment to such a language perfectly clear. Rather than through replication, Meadmore achieves his effects in these as well as in earlier sculptures through his sculptural language: close attention to matters of proportion, balance, and relationships between parts; and of course, with his module. Meadmore's module is a form rooted in a certain kind of geometric order—thus rational, impersonal, and man-made—but whose taut, controlled curvature is often made to express something more potently human.

As McCaughey observed about this aspect of Meadmore's work,

Meadmore's sense of life lived within the monolith points back to [Henry] Moore but without the trappings of organic ideology. . . . This torsion which compels mass through its convolution is not suggested through some internal power as though the sculpture were being

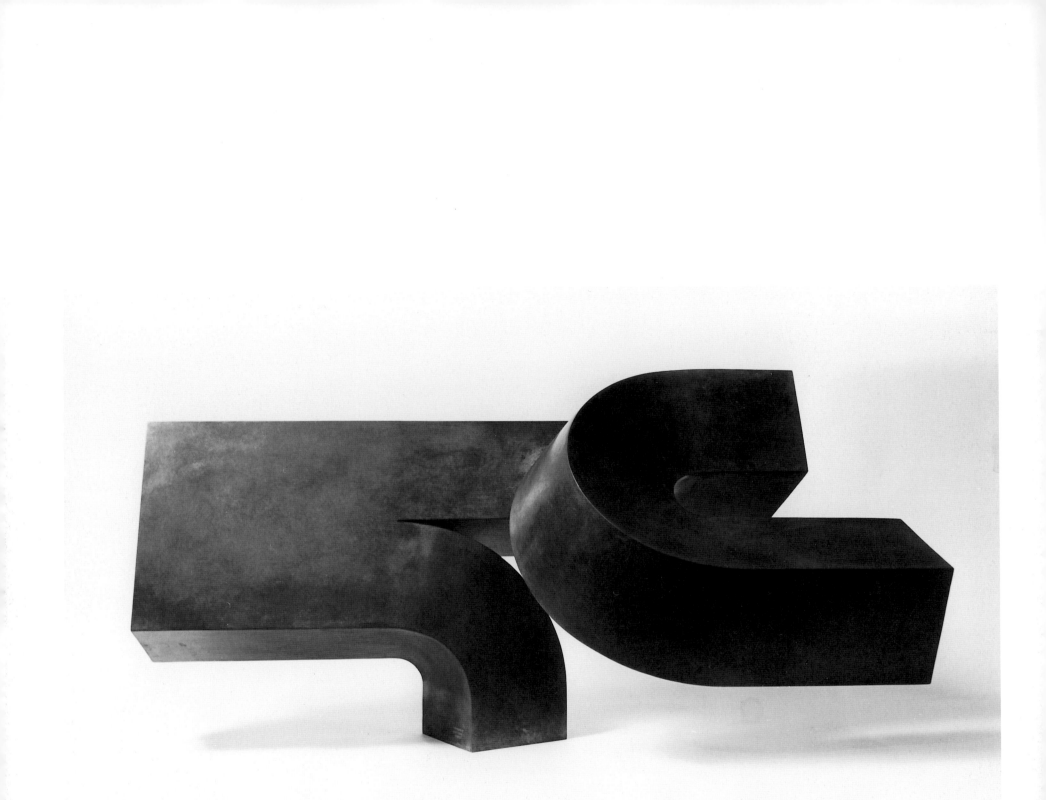

HEREBY 1983
Bronze
17″ × 33″ × 19″
Private collection

ASIDE 1983 ▷
Bronze
16″ × 32″ × 19½″
Private collection

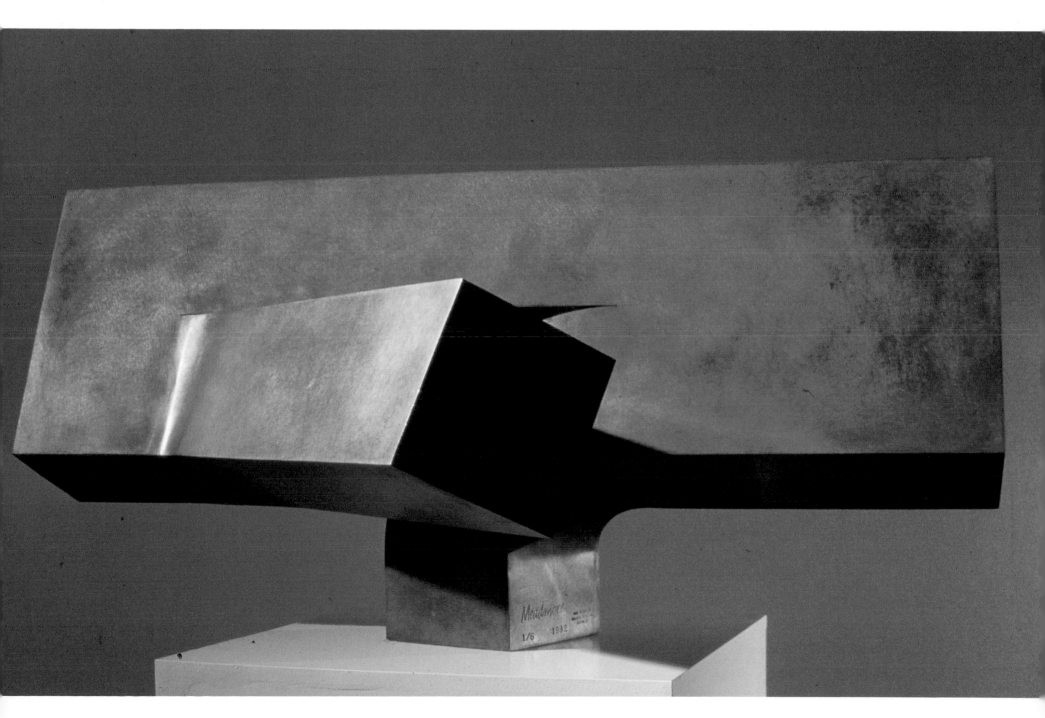

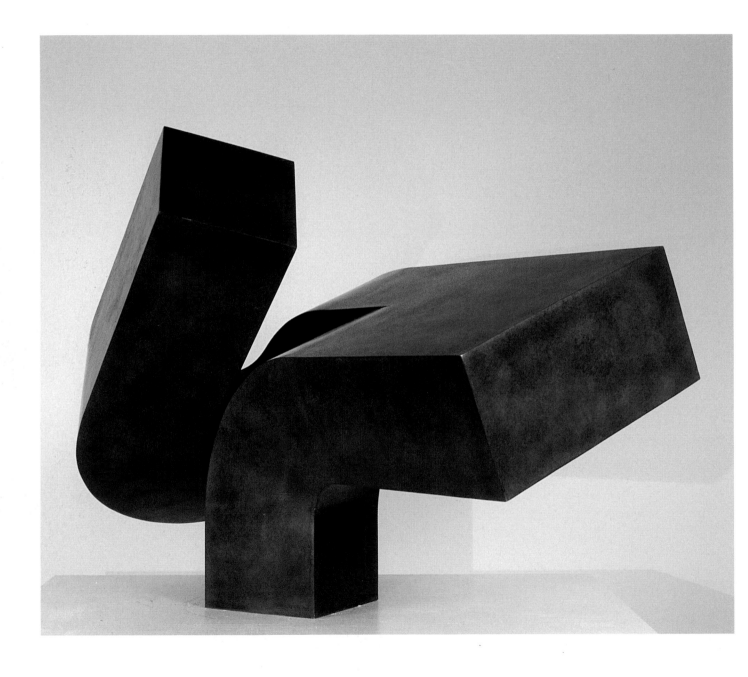

wrenched from within. Quite the contrary: movement in Meadmore is the product of line and edge; that which is entirely accessible to optical experience. [46]

Since 1990 Meadmore's sculpture has followed two parallel paths. First, the artist has felt free to return to formal ideas developed in the three main phases of his work: the dense, coiled sculptures of the 1960s, the sculptures composed of multiple parts made in the 1970s, and the branching sculptures of the 1980s. In doing so, Meadmore has refused to look upon his work of the preceding decades in terms of a series of distinct episodes in a linear progression. Instead, it serves as a collection of formal resources available to be drawn on and reworked at will. Thus *Terpsichore* and *Helix,* both of 1993, return to the dense coil configuration of Meadmore's work of the 1960s,

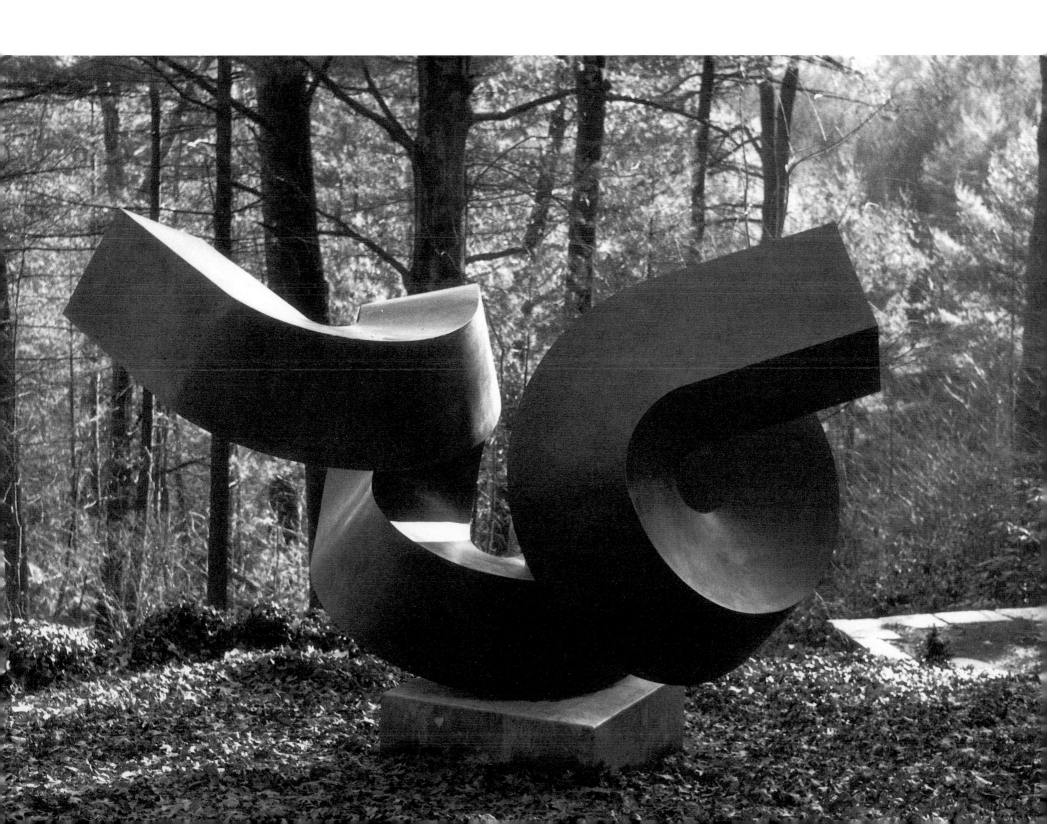

HELIX 1993
Bronze
6¾″ × 13½″ × 6″
Collection of the artist

but with a more pronounced Baroque flavor than any of the sculptures of that earlier decade.

Second, and in keeping with this new practice of regarding his earlier work as a resource that can be built on and elaborated instead of being left static, Meadmore has recently made several sculptures that combine the characteristics of two or more of these three phases of his career. *Prez* (1993), for example, combines the multiple modular curves of the 1960s pieces with the splitting and branching of the sculptures of the 1980s.

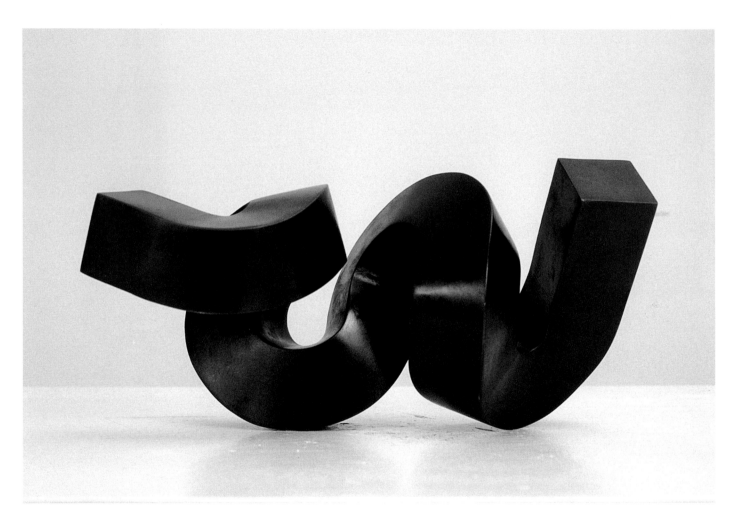

10

Meadmore's sculpture of these two decades, like that of the 1960s, had been conceived primarily as outdoor art. Although in its earliest form, Meadmore's work is a small model and is often placed on pedestals in domestic settings or commercial galleries, he envisions a public siting as its ultimate destination.

Meadmore's first outdoor work was the 1968 *Curl,* donated by Percy Uris in 1969 to Columbia University in New York. The purchase of this piece, as well as the artist's subsequent career, coincided with an explosion of public sculpture in this country sparked by abundant corporate patronage, new technologies that offered sculptors new possibilities, and, above all, the proliferation of the "One Percent for Art" laws at all levels of government that mandated public spending on public art.

This development has been very much of a mixed blessing, some of the reasons for which were recognized as early as 1968 by Barbara Rose. In an important article she published on the subject,

she gave the pejorative label "blowup" to much of the outdoor sculpture that had already appeared and has continued to do so in such quantity ever since. For Rose, "blowup" art is simply a grossly enlarged version of "forms conceived on a tabletop scale," in which the governing impulse is "bigness for its own sake," or to put it another way, "the pernicious notion of scale as content."[47]

A related problem in public sculpture today, which Rose's article dealt with only implicitly, has to do with the way such art is indifferent to its site. Much of it has acquired the name "plop art" owing to the fact that its utter incongruity gives it the impression of having been simply lowered into position and abandoned.

A further liability of public art is that a great deal of it is not so much bad—failed or misplaced art—as bland. It fades into the very urban landscape it exists to enhance. And what is not bland is usually either ugly or obtrusive in some other way. All these issues—as well as the many

others involved—have not abated; indeed, they have grown more acute over the years as more and more ill-suited commissions have appeared.

Unlike the great mass of contemporary sculpture, Meadmore's is uniquely suited to its role as public art, one reason being that he takes a number of factors into account in order to avoid, among other things, the "plop-art syndrome." In an unpublished manuscript on the subject of outdoor sculpture, Meadmore expressed sentiments on the question of scale very similar to those discussed by Barbara Rose. He wrote:

A large sculpture stretches the limits of human scale in its overall dimensions, and if this scale is stretched to the breaking point one merely has a small architectural object. Obviously a sculpture has to be reasonably large to read effectively in outdoor space, but less obviously not all sculpture will stand this degree of enlargement. A large percentage of sculpture is at its best at an intimate scale, and enlargement would simply destroy the qualities it has. One of the first requirements is that the sculptor should be conceiv-

PERDIDO 1978
Steel
15′ × 15′4″ × 4′8″
Mr. & Mrs. Jay Schokett, Newport,
Rhode Island

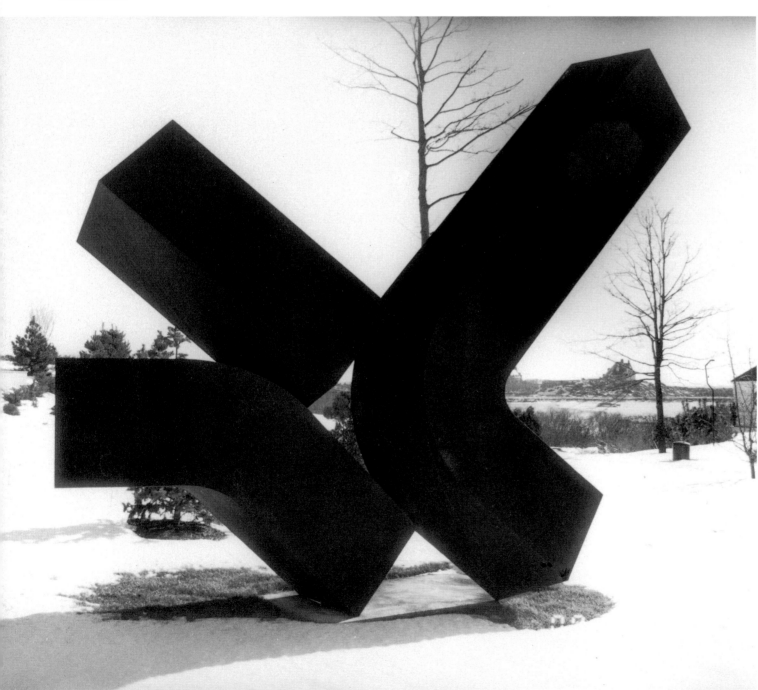

ing on a large scale, and when he is, the effect can be felt even in a small model. Henry Moore once said that "every idea has a correct physical size." I would refine this by saying that an idea may have several correct sizes but one that is the maximum beyond which a sharp decline in quality sets in, or, in other words, size beyond that of idea is gratuitous. At the other extreme, a piece that is too small for outdoors loses almost everything it has because it will rarely be seen from a close viewing distance for appreciation of its real qualities.[48]

One reason Meadmore's sculpture works so well in an outdoor context is because, as we have seen in relation to the work reproduced on the contact sheet, his is an innately monumental language, one that is, at least up to a point, far more extensible and reducible than almost any other. Meadmore can preserve the sense of internal coherence, and above all the energy, of one of his works in a way most other sculptors cannot when their work is enlarged or reduced, at least beyond certain limits. Thus Meadmore is able to avoid the "blowup" trap decried by Barbara Rose.

Another reason is Meadmore's own thoughtful approach to ques-

BETWEEN 1979
Steel
28′ × 19′ × 4′9″
University of Perth, Australia

tions of scale. He believes that
"there are several favorable scales
for sculpture." One is small, inti-
mately scaled sculpture.

Beyond that, there is another scale.
. . . [This one] goes beyond the hu-
man scale and acts as a bridge
between human scale and architec-
tural scale. By that I mean we relate
to a building not in terms of its whole
form, but in terms of its details like
doors and windows, and these act
as some sort of bridge between our-
selves and the whole building. With
sculpture, we can put something in
the environment which helps bridge
the gap between ourselves and the
enormous things around us.

Beyond that, there is a third scale,
which is the actual architectural
scale, and I think there are in-
stances where sculptors could do
this as well. We see things like the
Eiffel Tower, for instance, the Wash-
ington Monument, and the St. Louis
Arch, all of which were designed by
architects or engineers. They were
not buildings at all but actual forms
in the environment which do not de-
lineate livable space. . . . So in look-
ing at scale in sculpture, you are
looking at it in relation *to* something
or other, the buildings around us, or
the city as a whole.[49]

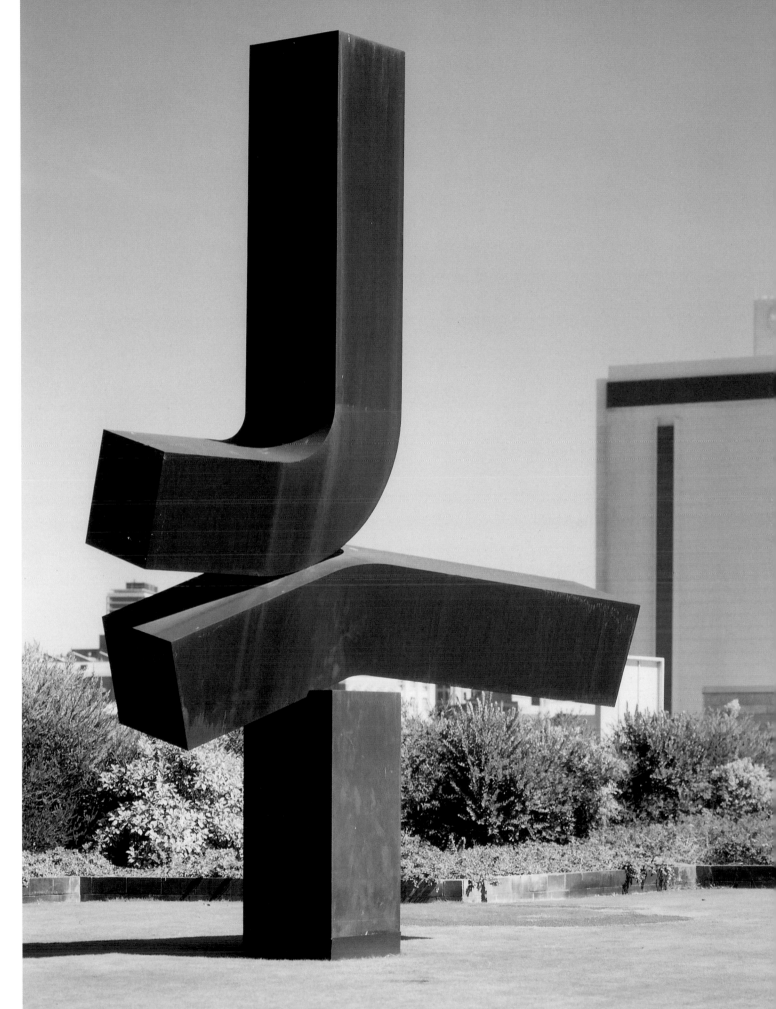

EXTENT 1981
Aluminum, painted black
11′ × 19′3″ × 13′
Displayed at Top Gallant Farm (Emmerich
sculpture park)

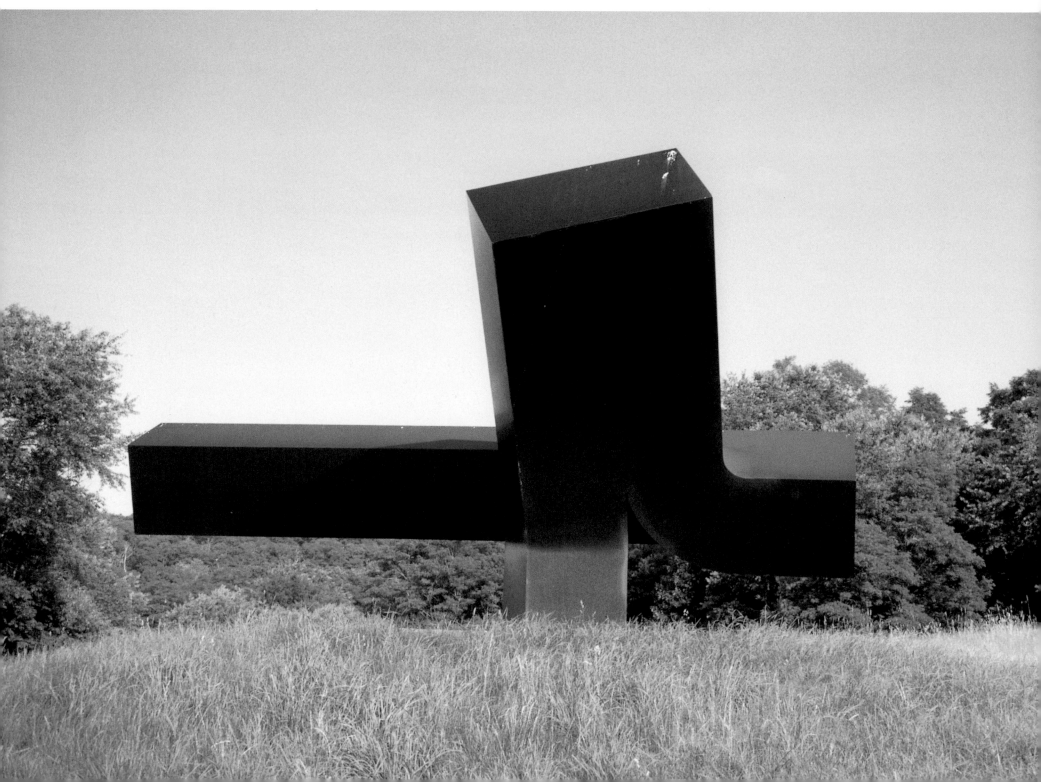

Meadmore's own preference as far as scale is concerned is to place the focal point of his sculptures at eye level, "which usually means having a piece ten to fifteen feet tall," although he acknowledges that this is not always possible.[50]

But his reference in the above remarks to "the city as a whole" is telling, for it reveals not only the existence of another factor in his thinking about scale—the importance of taking the site into consideration—but that in a sense he comes at the whole issue of public art from a different perspective from the artists Barbara Rose explicitly and implicitly criticized in her article. For, as he says later in the remarks from which the above quotation is drawn, "We should really be concerned with scale in terms of people and the space the sculpture occupies, and the scale of that space in the city itself."

In his view, in other words, outdoor sculpture must be a function of the whole environment, a matter of urbanism as much as aesthetics. To this end, Meadmore does not create sculptures for specific

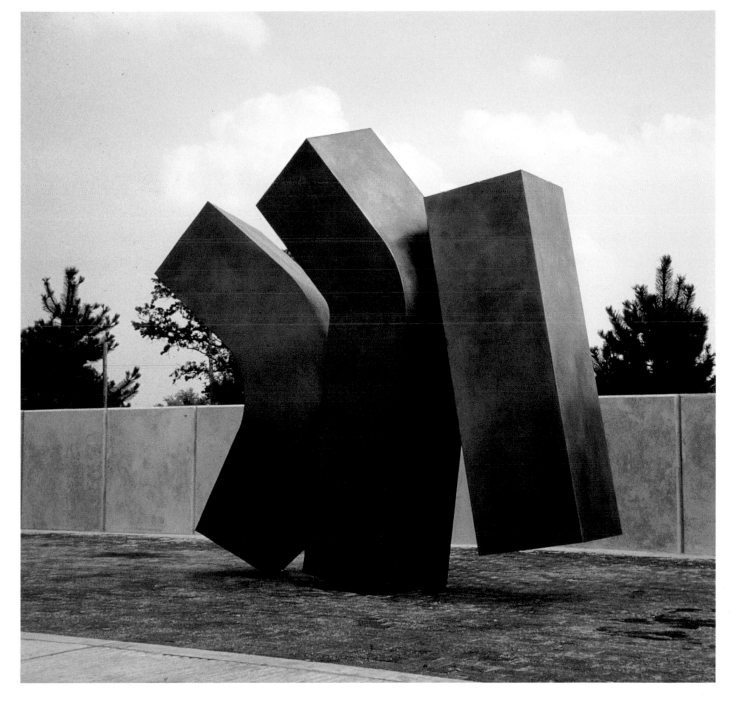

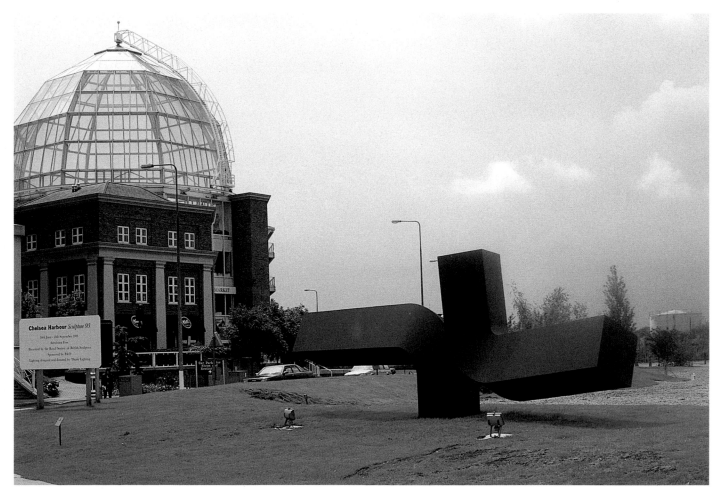

NIGHT AND DAY 1979
Aluminum, painted black
8′ × 23′6″ × 3′5″
Collection of the artist
(Displayed at Chelsea Harbour, London)

OFFSHOOT 1982 ▷
Aluminum, painted black
10′ × 24′ × 12′
Queensland Art Gallery, Australia

commissions, but selects a work from existing models that he feels will be best suited to the proposed site. He considers the size and height of the nearby buildings, their proximity to the proposed location of the sculpture, and the dimensions of the area.[51]

But it is in the sculptures themselves, of course, that this humane, unselfish, and all-inclusive view of public art becomes apparent. Like the work of certain other public sculptors, Isamu Noguchi and George Rickey among them, Meadmore's sculpture is a positive, active, unifying force in the environment. It fulfills his view that "sculptures [must] argue for their own significance" and "assume their own importance in those spaces,"[52] rather than functioning simply as decorations or embellishments. They should be a positive force in the public arena, not a neutral or negative one.

Meadmore's sculpture fulfills these imperatives in its ability to seize

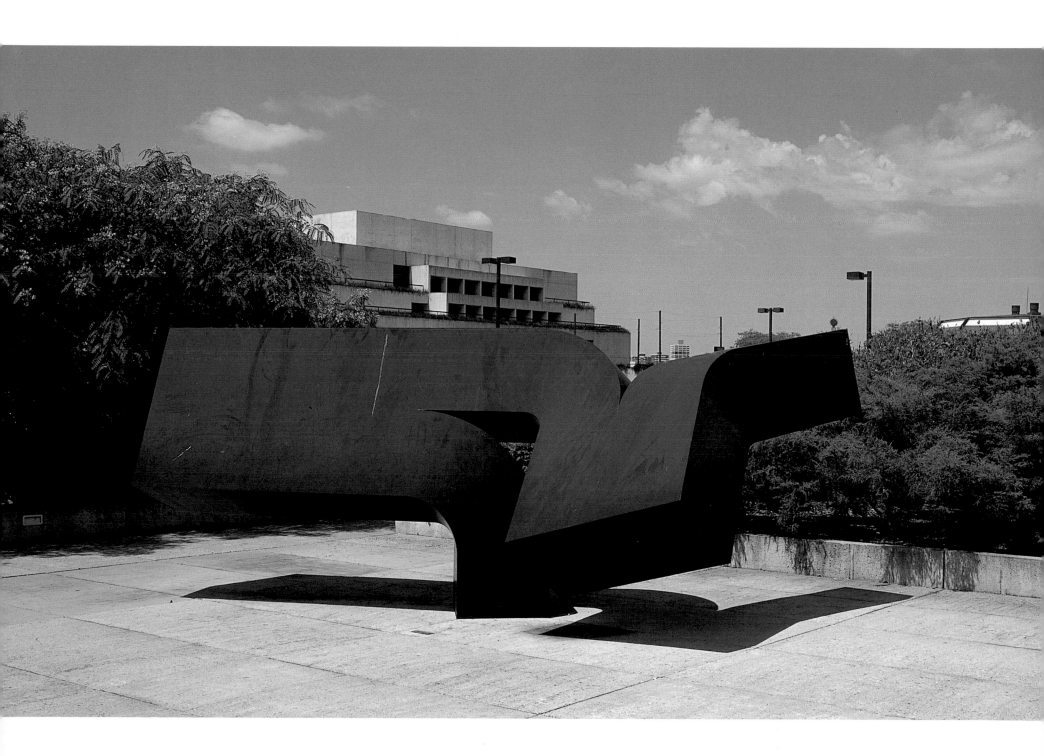

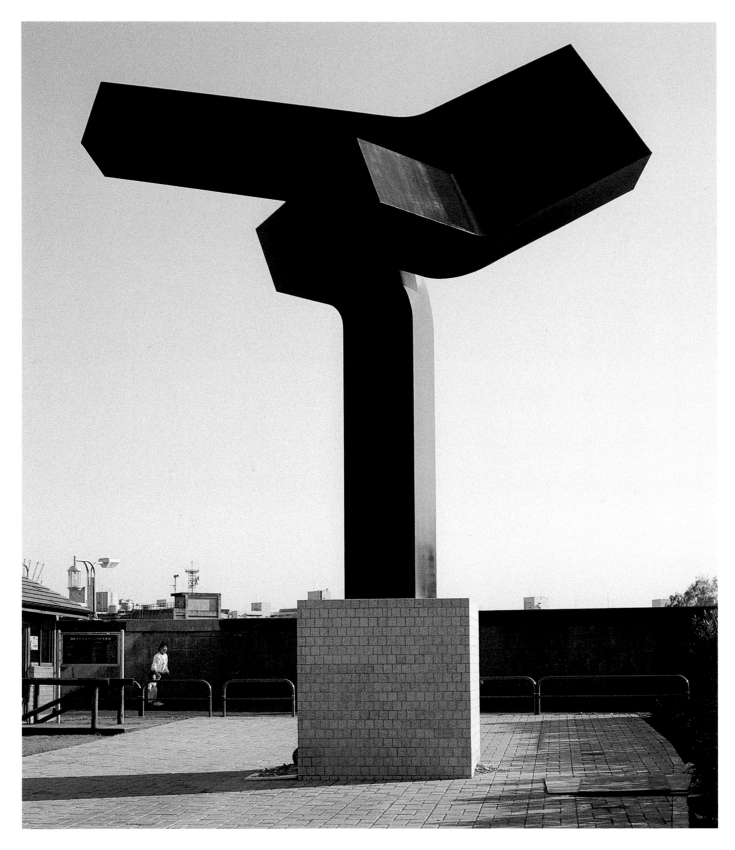

OUTSPREAD 1991
Aluminum, painted black
34′ × 24′ × 10′6″
Adachi Ward, Tokyo

OVERHANG 1986 ▷
Aluminum, painted black
9′3″ × 14′9″ × 9′9″
Mr. & Mrs. Leonard Dobbs, Sands Point,
New York

the viewer's attention and sense of excitement through dynamic energy and presence. It knits with its site not simply through activating the space around it, however, but through its assertive three dimensionality. It functions equally well at almost any angle, any point near or far. And this accessibility of multiple viewing invites the pedestrian in transit, at almost any point in his journey, to pause and look, to take himself out of the flux of everyday life, and to engage in a moment of contemplation and reflection. Of how much other public art can a similar observation be made?

Thus, Meadmore's sculpture is not an imposition, or even just an embellishment, but an active voice, one partner in a potential, constantly available dialogue and hence an oasis of humanity in the urban environment.

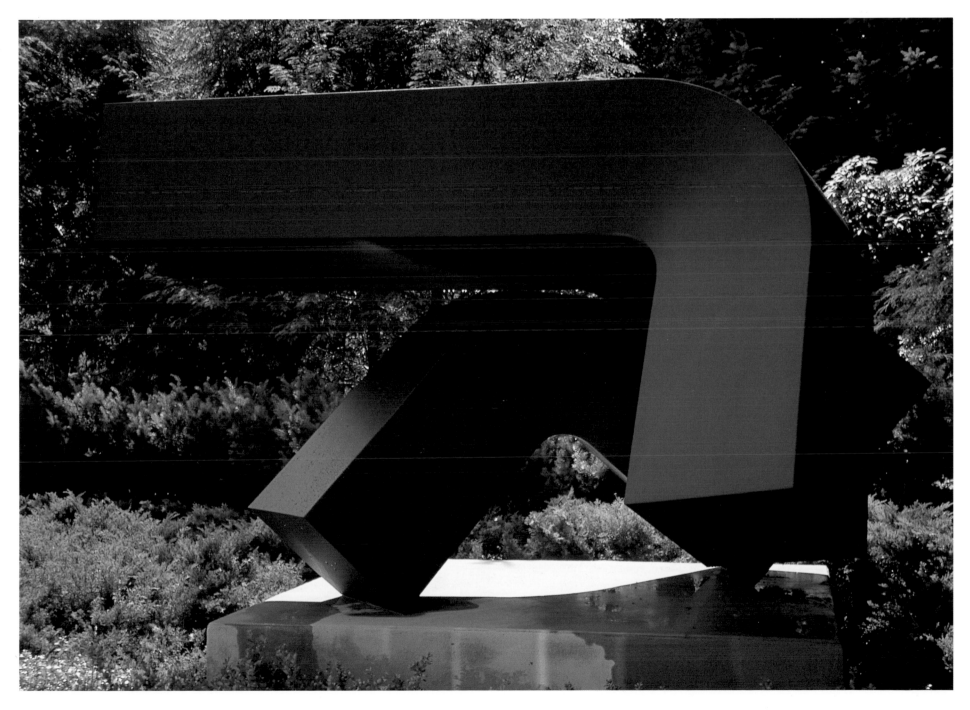

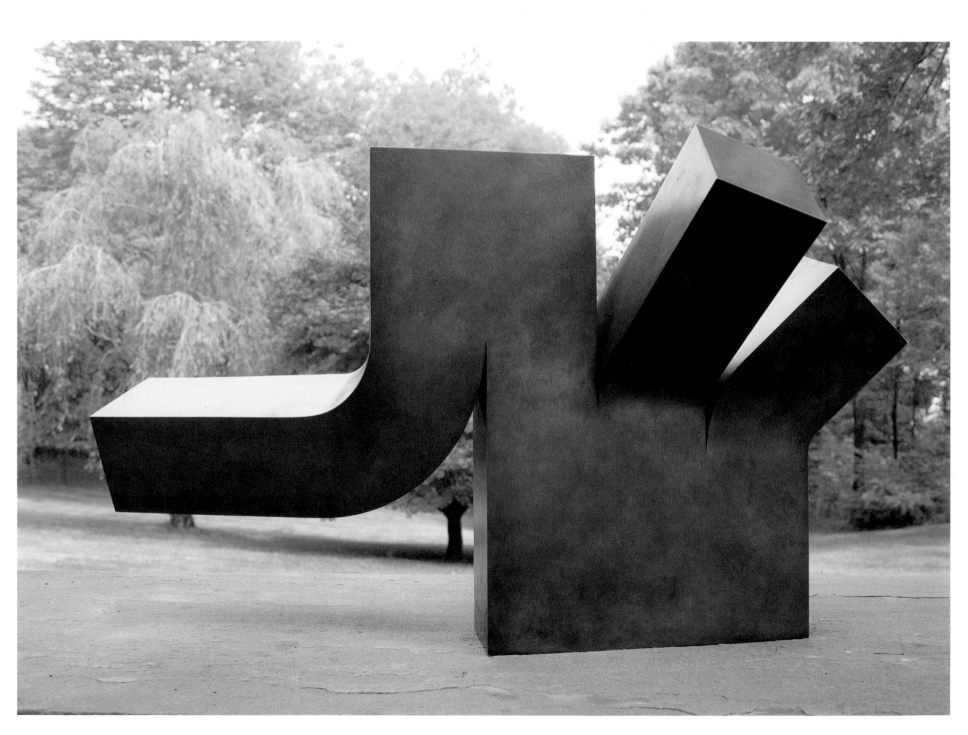

11

It has been said that Meadmore's contribution to Minimalism was the curve.[53] But such an observation shrinks Meadmore's effort, reducing it to the equivalent of a move in a chess game, or the invention of a simple ornament or device. It substitutes a standard of cleverness and even a kind of artifice for the workings of the artistic imagination.

This narrow assessment fails to account for his sculpture's manifold achievements: its ability to seize our attention on levels ranging from the purely aesthetic to the acutely physical; its skill at commanding and holding a public space; its ability to transform that space into a lively, animated environment; the way it elegantly and eloquently gives voice to ideas beyond itself; and its fusion of formal invention with intense feeling.

But even this listing only takes us so far. To understand the exact nature of Meadmore's contribution to the art of his time, one has to look elsewhere.

In the same 1979 interview in which he criticized an early phase of his own sculpture for being "a bit simplistically graphic," Meadmore said, "I am interested in geometry as a grammar which, if understood, can be used with great flexibility and expressiveness."[54]

This is exactly what, from about 1966 onward, Meadmore has done. Beginning with *Bent Column* of that year, the artist has steadily evolved a sculptural language that was adaptable, supple, and capable of yielding significant variations both in the form of the sculpture and in the ideas and feelings it expressed. A casual survey of the different phases of his career shows this. In the process, of course, he produced sculpture of real originality and quality. For confirmation, one has only to look at the plethora of similar but inferior work produced contemporaneously with Meadmore's, the incalculable tonnage of academic abstraction that has appeared outdoors during the last three decades made by sculptors whose names are already forgotten.

But Meadmore has gone farther. His starting point was geometry, a language or "grammar" that is both rigorously structured and conceptual in nature—a construct of the mind—and therefore intangible. He has evolved a method that has transformed geometry into something pliant and plastic. In his hands geometry has acquired an expressive suppleness and materiality more typical of such conventional and palpable media as wood and clay. To borrow his own phrase, Meadmore has in his work "transcended geometry," thus placing the stamp of his individual vision on one of the primary modes of twentieth-century art.

◁ **WALLFLOWER** 1987
Bronze
23″ × 44″ × 15″
Judith Meadmore, New York

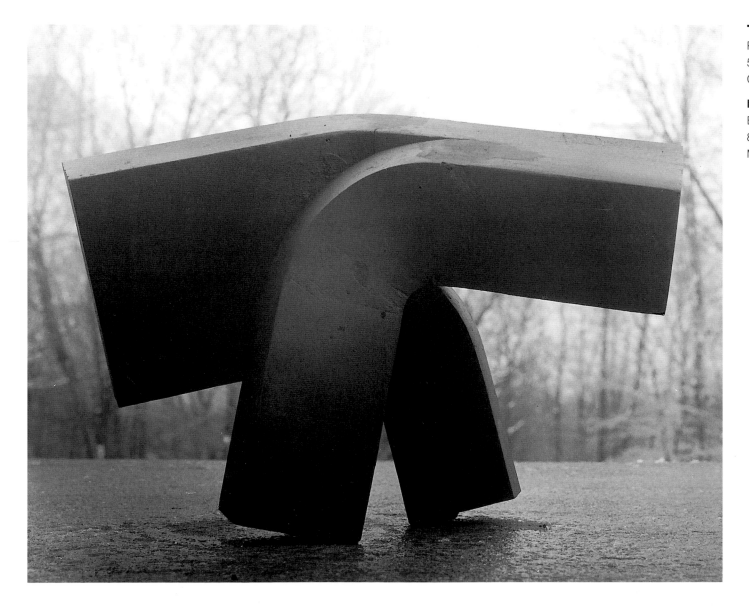

T FOR TWO 1986
Polyester maquette
5½″ × 9″ × 4½″
Collection of the artist

DELAUNAY'S DILEMMA 1992 ▷
Bronze
8½″ × 9″ × 5½″
Mr. & Mrs. Tony Allen

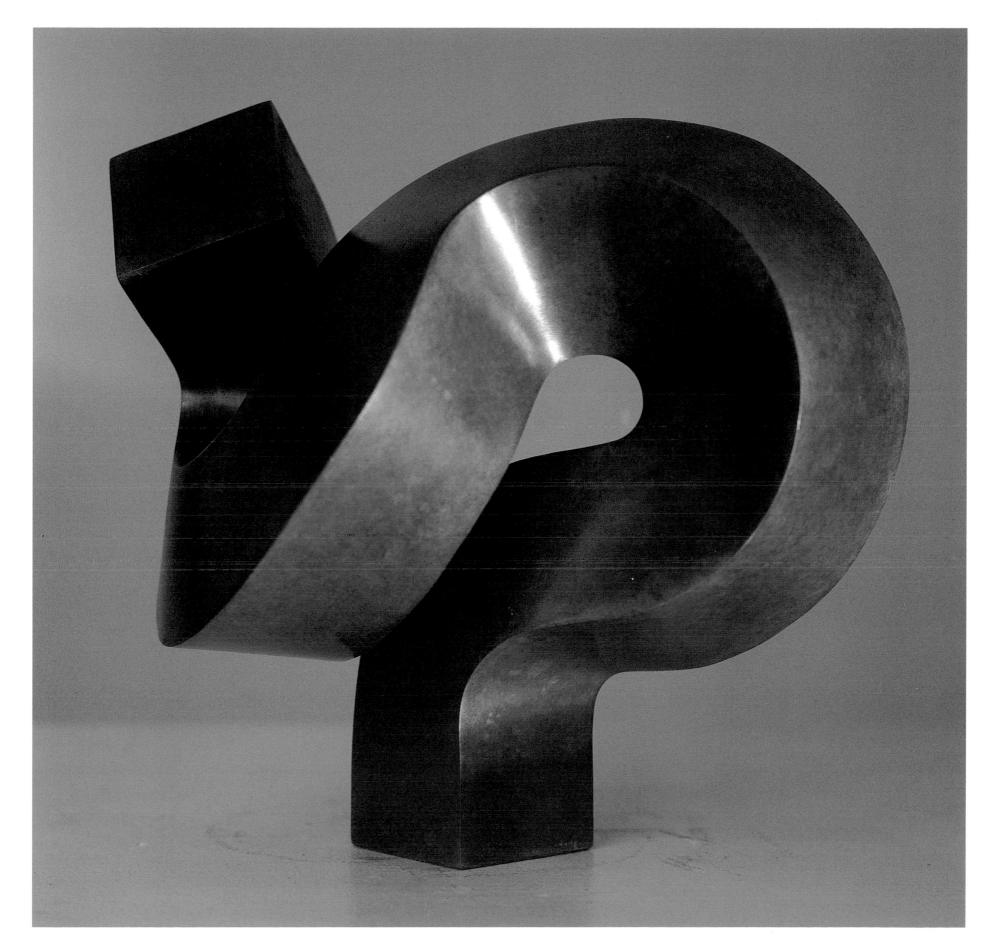

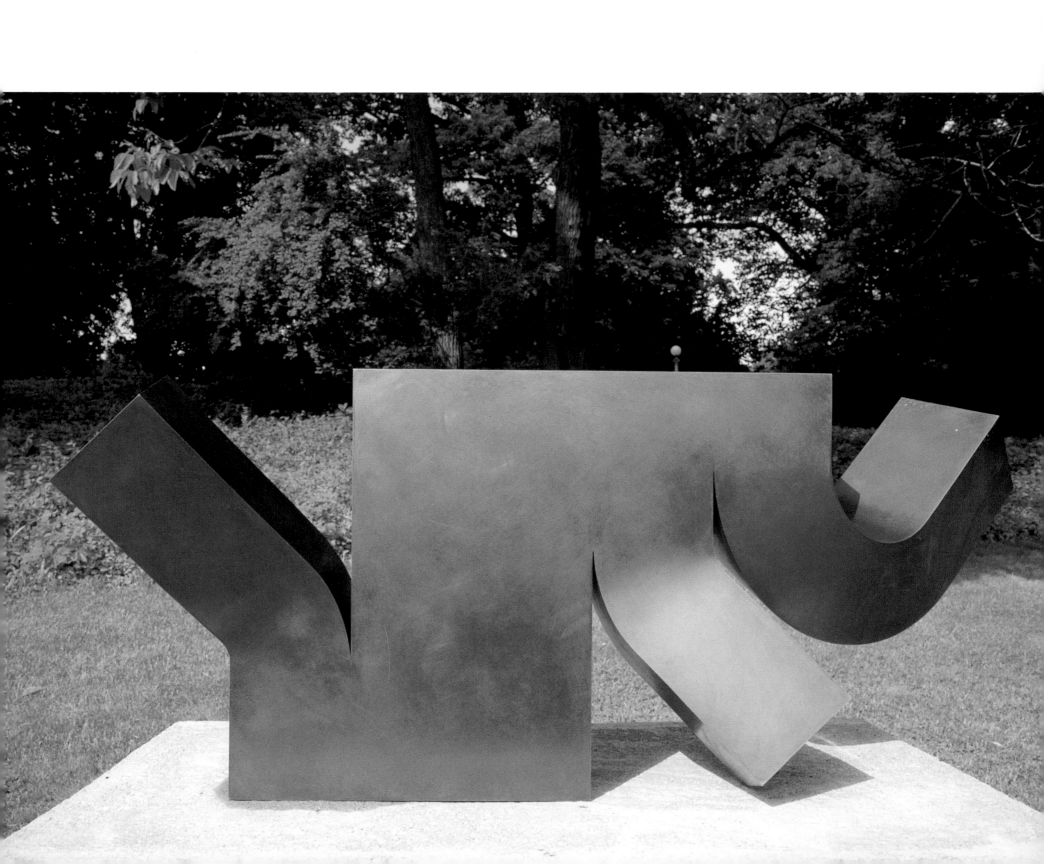

◁ **WALL FOR BOJANGLES** 1987
Bronze
18″×44″×13″
Collection of the artist

WALL KING 1988
Bronze
19″×31″×15″
Collection of the artist

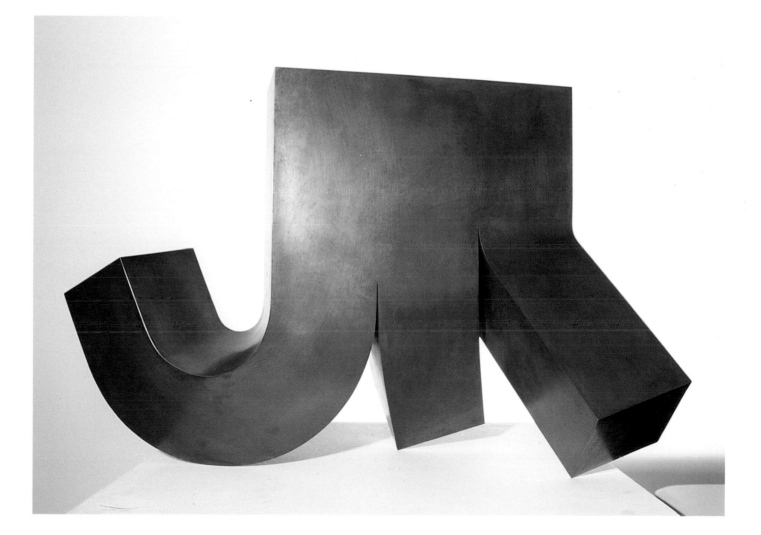

TRIOLITH B 1990
Bronze
14″×31″×16″
Collection of the artist

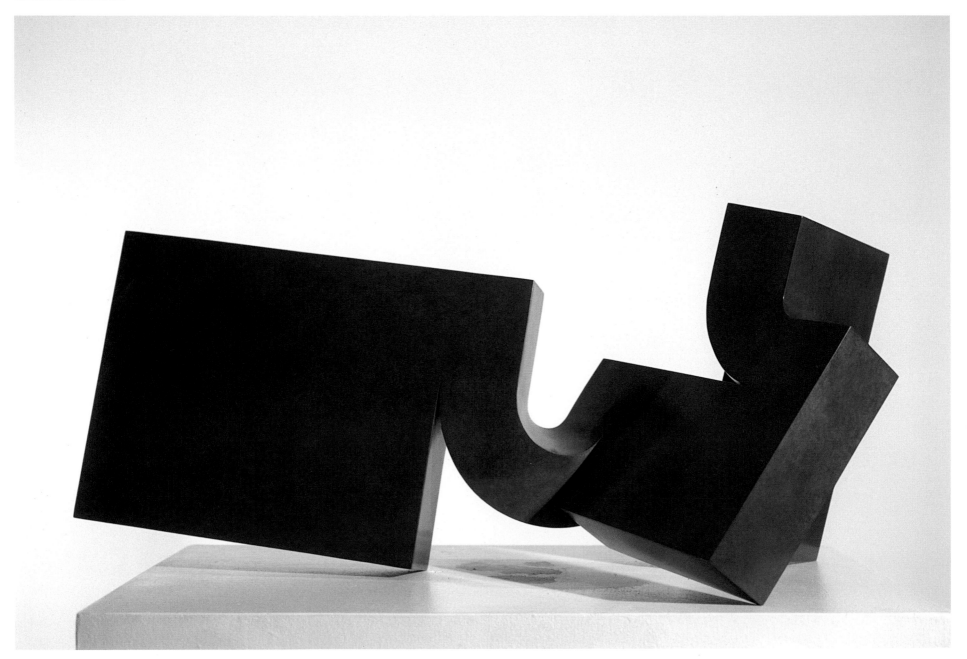

TRIOLITH A 1990
Bronze
21″×35″×54″
Collection of the artist

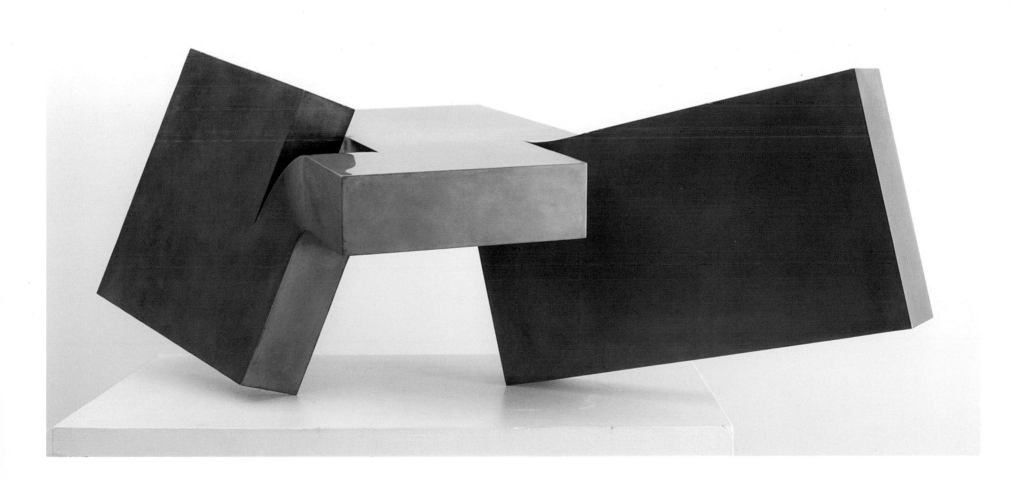

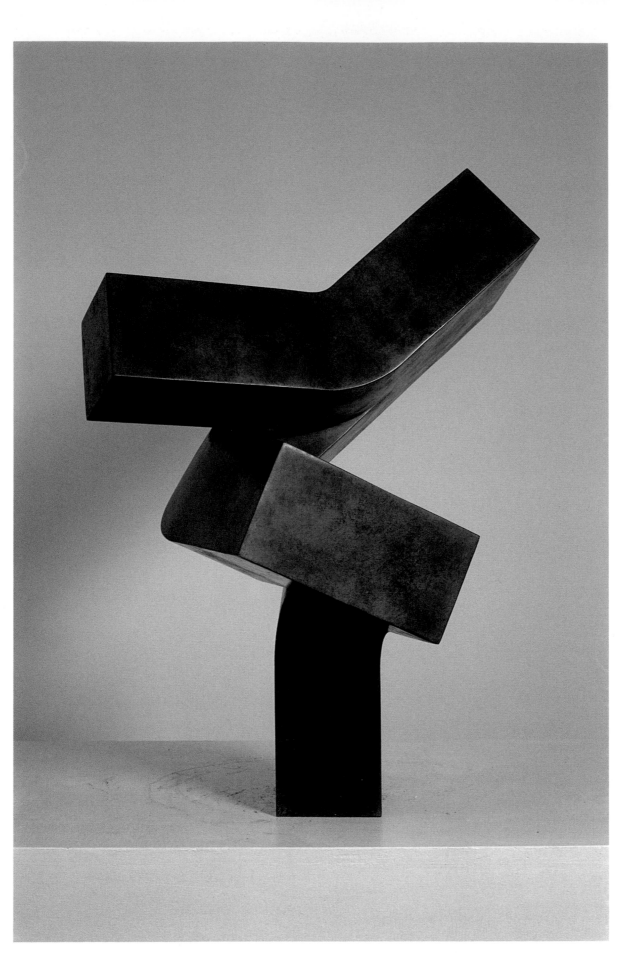

ALWAYS 1992
Bronze
31″ × 23″ × 18″
Collection of the artist

HOB NOB 1992
Bronze
22″×52″×30″
Collection of the artist

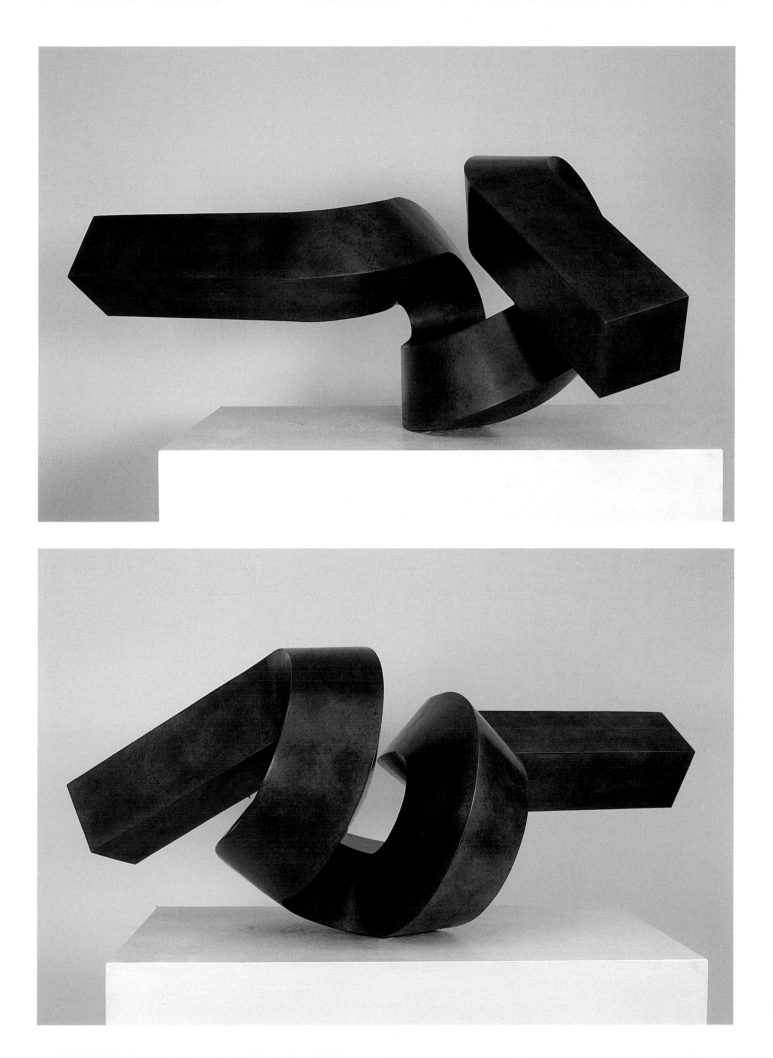

U & I 1992
Bronze
22″ × 39″ × 22½″
Collection of the artist

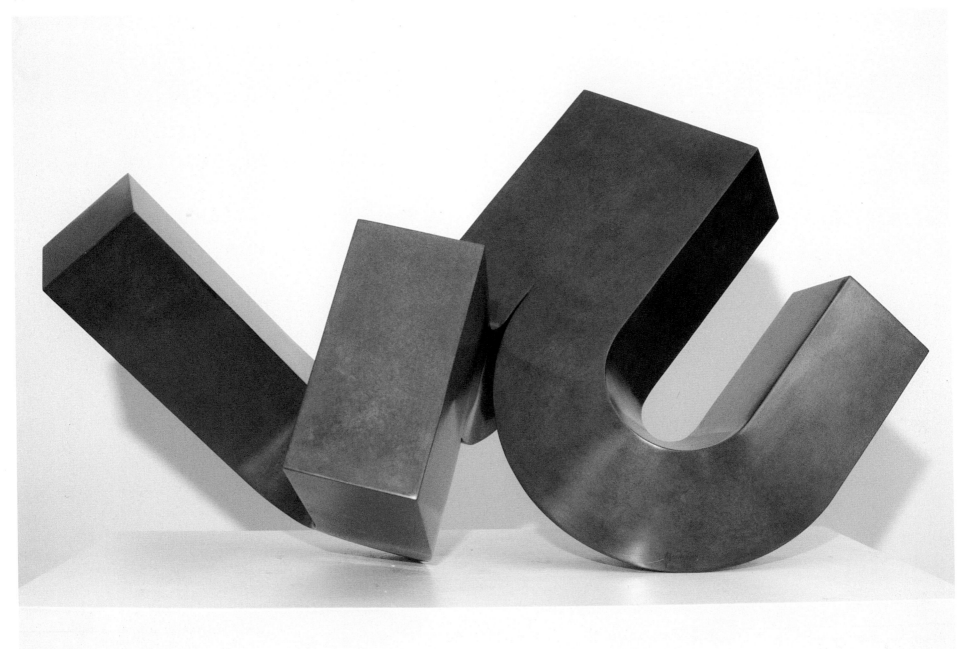

JERICHO 1987
Bronze
22″ × 50″ × 17½″
Private collection

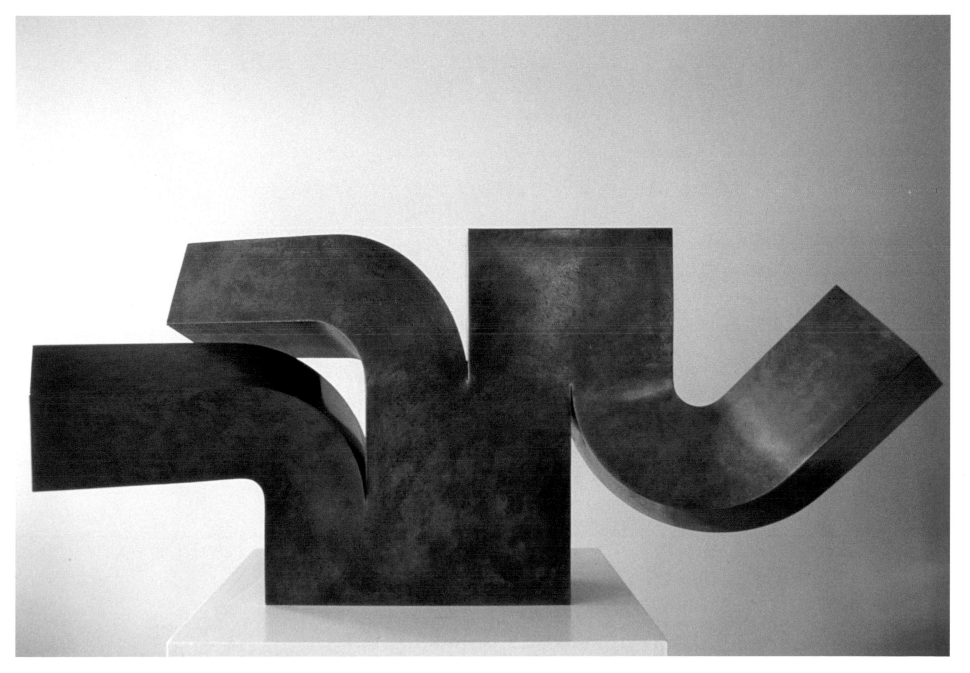

NOTES

1. Seitz, *Art in the Age of Aquarius: 1955–1970,* p. 124, and Robertson, *Meadmore,* p. 4, respectively.

2. The term is Meadmore's. It is discussed below.

3. All biographical information comes from Robertson, op. cit., Siegel 1972, and author's interviews with the artist, October and November 1992.

4. McCulloch, *Encyclopedia of Australian Art,* for information on Hilder.

5. Gibson, interviews.

6. Gibson, interviews.

7. Glaser, "Questions to Stella and Judd," in Battcock, *Minimal Art,* p. 158.

8. Soon after, the sculptor Cesar employed a similar technique, pouring colored polyurethane foam onto the ground and allowing it to expand to several times its original volume and then to harden.

9. Meadmore, 10, p. 26.

10. Weinberg, "An Interview with Clement Meadmore," p. 25.

11. Gibson, interviews.

12. Siegel 1971, p. 66.

13. Gibson, interviews.

14. Gibson, interviews.

15. Gibson, interviews.

16. Gibson, interviews.

17. Gibson, interviews.

18. Gibson, interviews.

19. Gibson, interviews.

20. Gibson, interviews.

21. Lippard, "Tony Smith: 'The Ineluctable Modality of the Visible,'" p. 24.

22. Gibson, interviews. Kynaston McShine refused to be interviewed for this monograph.

23. Gibson, interviews.

24. Like many other modern sculptors (Henry Moore, David Smith, and, most famously, Brancusi), Meadmore has for the most part been his own photographer, and for much the same reasons as the others, because he feels only he knows the best angles from which to shoot his work.

25. Brancusi was, however, an influence on Meadmore. During our interviews he described it as one of outlook rather than form, one more reason he would have felt dissatisfied with the sculpture on the contact sheet that resembled Brancusi's *La Phoque.* Brancusi's influence on him, Meadmore said, was the realization that "sculpture can be that profound and abstract at the same time. I mean it would be very easy for Brancusi to take on sort of Art Deco qualities, which wouldn't be so good. But he manages to transcend all that. So I suppose the influence lay in realizing how serious sculpture could be."

26. Weinberg, op. cit., p. 24.

27. Gibson, interviews.

28. Weinberg, op. cit., p. 24.

29. Gibson, interviews.

30. Sandler, "Gesture and Non-Gesture in Recent Sculpture," in Battcock, *Minimal Art,* p. 308.

31. "[T]he new construction-sculpture begins to make itself felt as most *representative,* even if not the most fertile, visual art of our time," wrote Greenberg in "Sculpture in Our Time," *Arts Magazine* (June 1958). The essay is reprinted in John O'Brien, *Clement Greenberg: The Collected Essays and Criticism, vol. 4, Modernism with a Vengeance, 1957– 1969* (Chicago: University of Chicago Press, 1993), pp. 55–61.

32. McCaughey, "The Monolith and Modernist Sculpture," p. 20.

33. Siegel 1972, p. 57.

34. Meadmore quoted in anonymous, unsourced review in artist's archive.

35. Gibson, interviews.

36. Weinberg, op. cit., p. 25.

37. Fordyce, "Geometric Magician," p. 2.

38. Weinberg, op. cit., p. 25.

39. Siegel 1972, p. 57.

40. Robertson, op. cit., p. 3.

41. Meadmore 6, p. 7.

42. Hughes, "Solid Man," p. 66.

43. Meadmore 6, p. 7. Compare this statement with the more common approach to the question of spirituality in art expressed by the Abstract Expressionist painter Richard Pousette-Dart in a notebook entry of 1939: "I am an artist of the concealed power of the spirit not of the brute physical form" (cited in Robert Hobbs and Joanne Kuebler, *Richard Pousette-Dart* [Indianapolis: Indianapolis Museum of Art, 1990], p. 11).

44. Meadmore 6, p. 6.

45. Siegel 1972, p. 56.

46. McCaughey, op. cit., p. 23.

47. Rose, *Autocritique,* p. 161.

48. Meadmore 2, p. 1.

49. Meadmore 11, "Symposium on Three Dimensions," p. 62.

50. Gibson, interviews.

51. Siegel 1972, p. 59.

52. Meadmore 11, p. 62.

53. Siegel 1972, p. 57.

54. Weinberg, op. cit., p. 25.

BIBLIOGRAPHY

STATEMENTS BY THE ARTIST

Gibson, Eric. Interviews with Clement Meadmore, October and November 1992.

Meadmore 1. "Formal Problems of Non-figurative Sculpture." Unpublished manuscript. N.d.

Meadmore 2. "Sculpture for Architects: A Primer on the Selection of Outdoor Sculpture." Unpublished manuscript. N.d.

Meadmore 3. Untitled 2-page statement on the function of the artist. Unpublished manuscript. Unpaginated. N.d.

Meadmore 4. "Relief." Unpublished manuscript. N.d.

Meadmore 5. Untitled 1-page statement on the spiritual world of the artist. Unpublished manuscript. Unpaginated. N.d.

Meadmore 6. Notes for an unpublished book on modern sculpture. N.d.

Meadmore 7. "Constructivist Sculpture, Yesterday and Tomorrow." Unpublished manuscript. N.d.

Meadmore 8. "Composition in Abstract Sculpture." Unpublished manuscript. N.d.

Meadmore 9. "A Sketch Class for Welded Sculpture." Unpublished manuscript. 1982.

Meadmore 10. "Thoughts on Earthworks, Random Distribution, Softness, and Gravity." *Arts Magazine* (Feb. 1969): 26–28.

Meadmore 11. "Symposium on Three Dimensions." Statements by Edward F. Fry, Meadmore, and Barbara Rose. *Arts Magazine* (Jan. 1975): 62.

Meadmore 12. *Skyscraper Sculptures: An Immodest Proposal*. Traveling exhibition catalog. 1979. Privately published.

Meadmore 13. *Dolmens: Monumental Abstract Sculpture, 4,000–3,000 B.C.* Unpublished manuscript. N.d.

Siegel 1971. Siegel, Jeanne, "Around Barnett Newman." *Art News* (Oct. 1971): 42–47, 59–66.

Weinberg, Helen A. "An Interview with Clement Meadmore." *DIALOGUE* [Akron Art Institute] (Mar.–Apr. 1979), pp. 24–25.

BOOKS AND CATALOGUES

Battcock, Gregory. *Minimal Art: A Critical Anthology*. New York: E. P. Dutton, 1968.

Catalano, Gary. *The Years of Hope: Australian Art and Criticism, 1959–1968*. Melbourne and New York: Oxford University Press, 1981.

Dabrowski, Magdalena. *Contrasts of Form: Geometric Abstract Art, 1910–1980*. New York: The Museum of Modern Art, 1985.

Hannan, William. *Clement Meadmore*. Melbourne: Gallery A, 1959.

Hess, Thomas B. *Barnett Newman*. New York: The Museum of Modern Art, 1971.

Hughes, Robert. *Meadmore: Small Bronzes, 1977–1978*. 1978. Privately published.

———. *Recent Australian Painting, 1961*. London: Whitechapel Gallery, 1961.

Karson, Robin S. *Silence and Slow Time*. South Hadley, Mass.: Mount Holyoke College Art Museum, 1978.

McCulloch, A. *Encyclopedia of Australian Art*. New York: Frederick A. Praeger, 1968.

McShine, Kynaston. *Primary Structures*. New York: The Jewish Museum, 1966.

O'Dell, Kathy. "Clement Meadmore." Entry in Sandler, Irving, Ed. *The Empire State Collection: Art for the Public*. New York: Harry N. Abrams, 1987, pp. 108–10.

Rand, Harry. "Clement Meadmore in Tokyo." Introduction to *Meadmore*. Tokyo: Contemporary Sculpture Center, 1989.

Redstone, Louis G. and Ruth R. *Public Art: New Directions*. New York: McGraw-Hill, 1981.

Robertson, Bryan. *Clement Meadmore: Sculptures, 1966–1973*. New York: Max Hutchinson Gallery, 1973.

Rose, Barbara. *Autocritique: Essays on Art and Anti-Art, 1963–1987*. New York: Weidenfeld & Nicholson, 1985.

Sandler, Irving. *American Art of the 1960s*. New York: Harper & Row, 1988.

Seitz, William C. *Art in the Age of Aquarius, 1955–1970*. Washington, D.C.: Smithsonian Institution Press, 1992.

Sturgeon, Graeme. *The Development of Australian Sculpture, 1788–1975*. London: Thames and Hudson, 1978.

Wilkin, Karen. *David Smith*. New York: Abbeville Press, 1984.

ARTICLES AND REVIEWS

"Sculptural Focal Points for New York Neighborhoods." *American Institute of Architects Journal* (Oct. 1976): 46–47.

Alloway, Lawrence. "Monumental Art at Cincinnati." *Arts Magazine* (Nov. 1970): 33.

Battcock, Gregory. Review of exhibition at the Max Hutchinson Gallery, New

York, and the Donald Morris Gallery, Detroit. *Art and Artists* (June 1972): 50.

B[enedikt]., M[ichael]. Review of exhibition at the Byron Gallery, New York. *Art News* (Oct. 1968): 14.

Baro, Gene. "Tony Smith: Toward Speculation in Pure Form." *Art International* (Summer 1967): 27–30.

Cavaliere, Barbara. "Clement Meadmore" (review of exhibition at the Hamilton Gallery, New York). *Arts Magazine* (May 1977): 24.

Davies, Hugh M. "Clement Meadmore." *Arts Magazine* (Mar. 1977): 5.

Diamond, Susan. "The New Neighbor Is a Sculptor." *The Patent Trader,* 16 June 1981, p. 7.

Domingo, Willis. Review of exhibition at the Max Hutchinson Gallery, New York. *Arts Magazine* (Apr. 1971): 82.

E[dgar]., N[atalie]. Review of exhibition at the Max Hutchinson Gallery, New York. *Art News* (Apr. 1971): 17.

Fordyce, Randy. "Geometric Magician." *Not Just Jazz: Viewpoints* (Fall 1980): 4–5.

Friedriechs, Yvonne. Review of exhibition at Galerie Denise René/Hans Meyer,

Düsseldorf. *Das Kunstwerk* (Sept.–Dec. 1974): 183.

Gibson, Eric. "Differing Aspects of Sculpture on View" (review of outdoor installations by Clement Meadmore and Jene Highstein). *The Washington Times,* 12 Dec. 1991, Washington Weekend, p. M 22.

Glaser, Bruce. "Questions to Stella and Judd." *Art News* (Sept. 1966): 26–28. Reprinted in Battcock, *Minimal Art,* pp. 148–64.

Hughes, Robert. "Solid Man." *Time,* 5 Apr. 1971, p. 66.

Jarmusch, Ann. Review of exhibition at Olympia Galleries, Philadelphia. *Art News* (Nov. 1976): 100.

Kingsley, April. "New York" (review of exhibition at the Max Hutchinson Gallery, New York). *Art International* (Mar. 1973): 47.

L[ast]., M[artin]. Review of exhibition at the Max Hutchinson Gallery, New York. *Art News* (Apr. 1970): 69.

Lippard, Lucy. "Tony Smith: 'The Ineluctable Modality of the Visible.'" *Art International* (Summer 1967): 24–27.

Lubell, Ellen. "Clement Meadmore" (review of exhibition at the Max Hutchinson

Gallery, New York). *Arts Magazine* (May 1972): 69–70.

———. "Clement Meadmore" (review of exhibition at the Max Hutchinson Gallery, New York). *Arts Magazine* (Feb. 1973): 83.

McCaughey, Patrick. "The Monolith and Modernist Sculpture." *Art International* (Nov. 1970): 19–24.

McCulloch, Alan. "Australia" (review of Meadmore sculpture for the A. M. P. Tower in Melbourne). *Art International* (Apr. 1970): 59.

Maraini, Toni. "18 Sculpteurs à Mexico." *Art International* (Apr. 1969): 24.

Mazur, Carole. "Meadmore, Nauman, Vega." *Albuquerque Journal,* 1 Feb. 1981, sect. D, p. 1.

Mellow, James R. "The 1967 Guggenheim International." *Art International* (Christmas 1967): 51.

———. "New York Letter." *Art International* (Christmas 1968): 62.

N[emser]., C[indy]. "Clement Meadmore" (review of exhibition at the Max Hutchinson Gallery, New York). *Arts Magazine* (May 1970): 58.

Ratcliff, Carter. "New York Letter" (review of exhibition at the Max Hutchinson Gal-

lery, New York). *Art International* (Summer 1970): 137.

———. "New York Letter" (review of exhibition at the Max Hutchinson Gallery, New York). *Art International* (May 1972): 46.

Rose, Barbara. "Blowup: The Problem of Scale in Sculpture." *Art in America* (July 1968): 80–91. Reprinted in *Autocritique,* pp. 157–62.

Sandler, Irving. "Gesture and Non-Gesture in Recent Sculpture." In Battcock, *Minimal Art,* pp. 308–16.

Shirey, David. "Cultural Olympics: The Route of Friendship." *Arts Magazine* (Dec. 1968–Jan. 1969): 19.

Siegel 1968. S[iegel]., J[eanne]. "Clement Meadmore" (review of exhibition at the Byron Gallery, New York). *Arts Magazine* (Sept. 1968): 59.

Siegel 1972. Siegel, Jeanne. "Clement Meadmore: Circling the Square." *Art News* (Feb. 1972): 56–59.

Siegel, 1973. ———. Review of exhibition at the Max Hutchinson Gallery, New York. *Art News* (Jan. 1973): 80.

Sydney, A. "Max Hutchinson's Gallery." *Studio International* (Apr. 1972): 181.

CLEMENT MEADMORE

CHRONOLOGY

1929 Born Melbourne, Australia, February 9

1945 Completed high school

1948–49 Studied industrial design at Royal Melbourne Institute of Technology

1953 Traveled to England, France, and Germany

1959 Visited Japan

1960 Moved to Sydney, Australia

1963 Moved to New York

1976 Became U.S. citizen

COLLECTIONS

Adachi Outdoor Sculpture Collection, Japan

Art Gallery of New South Wales

The Art Institute of Chicago

Art Gallery of Western Australia

Atlantic Richfield Oil Company

Australian Mutual Provident Society

Blue Cross/Blue Shield, Michigan

Bradley Collection, Milwaukee

Chase Manhattan Bank

City of New York

Cleveland Museum of Art

Columbia University, New York City

Columbus Museum of Art, Ohio

Corcoran Gallery of Art, Washington, D.C.

Davenport Art Gallery, Iowa

The Detroit Institute of Arts

Developers Diversified, Moreland Hills, Ohio

Fukuoka City, Japan

Gallaudet College, Washington, D.C.

Greycoat-Hanover Associates, New York City

Hale Boggs Federal Building, New Orleans

Johnson County Community College, Overland Park, Kansas

Kitz Building, Makuhari, Japan

Lake Fairfax Business Center, Reston, Virginia

Libbey-Owens-Ford, Toledo, Ohio

Linclay Corporation, Cincinnati, Ohio

McAuley Health Center, Ann Arbor, Michigan

MEPC-Quorum, Dallas

The Metropolitan Museum of Art, New York City

Mexico City

Museum of Art, Rhode Island School of Design, Providence

National Gallery of Victoria

National Gallery, Canberra, Australia

National Trust for Historic Preservation, Nelson A. Rockefeller bequest, Pocantico Historic Area

Newport Harbor Art Museum, Newport Beach, California

New York State, Albany

Northbridge Center, Palm Beach

Pittsburgh National Bank

Portland Art Museum, Oregon

Princeton University

Queensland Art Gallery, Australia

Smith Kline Corporation, Philadelphia

J. B. Speed Art Museum, Louisville, Kentucky

Sterling Drug, Pennsylvania

Tokyo Metropolitan Art Space

University of Houston

Victorian Arts Centre, Australia

Yokohama Private Railroad, Japan

SOLO EXHIBITIONS

1954, 1959, 1962 Melbourne

1960, 1962 Sydney

1967, 1968 Byron Gallery, New York City

1970, 1971, 1972, 1983 Max Hutchinson Gallery, New York City

1971 Richard Feigen Gallery, Chicago

1972, 1973, 1983, 1989 Donald Morris Gallery, Detroit

1974 Galerie Denise Rene/Hans Mayer, Düsseldorf

1975 Rice University, Houston

1975 University of Texas, Austin

1976 Louisiana Gallery, Houston

1976 King Pitcher Gallery, Pittsburgh

1976 Olympia Gallery, Philadelphia

1977, 1978 Hamilton Gallery of Contemporary Art, New York City

1977, 1978 Suzette Schochet Gallery, Newport, Rhode Island

1977 Ruth S. Schaffner Gallery, Los Angeles

1978 Sunne Savage Gallery, Boston

1978 Irving Galleries, Palm Beach, Florida

1978 Michael Berger Gallery, Pittsburgh

1979 The New Gallery of Contemporary Art, Cleveland

1979 Roy Boyd Gallery, Chicago

1979 David Barnett Gallery, Milwaukee

1979 Hoshour Gallery, Albuquerque

1980 J. B. Speed Art Museum, Louisville

1980 Davenport Art Gallery, Iowa

1980 Jacksonville Art Museum, Florida

1980 Columbus Museum of Art, Ohio

1981 Albuquerque Museum, New Mexico

1981 Amarillo Art Center, Texas

1982 Grand Rapids Art Museum, Michigan

1986, 1989 David Barnett Gallery, Milwaukee

1986 White Plains Library, New York

1987 Macquarie Gallery, Sydney, Australia

1988 Ingber Gallery, New York City

1988 International Monetary Fund, Washington, D.C.

1989 Sound Shore Gallery, Stamford, Connecticut

1989 Contemporary Sculpture Center, Tokyo

GROUP EXHIBITIONS

1956 Arts Festival, Olympic Games, Melbourne

1961 International Sculpture Biennale, Paris

1967 Guggenheim Museum, New York City

1968 Newark Museum, Newark, New Jersey

1967, 1969 Larry Aldrich Museum, Ridgefield, Connecticut

1968 Riverside Museum, New York City

1969 The Museum of Modern Art, New York City, Rockefeller Collection

1968, 1969, 1973 Whitney Museum Annual, New York City

1969 Mexican Olympics Outdoor Sculpture

1970 Monumental Art, Cincinnati, Ohio

1970 "7 Outside," Indianapolis

1971 "Sculpture in the Parks," New Jersey

1971 International Sculpture Symposium, Burlington, Vermont

1972 Washington Heights Outdoor Sculpture Project, New York City

1973 "The City Is for People," Fine Arts Gallery of San Diego

1973 "Sculpture off the Pedestal," Grand Rapids, Michigan

1974 Monumenta, Newport, Rhode Island

1974 Invitational Sculpture Show, Bethlehem, Pennsylvania

1975 Outdoor Show, Houston

1976 Super Sculpture, New Orleans

1976 Lehman College, New York City

1977 Three Rivers Arts Festival, Pittsburgh

1977 Project—New Urban Monuments, Akron, Ohio

1978 Mount Holyoke College, Massachusetts

1978 Living Sculpture, OK Harris Gallery, New York City

1981 "Sculpture Outside," Cleveland, Ohio

1983 "Bronze in Washington Square," Washington, D.C.

1984 Contemporary Sculpture, Toledo, Ohio

1984 Dubelle Gallery, New York City

1985 School of Visual Arts, New York City

1987 The Gallery at Hastings-on-Hudson, New York

1989 ACA Gallery, New York City

1989 André Zarre Gallery, New York City

1989 Sound Shore Gallery, Stamford, Connecticut

1991 André Emmerich Gallery, New York City

1992 André Emmerich Gallery, New York City

1992 Gloria Luria Gallery, Miami, Florida

1992 American Abstract Artists, Edwin A. Ulrich Museum of Art, Wichita, Kansas

1993 Chelsea Harbour Sculpture 93, London

1993 André Emmerich Gallery, New York City

INDEX

Page numbers in *italics* refer to illustrations.